Black&White
PHOTOGRAPHY

a practical guide

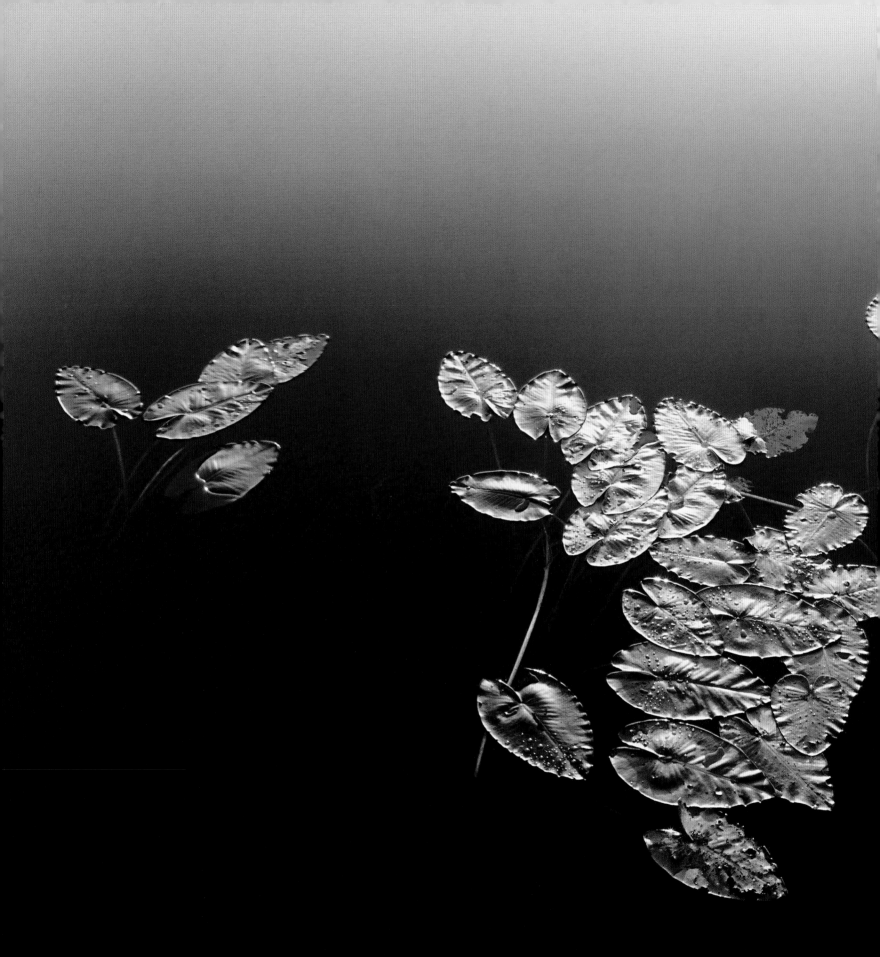

Black&White
PHOTOGRAPHY
a practical guide

STEVE MULLIGAN

photographers'
pip
institute press

This book is dedicated to my daughter, Alyssa, a budding black
& white photographer in her own right, and to the memory of
Minor White, still the greatest of all black & white photographers.

First published 2006 by

Photographers' Institute Press / PIP

an imprint of
The Guild of Master Craftsman
Publications Ltd,
166 High Street, Lewes,
East Sussex BN7 1XU

Text and photographs (except as listed on page 189) © Steve Mulligan 2006

© in the Work Photographers' Institute Press / PIP 2006

ISBN-13: 978-1-86108-428-6 ISBN-10: 1-86108-428-5

Production Manager Hilary MacCallum
Managing Editor Gerrie Purcell
Photography Books Project Editor James Beattie
Project Editor Stephen Haynes
Managing Art Editor Gilda Pacitti

facing page
Agave, Del Mar, California

Typefaces: Garamond and Foundry Sans
Colour reproduction by Altaimage
Printed in China by Hing Yip Printing Co Ltd

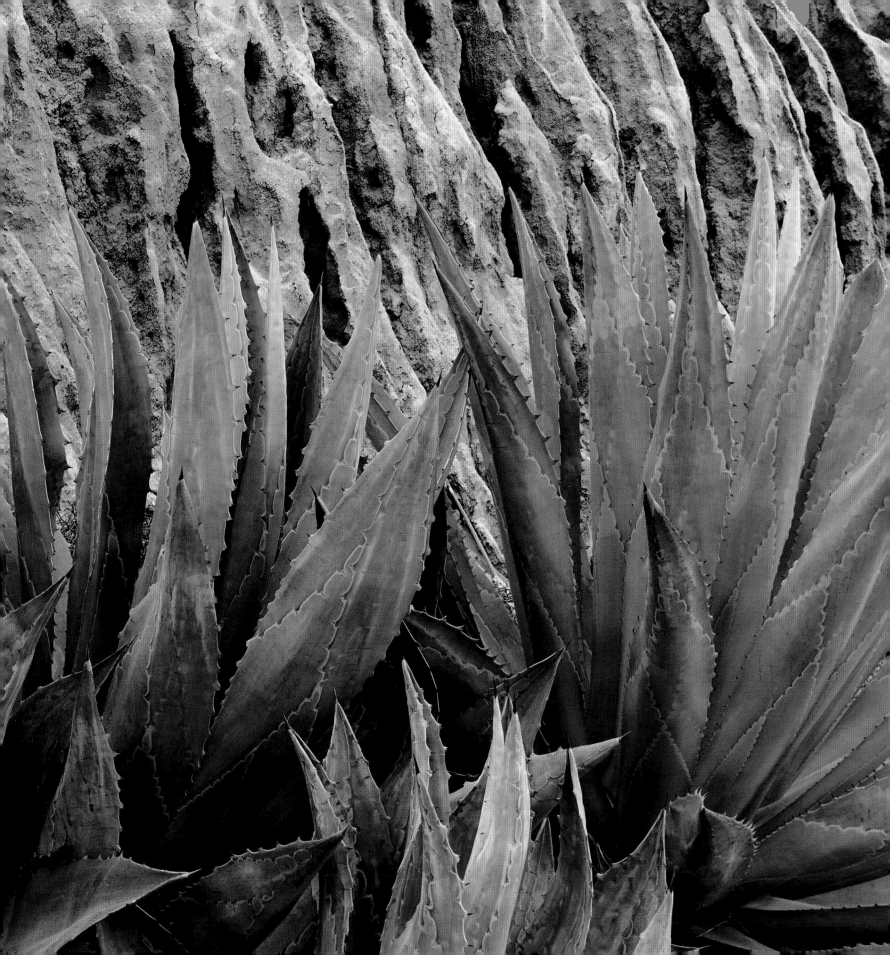

Contents

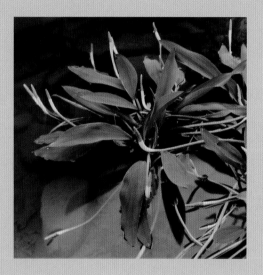 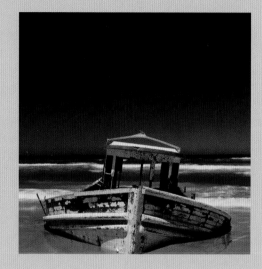 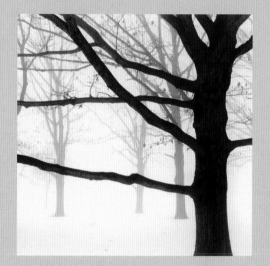

Chapter 1

Cameras & Film

Chapter 2

Exposure & Development

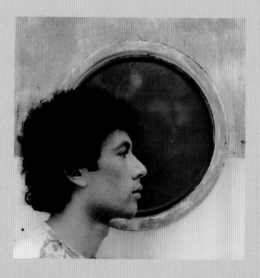

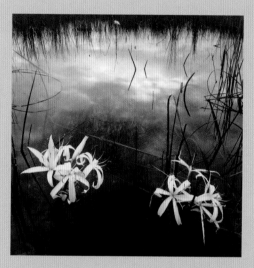

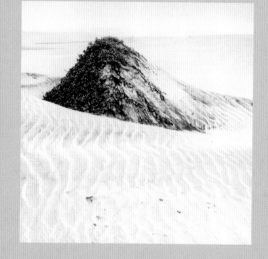

Chapter 3

Composition

page 87

Chapter 4

Printing

page 119

Chapter 5

Series

page 171

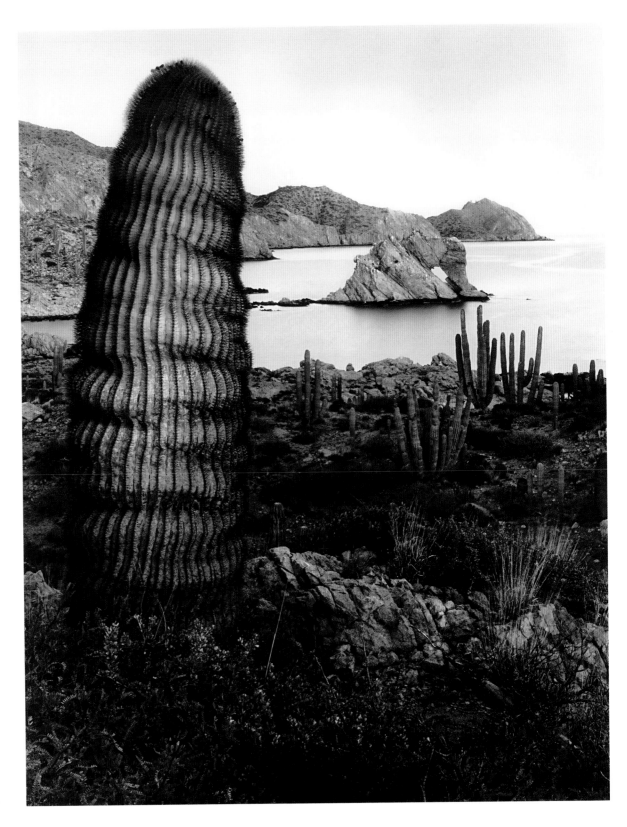

**Giant Barrel Cactus,
Santa Catalina Island,
Baja, Mexico**

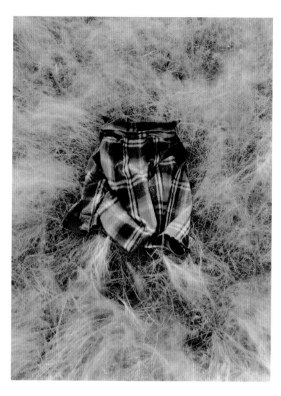

Jacket in Grasses, South Dakota

Foreword

Above the mantelpiece on my living-room wall hang two framed, black & white prints. One depicts a teardrop-shaped pool nestling within a softly fluid rock formation, a luminous highlight at the top of the 'teardrop' anchoring the composition; the other shows a curved procession of potholes – each one housing a layer of smooth, white ice – disappearing into the horizon, looking for all the world as if a woolly mammoth trod this path many thousands of years ago, leaving a trail of footprints as its legacy. What characterizes this second print is, again, the luminosity that makes the frozen water appear lit from within. The photographer responsible for these two prints is Steve Mulligan, and, of all the motifs that identify his work, this incandescent glow is probably the most powerful.

Sometimes prints that are framed and hung can all too quickly become 'wallpaper'. We are exposed to so much visual stimulation in every aspect of our twenty-first-century lives that we start to filter out much of what we are regularly exposed to. Not so with my pair of Steve Mulligan prints, however. While they invariably catch the eye of new visitors, I regularly find myself spending several minutes at a time contemplating them. So what is it that draws me back to his photographs time and time again? Perhaps it is the compositions, which are as intriguing as they are compelling. Perhaps it is the delicacy of touch that is rarely equalled in black & white photography. Perhaps it is because he eschews drama for drama's sake, and never forces an instantaneous 'wow' factor into a scene that doesn't require it. His more measured, contemplative way of working – as frustrating as he admits it can be at times – results in an image whose impact lasts for a long time after the initial intake of breath has subsided.

Whether novice or established, photographers of every level should benefit from absorbing aspects of Steve's philosophy on photography, and it is those photographers who will be inspired by the wealth of knowledge and expertise shared in the pages of this book.

Ailsa McWhinnie
Editor, *Black & White Photography*

Introduction

TRADITIONAL BLACK & WHITE PHOTOGRAPHY HAS A SPECIAL APPEAL OF ITS OWN – ALL THE MORE SO IN TODAY'S WORLD, WHERE WE ARE CONSTANTLY EXPOSED TO LURID COLOUR ON ALL SIDES.

Working in black & white has often been presented as a complicated and difficult endeavour, particularly in recent years. This is patently untrue, for the process is accessible to anyone, regardless of previous experience or training. The simplest 35mm SLR camera with a built-in meter can be used to create high-quality monochrome prints. Some basic equipment, a few supplies, and a small, darkened room are all the ingredients you need to express your personal vision.

'it is impossible to maintain good control without personally handling all aspects of the process'

This book will present a basic, easy-to-use system for exposing, developing and printing film. During my slow, and often painful, progression down the road of photographic experience, I have pared down those techniques that complicate the process unnecessarily. While discarding these impediments, I have also explored and clarified those aspects of the process that simplify the work and bring me nearer to the goal of making a luminous photograph that expresses my personal vision.

Black & white photography could be called Machiavellian, in the sense that the end totally justifies the means. The methods employed are unimportant, as long as the final result is a good photograph. Unfortunately, it is impossible to maintain good control over your results without personally handling all aspects of the process, and a darkroom is necessary – but it is an easy and relatively cheap thing to build and equip, as we shall see.

Over the last thirty years I have developed and refined a system that allows good control over the materials while simultaneously encouraging creativity. In black & white photography there is frequently an undue emphasis on tools – particularly cameras – and also on whatever techniques and films are currently in vogue. Product manufacturers tend to gloss over the fact that the simple and primary goal of most monochrome photography is to create meaningful images. In order to achieve personal photographic success, it is necessary, however difficult it may be, to concentrate on the process rather than the advertisers' hype.

AN OUTLINE OF THIS BOOK

The first step in black & white must be control of your camera; this is relatively easy to master, and is discussed in Chapter 1. The subject of lenses is also quite approachable – the main thing is knowing which one to select for a given situation. Film choice will be the next step, and your options will be narrowed down by the type of photography you choose to undertake. There are relatively few good films on the market nowadays, and even fewer decent developers, so these choices are fairly straightforward.

'the simple and primary goal of most monochrome photography is to create meaningful images'

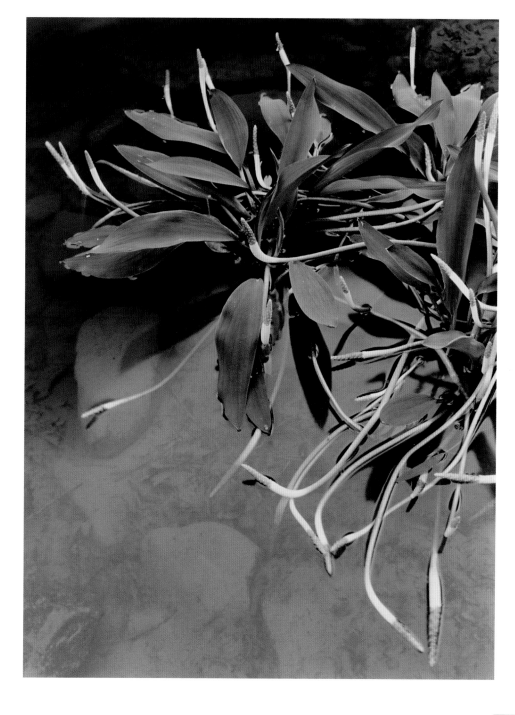

right

Golden Club

One of the strangest aquatic plants I have ever come across, this golden club was flowering in the shallow water of a stream in eastern Pennsylvania. It took me some time to compose this shot, and, as I had forgotten to bring my water shoes on this trip, my bare feet became quite cold.

Dropping my Gitzo tripod down to isolate this grouping, the composition jumped out at me from the camera's ground glass. The water, even along the stream's edge, had a weak current, causing a slight wiggle in the foreground flowers.

Toyo 4 x 5in field view camera + Caltar 135mm lens, Ilford FP4 Plus, 1 sec at f/32; development normal

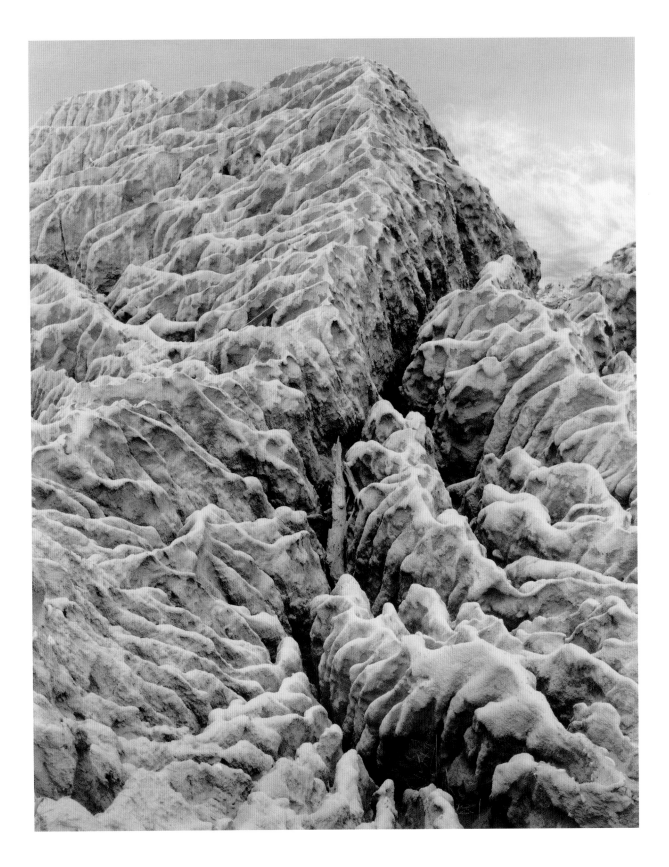

Erosion

This fantastically eroded formation is on a hill overlooking the Pacific Ocean in Torrey Pines, one of California's premier state parks. The soft evening light accentuates the repeating design of the eroded hillside, and the long exposure has blurred the distant surf. The perspective in this image is skewed because the surf resembles clouds, and this type of compositional oddity appeals to me.

Tachihara 4 x 5in view camera + Super Angulon 90mm lens, Ilford FP4 Plus, 5 sec at f/64; development normal −1

Once camera technique is under control, and the film has been picked, the next step will be film development. This is dictated by several things, including the speed of the film and the contrast and brightness of the scene, and all of these factors will be investigated in Chapter 2. The other important aspect of film use is exposure; I use and recommend the Zone System, a tried and tested methodology which offers reliable control over the various tones within the final print, particularly shadow and highlight detail.

Composition is exceedingly important, and can be a major factor in the success or failure of an image. Some of the innumerable styles and approaches available to the photographer will be explored in Chapter 3.

The next step will be printing, covered in detail in Chapter 4, where the darkroom becomes the final stage in the evolution of the print. Paper selection is important; there are many brands and types available, and we will consider how to choose a paper that suits your own photography. Methods of printing will be explored, with an emphasis on the split-contrast technique, which I consider the most effective. The basic methods of print manipulation will be explained, as will developer choices and dilutions.

'With a little imagination, you should be able to find an organization that needs a photographer's help.'

Chapter 4 also covers the various finishing touches which are needed to bring out the best in your print, from discreet retouching to the final presentation of the photograph. We will look at darkroom construction, considering the best and the cheapest methods to build and equip one.

GETTING INVOLVED

Photography can be a powerful tool, and this is an avenue that you may want to explore. There are innumerable good causes in the world today that deserve support, and a surprising number of them need photographs. One cause which is particularly relevant to my own work is the environment; environmental organizations will always be arrayed against big money interests, and will always need help. I have donated shooting sessions and photographs to several organizations in the US, including various state offices of the Nature Conservancy, and the Southern Utah Wilderness Association. The latter group is trying to protect the red-rock wilderness of southern Utah from massive exploitation – a herculean task – and I do a yearly aerial shoot for them, documenting recent trespasses and damage to public lands.

There are other groups not involved in environmental causes that can also benefit from photography. I donate a print every year to the Salt Lake Rape Crisis Center art auction; this group is a powerful advocate for women's rights in northern Utah. Our local domestic violence shelter holds an annual art auction, and I regularly donate prints to them. With a little imagination, you should be able to find an organization that needs a photographer's help. In my case, these donations are a way of giving something back, of expressing thanks for the enjoyment and livelihood provided to me through photography.

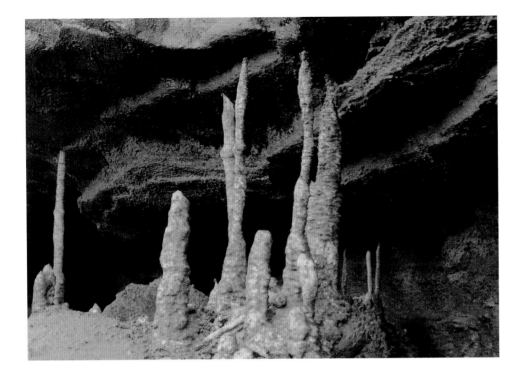

above | **Stalagmites**

by Alyssa Mulligan

These strange salt formations near my home town in Utah have become a favourite subject of mine in recent years. My daughter Alyssa had recently been given an old 35mm SLR by her grandfather, and she wanted to expose some film in it. As I was keen to explore this area further, we hiked down to the Pollack Canyon stalagmites. With her small tripod, Alyssa selected a composition, and, with minimal coaching from me, she focused and exposed several frames of film. When I helped her print the best negative, I was surprised at the strength of her composition.

Nikon F + 50mm lens, Kodak Tri-X, 1/4 sec at f/22; development normal

KEEPING IT SIMPLE

Good photography need not be difficult. With the discovery of her grandfather's Nikon F in the back of a closet, my 16-year-old daughter has recently evinced an interest in photography. On a recent hike, and with only limited help from me, she composed and took the remarkably good photo shown here.

There is often a huge gap between photographic theory and the reality of composing, shooting and managing a decent print. Over the years I have been told some very interesting theories, and these have always been presented to me as established fact. After a certain amount of experience, however, it becomes obvious when a particular procedure will not work. Any exposition of photographic technique should always be examined with a grain of salt – and this book is no exception, though the techniques and philosophies presented here certainly work for me, and should give anyone a sound base. With time and experience, you will expand your photographic ability, developing your own style and your personal variations on the techniques and compositions you have learned from others.

There are many philosophical and pictorial approaches to black & white photography, running the gamut from photojournalism to portraiture, and including architectural, still-life and landscape work. Each school has its own preferences in camera and material selection, but the basic techniques remain the same. The following chapters will guide you through these basics, and help you to choose the best equipment and techniques for whatever particular photographic goal you desire. If this book can assist in refining your photography, and can help you avoid some pitfalls along the way, then I will count it a success.

Penglai Fairy Islands

Although I have never mentioned this to my wife, we travelled to China solely for the purpose of finding and photographing these rock formations. I had seen some colour photos from this area, and had developed a strong desire to shoot here.

Staying at Huang Shan for several days, I was enchanted by the landscape, but frustrated by my inability to find the fairy rocks, a problem exacerbated by the fact that no one else on the mountain spoke English. Rising from a sleepless night at 2am, I took advantage of the full moon, and began to walk the ancient trail along the spine of Yellow Mountain. This stands as my most spectacular hike, a slow stroll through a fabulous landscape of moonlit fog, twisted trees and sharp peaks. After walking for five hours, I arrived at the small hotel located at the northern end of this range, and asked the clerk about the rocks. My childish sketch generated an excited reaction, culminating in his vaulting over the counter, waving for me to follow. Abandoning his post, he led me down a trail for two miles, beaming with pride as he showed me the Penglai Fairy Islands. After accepting my profuse thanks, he returned to his post, and I contemplated these elusive pinnacles. The small, twisted pine trees are exquisite, and greatly add to the allure of the sharp and grainy rocks.

The sun was minutes from rising, but the ubiquitous Huang Shan fog rolled in, obscuring any chance of dawn light. As the fog lit up, however, the magic inherent in these spires also appeared, and I spent a wonderful hour with the fairy rocks, making several exposures.

Toyo 4 x 5in field view camera + Rodenstock 135mm lens, Ilford FP4 Plus, 30 sec at f/45; development normal −2

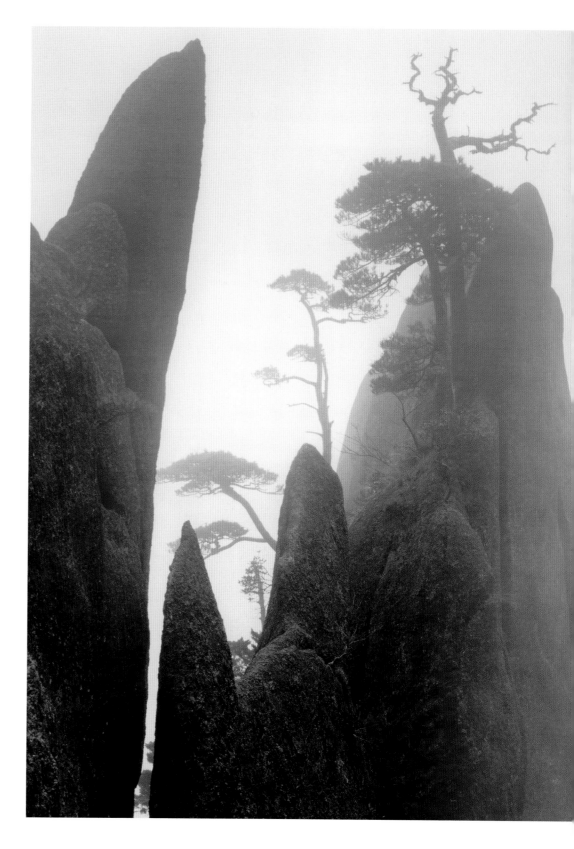

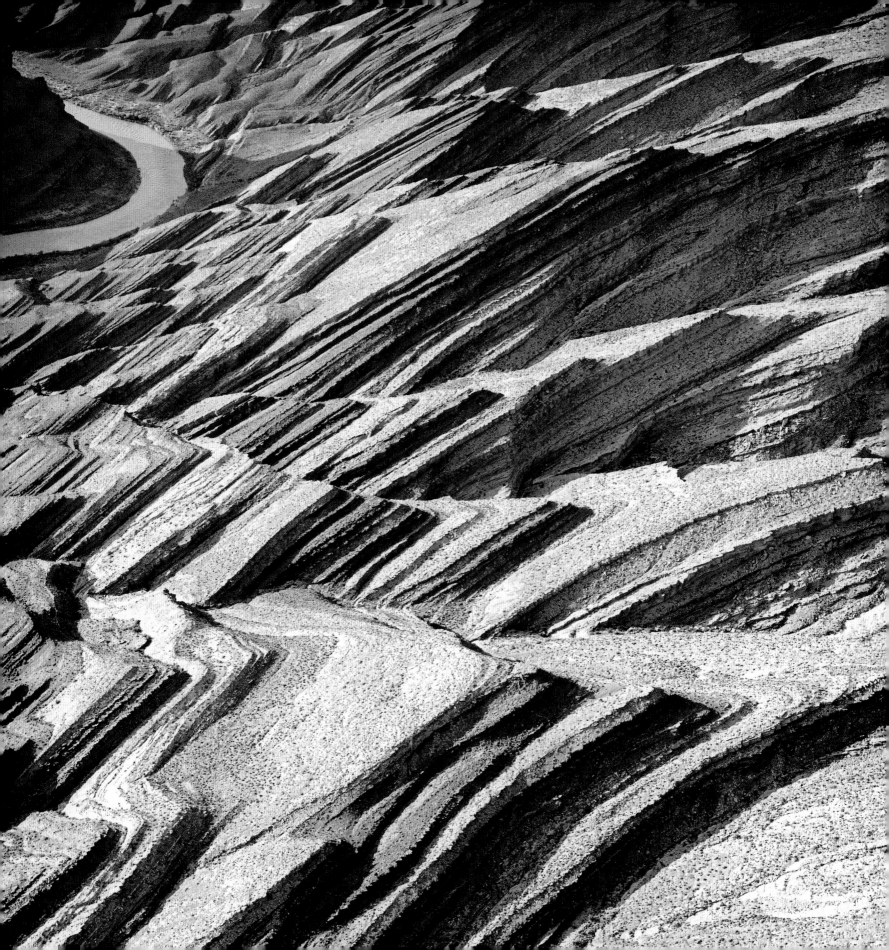

Chapter 1

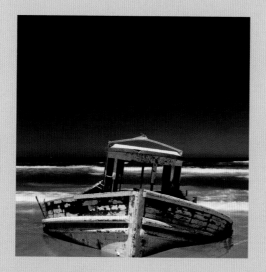

Cameras & Film

Choosing your Equipment

THE VARIETY OF CAMERAS AND FORMATS AVAILABLE CAN BE INTIMIDATING, AS CAN THE MANY TYPES OF FILM OFFERED. SELECT JUST A FEW PRODUCTS TO TRY, AND AFTER SOME MINIMAL TESTING, CHOOSE THE COMBINATIONS THAT SEEM TO WORK FOR YOUR PHOTOGRAPHY.

Camera selection depends completely on your chosen style of photography and subject matter, and on the desired end result. My subject of choice is landscape, and because of this, my main camera is a Toyo 4 x 5in view camera. The large negative necessitates a slow and thoughtful pace, and this approach favours my personal

'I have several modified toy cameras, for those times when dark humour overcomes my sensibilities.'

philosophy. I also use two medium-format Pentax 67s for aerial work, and have several modified toy cameras, for those times when dark humour overcomes my sensibilities. Over the years I have had several 35mm cameras, beginning with a Petri (my first camera) and ending with an Olympus OM-1.

CAMERA BASICS

The basic mechanism of any film-based camera is fairly simple, and the lens is the most important piece of this tool. A camera lens consists of several pieces of optical glass arranged in a certain order, the focal length (whether wide, normal or telephoto) being determined by their shape and alignment. By changing the distance between the individual elements, focus is modified, and this distance can be figured either

by reading the distance setting on the lens barrel, or (in most cases) by looking through the viewfinder. Also enclosed within the barrel that holds the optics is the adjustable diaphragm which controls the lens **APERTURE**, regulating the amount of light that will reach the film. Lenses usually mount onto a camera body by means of a bayonet or twist-and-lock mechanism.

The camera body's main function is to hold the film flat, while allowing the lens to expose light onto it by way of the shutter and diaphragm. In the case of SLRs (single-lens reflex cameras), a mirror reflects the scene up into the viewfinder, popping up out of the way during the actual exposure. Twin-lens reflexes have two lenses – one for the viewfinder and one for the film exposure – while rangefinders and other 'direct vision' cameras have a vewfinder window placed close to the lens. In 35mm and medium-format cameras, the roll of film is advanced after each exposure, either automatically or through the use of a lever mounted on top of the body. In large-format view cameras, a single sheet of film is exposed, and then the film holder is flipped to expose a second piece of film.

In most SLRs, the **SHUTTER** is built into the body. This mechanism controls the duration for which the film is exposed to the film. (The aperture controls the amount of light allowed through the lens during the duration of the shutter opening.)

page 16

Raplee Anticline

The San Juan is a small river in southern Utah, surrounded by amazing sandstone formations. I shot this structure from the air. My pilot was sympathetic, understanding the angle required, and the mid-afternoon light was perfect, giving sharp edges to the triangular shadows, with the small section of river adding perspective.

right

Twisted Fence

This was taken with my favourite toy camera, one that cost me just 99 cents 30 years ago. It has withstood unbelievable abuse and continues to work, providing me with limitless fun. Over the course of several months I photographed this fence with a number of different cameras, but this has always been my favourite. Toy cameras require a suspension of technical knowledge, and emphasize the primacy of pure vision.

Diana + partially melted lens, Ilford HP5 Plus, fixed exposure

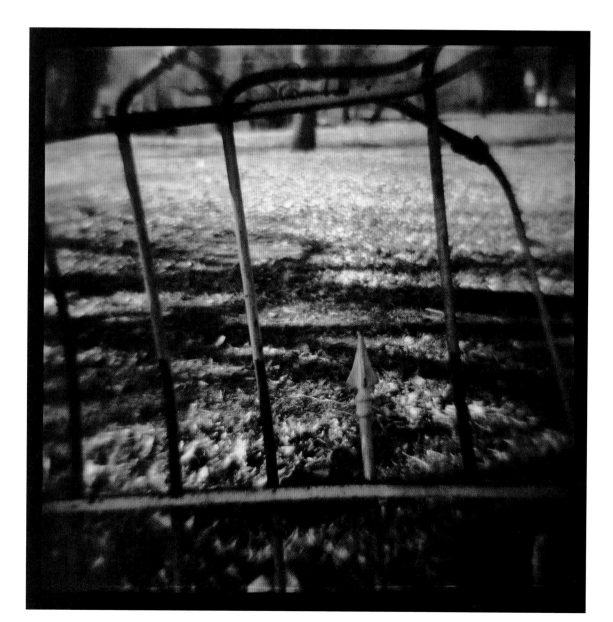

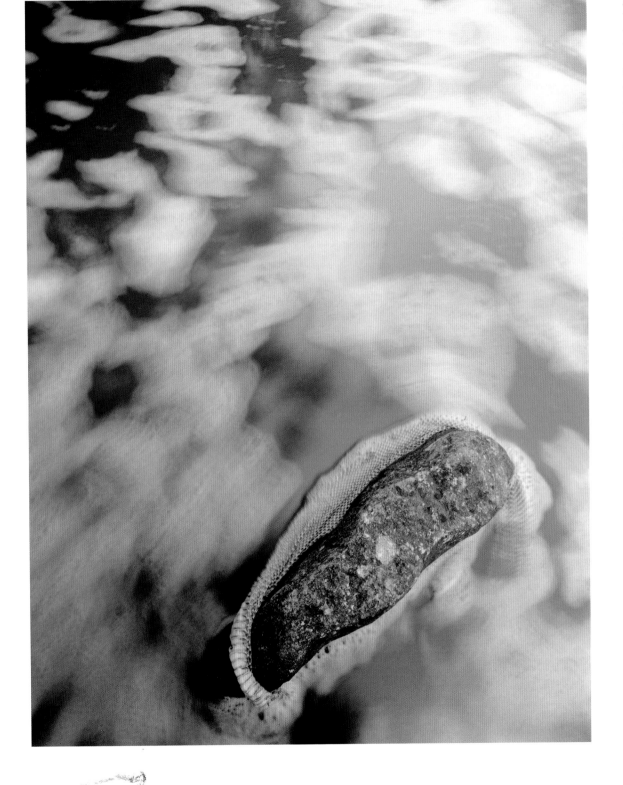

Butcher Creek

Waiting for evening light at a Kansas waterfall one hot and humid afternoon, I passed the time watching swirls of foam emanate from the base of the falls. Looking closely at a particular rock, I noticed that a long snakeskin had wrapped around it. The combination of the swirling foam (exaggerated here by a long exposure) and the skin draped around the rock intrigued me, and I tried several views before settling for this angle. This is a recent (and I realize, somewhat strange) image, but it has held my interest.

Toyo 4 x 5in field view camera + Nikkor 75mm lens, Ilford FP4 Plus, 1 sec at f/45

Shutter speeds can run from 1 second or longer up to 1/1000 of a second or faster. Most cameras also have a B (bulb) or T (time) option on the shutter control, allowing exposures of much longer duration when needed. The relationship between aperture and shutter speed is of paramount importance, and will be explored in depth in the next chapter.

To help determine exposure, most cameras have some type of **LIGHT METER** built in. This usually offers **THROUGH-THE-LENS (TTL) METERING**, measuring the light as it passes through the camera lens. One of the simplest types is the 'match-needle' meter, where a movable line is positioned within a stationary circle, or a pointer moves against a scale. Modern cameras generally offer an aperture- or shutter-priority mode, or both. These allow the photographer to set the aperture while the meter automatically selects the shutter speed, or vice versa. Many also have a fully automatic mode, where the meter selects all aspects of an exposure, but this cannot be recommended, as it takes control away from the photographer. There is normally a fully manual mode also. Cameras with internal meters also have an ISO dial, which sets the speed of the film; this is explained on page 51.

Separate **HAND-HELD METERS** work on the same principle, with an ISO setting and some type of match system; they present a series of aperture/shutter-speed combinations from which the photographer can select that which will work best. This information then has to be transferred manually to the aperture and shutter controls.

Once the roll is finished, 35mm film is then rewound back into the cartridge, while medium-format film is rolled forward onto a separate reel, and then sealed with self-adhesive tape to await development. Large-format film is kept in the film holder after exposure, and must only be taken out in the darkroom.

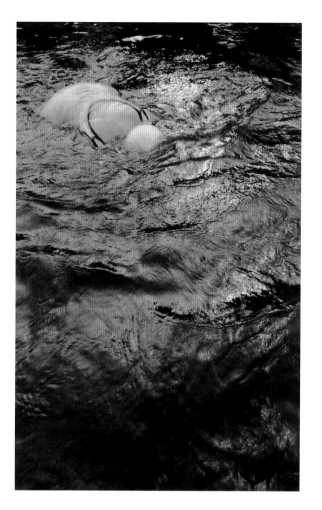

above

Grandma's Last Swim

My family would always spend a few weeks at my grandmother's cabin, on the St Croix River in northern Minnesota. Most afternoons were spent on the pontoon boat, anchored in the middle of the river, in a vain attempt to escape the voracious mosquitos. On this particular day, our grandma decided to climb in and swim around, which mostly involved dipping her face in the water and splashing quite a lot. Standing in the waist-deep river with my 35mm camera, I snapped several photos that day, unknowingly documenting the last time she would swim in her beloved St Croix. Her slowly fading health would preclude these episodes, to her great disappointment. The afternoon sun through the trees provided lovely light, and I have always been glad I took this photograph of her.

Olympus OM-1 + 28mm lens, Ilford HP5, 1/60 sec at f/11

35MM CAMERAS

'While the larger-format cameras will give higher definition in big enlargements, smaller prints give a nice feeling of intimacy to draw the viewer into the scene.'

For street photography and photojournalism, as well as for general ease of handling, 35mm is superb. The light, unobtrusive cameras are very easy to work with. The variety of camera types available can be confusing; however, as always, the best philosophy is to keep everything as simple as possible. Too many bells and whistles can become an annoying distraction. Basic compact or 'point and shoot' cameras are often capable of surprisingly good results, but the more sophisticated SLR and rangefinder models offer far more scope for serious photography, with interchangeable lenses, a wide range of other accessories, and full control over exposure and focus.

My first 35mm camera, bought when I was 15, was a Petri, fitted with a 50mm lens and a basic match-needle meter. My next was an Olympus OM-1, which was smaller and easier to use than the Petri, and also had simple but effective match-needle metering. I always kept a 28mm lens on it, and this moderate wideangle lens was perfect for spontaneous 'grab' shots, like the chance composition shown opposite.

The versatile 35mm format can be used for most styles of photography, from photojournalism to landscape. Using a tripod and smaller apertures will render surprisingly sharp negatives. While the larger-format cameras will give higher definition in big enlargements, smaller prints from 35mm give a nice feeling of intimacy, which can help to draw the viewer into the scene. Larger blow-ups from 35mm can also be interesting in their own right, and the extreme graininess that occurs with the faster films can give a special atmosphere of its own.

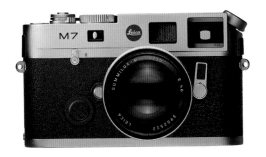

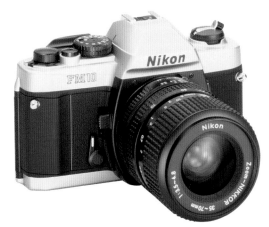

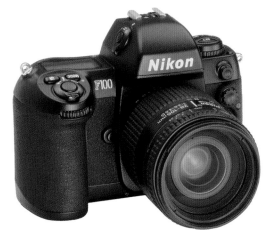

35mm compact

This is a sophisticated and expensive model with rangefinder focusing, but good results can be obtained with much simpler cameras. Many rangefinders will accept a range of lenses; cheaper compact cameras often have fixed zoom lenses.

35mm manual SLR

With a very wide range of lenses and other accessories, the 35mm SLR is probably the most versatile type of camera there is. Manual models offer full hands-on control of aperture and shutter speed, and many have aperture- or shutter-priority modes also.

35mm automatic SLR

Recent models offer very sophisticated automated exposure and focusing systems, but incorporate manual overrides for those of us who prefer to make our own decisions. Automatic film advance and rewind are standard features.

CHOOSING 35MM EQUIPMENT

The versatile **SINGLE-LENS REFLEX (SLR)** is the usual choice today, though rangefinder cameras have many supporters. The SLR's viewfinder shows the view through the lens itself, by means of a mirror which flips out of the way at the moment of exposure, and this permits very accurate composition. Though manufacturers are now 'rationalizing' their ranges, there are still many types of 35mm SLR available, and they can be very simple or incredibly complicated. A simple match-needle meter will work fine, as will aperture-priority or shutter-priority exposure modes. Of the two, aperture-priority is more appropriate for the exposure method recommended in this book, because it gives control of depth of field (see pages 112–114), which is an important aspect of the system; if a tripod is used, slow shutter speeds won't matter. Cameras with a spot-metering option, allowing you to measure the light reflected from a very small area of the subject, work very well with the Zone System (see Chapter 2), but any meter, in-camera or hand-held, will work with this methodology. Fully automatic exposure without manual overrides is not suitable, as it takes away all control from the photographer; but most modern 35mm cameras offer shutter or aperture priority in addition to the full-auto mode.

There is a huge variety of lenses available for 35mm SLRs, but, unless you have specialized needs, a small and simple selection will work best. A normal or standard lens (50mm) will always be a mainstay, and a wideangle (28 or 24mm) is a useful addition. A mild telephoto will occasionally be needed, perhaps a 200mm. There are several types of zooms available. Inexpensive lenses by third-party manufacturers vary in quality, so lenses made by the camera manufacturer are recommended. As with most good-quality camera equipment, used lenses will usually be fine.

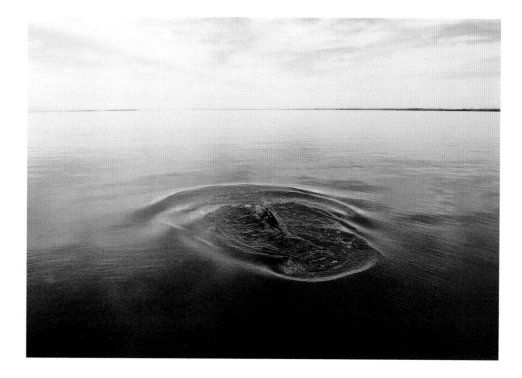

above | **Grey Whale**

This is a juvenile Pacific grey whale surfacing to take a breath. It was shot from an inflatable boat in Magdalena Bay, off the west Baja coast in Mexico. Every winter the bay is home to hundreds of whales who use its protected waters for birthing their babies. Though this kind of grab shot is difficult to meter properly, any kind of decent negative can be turned into a good print.

Olympus OM-1 + 28mm lens, Kodak Tri-X, 1/125 sec at f/5.6

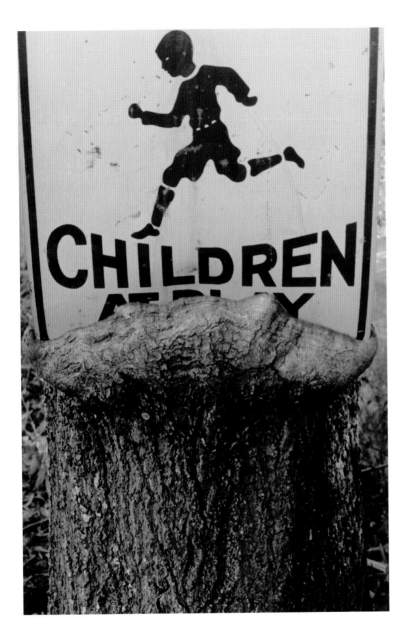

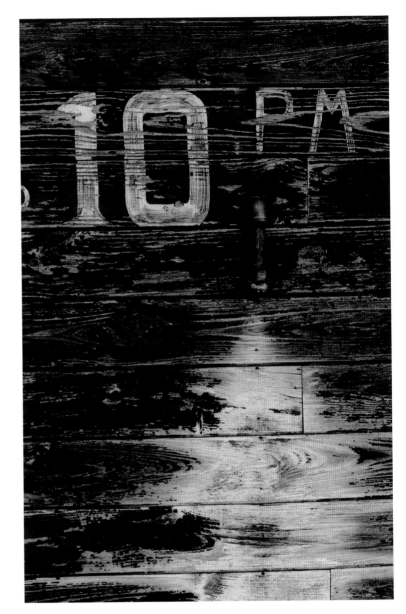

above

Children at Play

Though the negative has several flaws (the major one being extremely shallow depth of field), this quick grab shot was the best photo I took of this subject, perhaps because of its spontaneity. The children had long since grown up, but the elm tree inexorably continued eating the sign.

Olympus OM-1 + 28mm lens, Kodak Tri-X, 1/60 sec at f/5.6

above

10 PM

This was shot on my trusty old 35mm Petri, very soon after I came to understand the Zone System. The scene was on a laundromat wall opposite my college apartment, and I purposely dropped the shadows and raised the highlights to create a dramatic contrast.

Petri 35mm + 50mm lens, Kodak Tri-X, 1/15 sec at f/16

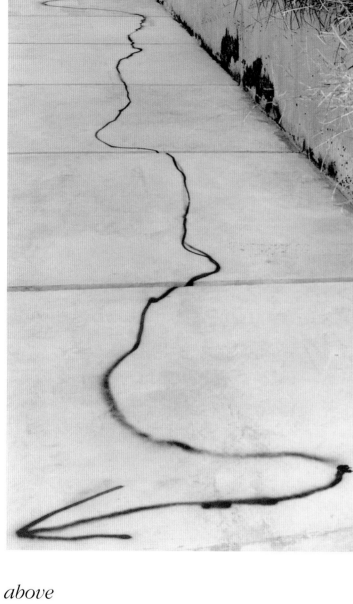

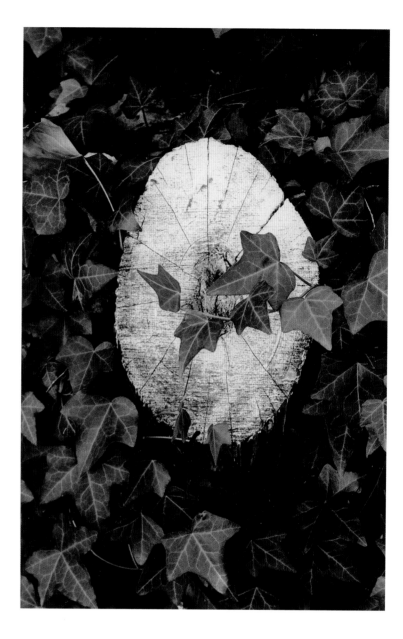

above

above

Sidewalk Arrow

This graffiti was on a sidewalk in San Francisco, and the sheer whimsy of it was magnificent. Of the three frames exposed, this one best displayed the reason I was smiling that afternoon. Despite being hand-held, the negative is decently sharp.

Olympus OM-1 + 28mm lens, Kodak Tri-X, 1/60 sec at f/11

Post & Ivy

This was also made shortly after my Zone System epiphany, and was taken in my backyard. Once again I purposely lowered the shadows and exaggerated the highlights, adding contrast to what was originally a flat scene.

Petri 35mm + 50mm lens, Kodak Tri-X, 1/15 sec at f/16

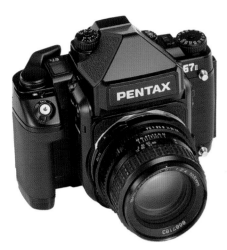

Pentax 67

This is my favourite camera for aerial photography, made in the style of a 35mm SLR but using the 6 x 7cm format on 120 film.

MEDIUM-FORMAT CAMERAS

Medium-format cameras using 120 rollfilm offer many incentives, giving a reasonably large negative size without the bulk and weight of a large-format view camera. There are several formats available, ranging from 6 x 4.5 to 6 x 9cm. My first medium-format camera was a 6 x 6cm Yashica-Mat, bought at a flea market for a pittance. This fun and reliable twin-lens reflex withstood several years of rough treatment. From there I moved up to a Hasselblad, which is a fine camera, but much more costly. Hasselblad optics may well be the sharpest on the market, and I used this camera for years, finally selling it when I became frustrated with the square format (I tend to see in rectangles, as a rule).

These days I use a pair of Pentax 67s for aerial work. I find these workhorse SLRs perfect for the unusual demands of shooting from a small, fast-moving plane. Most current medium-format cameras are SLRs. Others feature **RANGEFINDER** focusing, in which a double image in the viewfinder merges into a single image when correctly focused. In **TWIN-LENS REFLEXES** like my old Yashica, the viewfinder displays a separate view from the lens, giving a close approximation of what will end up on the film. Most of these cameras incorporate some kind of parallax correction system, where the viewfinder lens is corrected to give a similar field of view to the taking lens.

right | # Serpent Intaglio

I had heard rumours of a prehistoric entrenchment in central Kansas, but had never been able to find the location. I mentioned my frustration to a friend who works for the Kansas Nature Conservancy. Much to my surprise, she said that it was close to her home town, and she gave me the name and number of the family that owned the property.

After receiving permission from the owner, my colleague Mike Snell and I set out with several hundred kilos of chalk and a spreader. After several hours we were both covered head-to-toe in chalk and coughing like old men, but the serpent was finally outlined.

This earthwork was made several hundred years ago, by digging the outline, then mixing lime into the soil to inhibit growth. After several centuries, the prairie grass still wasn't growing in the intaglio. The serpent is a solstice marker: a person standing on the tail, looking up the snake, will see the summer-solstice sun rise just above the head. The snake is eating an egg, a motif repeated in other earthworks in the eastern US.

My pilot flew us around the intaglio several times, and this was the best negative. Low-angle light is my favourite as a rule, but flat illumination worked best for this subject. A strong push in film development time added some 'pop' to the scene, and the distant tree line gives a subtle perspective.

Pentax 67 + 90mm lens, Ilford HP5 Plus, 1/500 sec at f/2.8; development normal +1

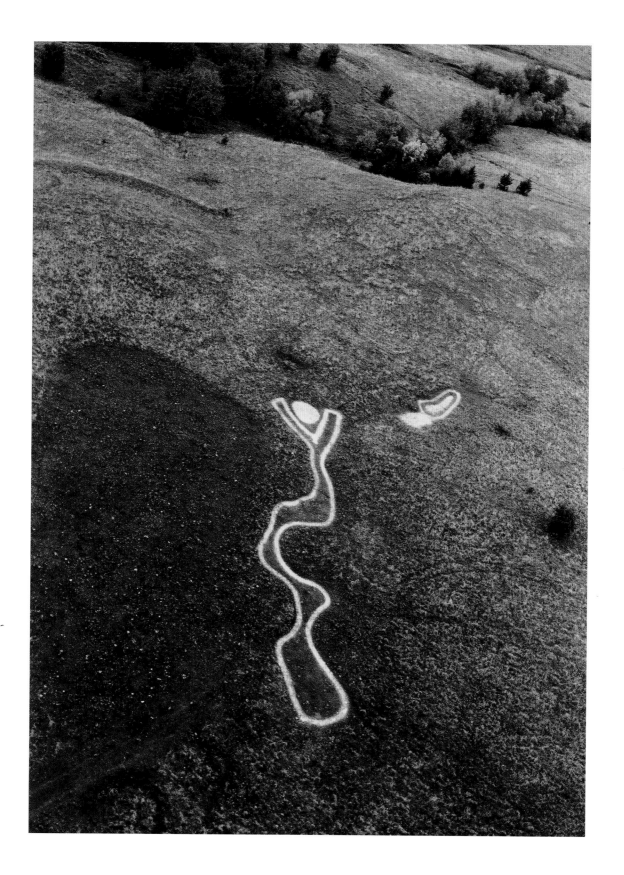

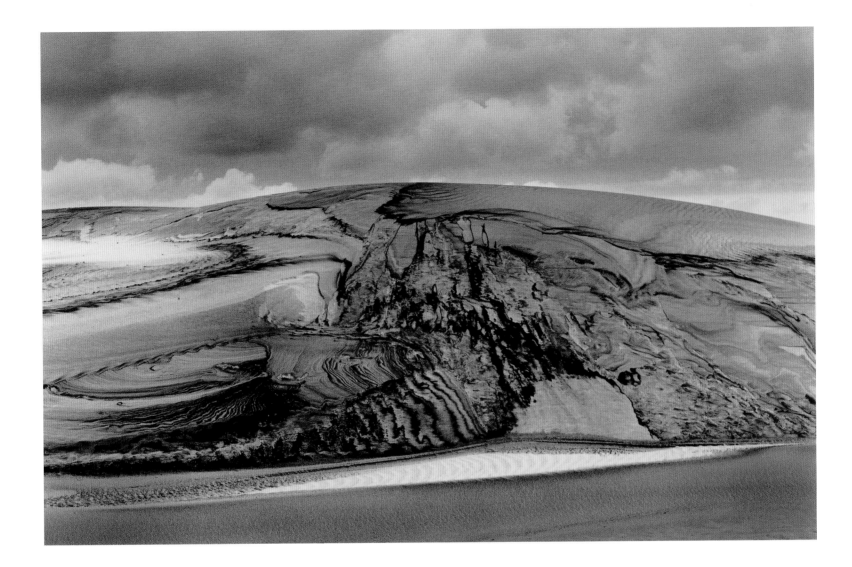

The various medium formats are a useful compromise between large format and 35mm, offering a larger negative than 35mm, but with the film still coming in rolls, which makes development much easier and allows for multiple exposures without reloading. These cameras are versatile, equally usable on a tripod or for hand-held work. Recent models are increasingly compact, which makes them even more attractive and easy to use. The Mamiya 645 is just one example of a good-quality camera with decent optics, and almost as easy to handle as a 35mm.

above | **Sand Dune**

This was taken on South Padre Island, a barrier sand-dune island off the south Texas coast, which was one of my favourite places to shoot while attending college. During a big storm, everybody in our hotel was forced to sleep in the basement because of the dangerous winds. Early the next morning I went wandering through the low, rolling dunes. The high winds had exposed the natural oil in the sand, and this scene caught my eye. The narrow band of white sand balanced nicely with the odd patterns, and the trailing edge of the storm provided a dramatic sky.

Hasselblad + 50mm lens, Ilford FP4, 1 sec at f/32

LARGE-FORMAT CAMERAS

The **VIEW CAMERA**, which comes in all sizes from 4 x 5 up to 11 x 14in (and occasionally even larger), is a tool that requires an introspective approach. In addition to the large size – which translates into a sharp, high-quality negative – it offers a range of 'movements' which allow the alignment of lens and film to be adjusted in order to control perspective and manipulate depth of field. (Depth of field is the distance between the nearest and furthest parts of the subject which appear in sharp focus; this important subject is explored on pages 112–113.)

The design of these cameras has remained basically unchanged for 100 years, and their make-up is quite simple. The base can be either a flat platform (as in most of the wooden 'field' cameras), or a metal bar or 'monorail' of some type (which is how most studio cameras are set up). A flat base allows the camera to fold flat, with the front element fitting into the rear part, an important feature for saving weight and space in the camera pack. Studio cameras tend to be stationary, and are heavier and larger than their field counterparts. The rear body in both types contains the **GROUND-GLASS SCREEN** on which the scene is composed and focused. The image on the screen is upside-down and laterally reversed, because camera optics inevitably reverse the scene, and view cameras, unlike smaller-format cameras, do not have mirrors or prisms to correct this. This can be disconcerting at first, but with time and experience it becomes unnoticeable.

The rear body is also where the **FILM HOLDER** is inserted, sliding behind the ground glass and held in place by tension clips. The rectangular plastic holders carry one sheet of film on each side, protected from light by thin **DARK SLIDES**. The slides are removed before exposure. After exposing one side, the slide is reinserted and the

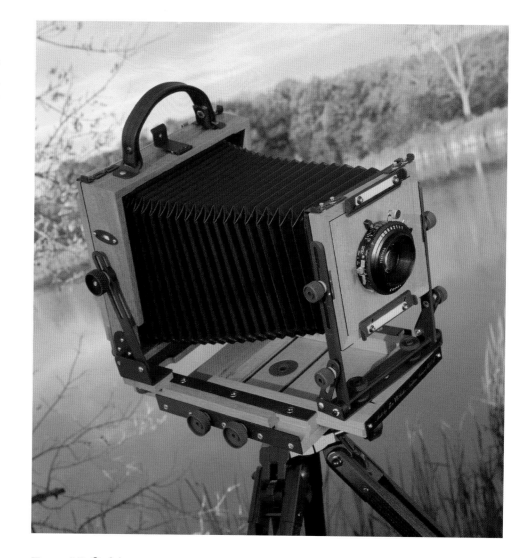

Zone VI field camera
The traditional wooden field view camera is still in production today, and its range of movements makes it exceptionally versatile for landscape, architectural and still-life work. This is the Zone VI 4 x 5in model.

film holder is flipped, allowing the opposite sheet of film to be used. Sheet film must be loaded in the dark, and is notched in the upper right-hand corner so you can tell which is the emulsion side. Before every use, I use canned air to clean out each side of the film holder, to keep the negatives as clean as possible. I also use lintless gloves to handle sheet film.

The **BELLOWS** is the middle part of the camera, an accordion of supple, lightproof material which connects the rear element with the front. The front element or 'standard' is designed to hold the lens, and in field cameras it moves on a

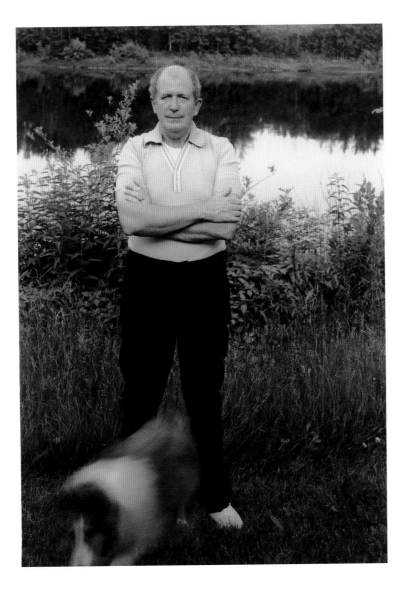

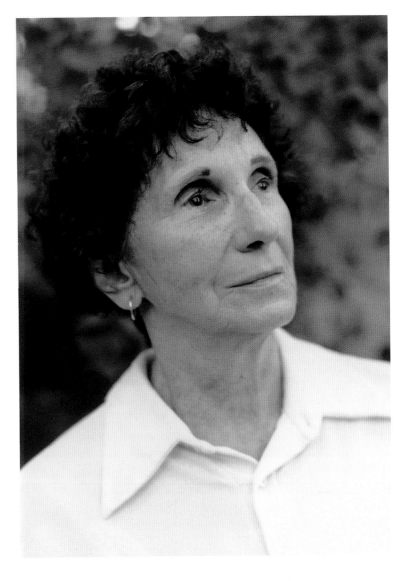

above

Don Mulligan

This is a portrait of my dad with Duffy, his favourite dog, on the banks of the St Croix River in northern Minnesota. At first I wanted just him in the photo, but the dog kept running excitedly around his feet. Bowing to the inevitable, I left Duffy in the photo. The long exposure blurred his movement, adding a nice element to the portrait.

Burke & James 5 x 7in monorail + 210mm lens, Kodak Plus-X, 1 sec at f/32

above

Blanche Weeks

This portrait of my maternal grandmother was taken in the backyard of her home in St Paul, Minnesota. Having my dad hold up a white sheet behind me to provide fill-in light, I had her look up, and managed to catch her quiet side on film. The shallow depth of field focuses attention on her face, and the late evening light gives a suitably gentle illumination.

Tachihara 4 x 5in view camera + Fujinon 150mm lens, Polaroid P/N, 1/4 sec at f/8

track to permit focusing. Monorail cameras can be focused from either the front or the rear standard, as both are movable. A telephoto lens needs more bellows extension than a wideangle.

CAMERA MOVEMENTS

The movements available include swing, shift and tilt. The tilting of the rear standard ('rear tilt') is particularly invaluable, as it can give astounding depth of field. Focusing on infinity (or on the part of the scene furthest from the camera), and combining the backward tilt with a small aperture, depth of field becomes virtually limitless. The rear standard is tilted back without disturbing the front standard. If the aperture is then closed down sufficiently (see page 112), the entire scene will be sharp. Though this technique works best with wideangle lenses, it can be employed, in varying degrees, with any lens. As the focal length of the lens increases, the allowable tilt decreases, but it can still be used at least to a minimal degree. This technique will work particularly well for extreme near–far compositions, but will help whenever a depth-of-field enhancement is required.

CHOOSING A VIEW CAMERA

There are many different view cameras available, and, as with most equipment, there is no real reason to buy a new model. There are many reputable equipment dealers, and I have always been satisfied with my purchases of used gear. Provided the bellows is lightproof and the rest of the camera seems to be tight, it should be workable. (Test the bellows by inserting a loaded film holder in the back element in daylight, removing and replacing the dark slide without tripping the shutter, and then developing the film. It should be a clear sheet after processing; if it is fogged, the bellows has a leak.)

Toyo field camera
The Toyo 4 x 5in field view camera, a rugged but heavy piece of equipment, is my current favourite.

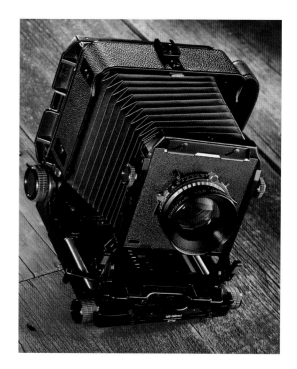

'The rear tilt is one of the best features of large-format cameras, as it can give astounding depth of field.'

The Toyo field view camera is a fine, tough piece of equipment, and I have been pleased with mine. Unfortunately it is on the heavy side, and lately my knees have been suggesting a return to a lighter wooden camera. I have been considering putting together a second pack, with a lighter camera and fewer lenses, for those occasional excruciatingly long walks.

My previous view cameras were a Wista and a Tachihara, both lightweight wooden 4 x 5s, and very well built. The Ebony is also a good example of a lighter field camera, well made and reliable.

In practice it doesn't much matter which camera is used, as long as it has rear tilt (front tilt and shift are also useful for perspective control in architectural work), and is light and serviceable.

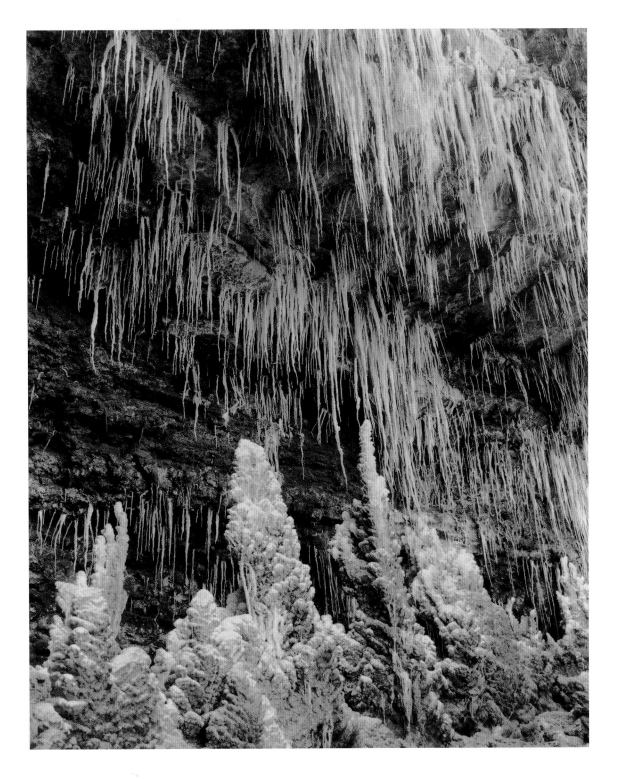

'Mites & 'Tites

These odd salt formations have been a recent obsession of mine, and this is the largest group I have so far found. This is a fantastical wall, and the tall base columns are 23ft (7m) high. It was hard to isolate this composition, as the alcove was huge and full of possibilities. Finally cropping this scene on the ground glass, I metered and exposed two sheets of film.

Toyo 4 x 5in field view camera + Nikkor 210mm lens, Ilford FP4 Plus, 1 sec at f/45

Lily Pads

Walking along a boardwalk in Everglades National Park, Florida, early one morning, I noticed this small group of lilies reflecting the sunrise. The flat, wet leaves were picking up a wonderful glow, and this highlight was accentuated by the dark foreground water. Letting the foreground go black, I concentrated on the details within the lily pads, and worked on accenting the smooth gradation from dark to light water.

Toyo 4 x 5in field view camera + Nikkor 210mm lens, Ilford FP4 Plus, 1 sec at f/45

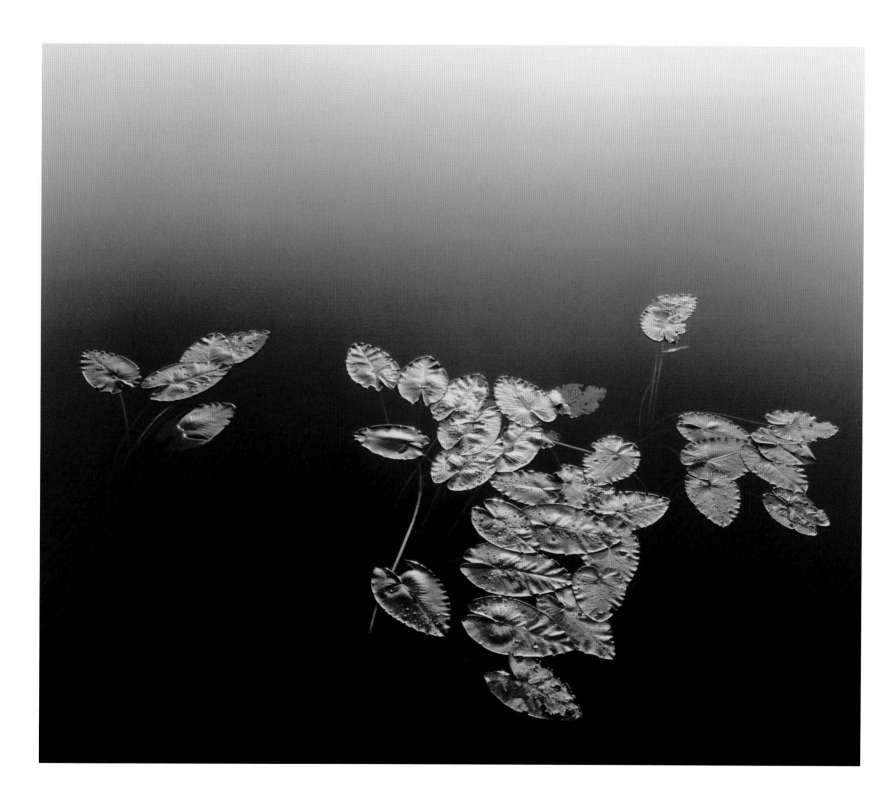

LENSES AND ACCESSORIES

View-camera lenses are fairly simple pieces of equipment, and they come in many focal lengths. A 150mm lens is considered normal or standard (see page 115), 90mm is a moderate wideangle, and 210mm is a medium telephoto. Each lens comes with a shutter and a diaphragm, giving a choice of speeds and apertures. Both lens and shutter are mounted on a lens board, which locks into the front standard of the view camera. As when using any camera on a tripod for long exposures, a **CABLE RELEASE** is required. This is a short length of cable, with one end that threads into the shutter release, while the other has a button to trip the shutter. This avoids any vibration that might occur when tripping the shutter by hand. Also required is a **DARK CLOTH**, which is simply a large rectangle of black cloth. This is draped over your head and the ground glass to exclude extraneous light, thereby improving visibility. Dark cloths come in several styles; mine is black on one side and white on the other, which helps to keep my head cool on hot days.

CARRYING LARGE-FORMAT GEAR

When any amount of hiking is required, a decent backpack is a must. There are currently several companies making good packs, and the main thing to check is that it has an internal frame. Another salient feature is a padded waist belt, which lifts the pack onto your hips, relieving pressure on the vulnerable area of the lower back. Most camera packs come with padded dividers, fixed with Velcro so you can rearrange them for safe storage of your equipment. My current pack is a Lowepro Super Trekker, and it is a comfortable and sturdy piece of equipment. This company makes packs in several sizes, and you can find one to accommodate most camera combinations.

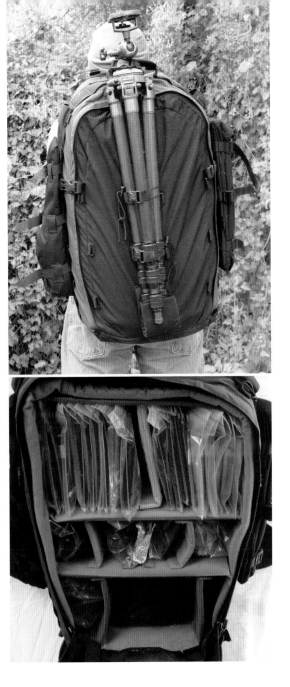

The larger view cameras, 5 x 7in and up, are too cumbersome for long hikes; their size and weight limit their use to short walks or studio work. Though they have some advantages, a 4 x 5 will satisfy most needs. I have worked with both 5 x 7 and 8 x 10, but always came back to 4 x 5. The larger cameras generally limit you to making contact prints (where the negative is laid directly on the paper; see page 135), and this eliminates many of the controls available in printing.

Wearing the pack
The Lowepro is comfortably strapped on my back, with the tripod attached.

Gear inside the pack
The top layer consists of film holders, each in a resealable plastic bag to keep the film clean in the field. The next layer is lenses, also in bags, arranged in order from wide to telephoto. The camera is on the bottom row, with the 400mm lens and the spot meter. Various pockets in the front flap (not shown) contain filters, brushes (to wipe the dark slide before opening the holder), cable releases, a compass, glow sticks, waterproof matches, a small first-aid kit and a solar blanket. Umbrellas and a large poncho are stored in the side pockets.

Delta Pool

This is a very symmetrical pothole, a natural depression in sandstone that catches and holds water. This was a hard photograph to compose, as the only vantage point was straight above it, on a steep slope of slickrock (smooth, wind-polished rock). My first inclination was to use the 135mm lens, but it was slightly too wide. Slipping the 150mm on the camera made the composition exactly right. During the session, a high white cloud was briefly reflected in the pool's tip, adding the final compositional touch.

Because the pool was in deep shade, and the upper rock was in sunlight, this negative is a nightmare to print, requiring some delicate burning and dodging. Despite this trouble, it is a recent personal favourite.

Toyo 4 x 5in field view camera + Caltar 150mm lens, Ilford FP4 Plus, 1 sec at f/64

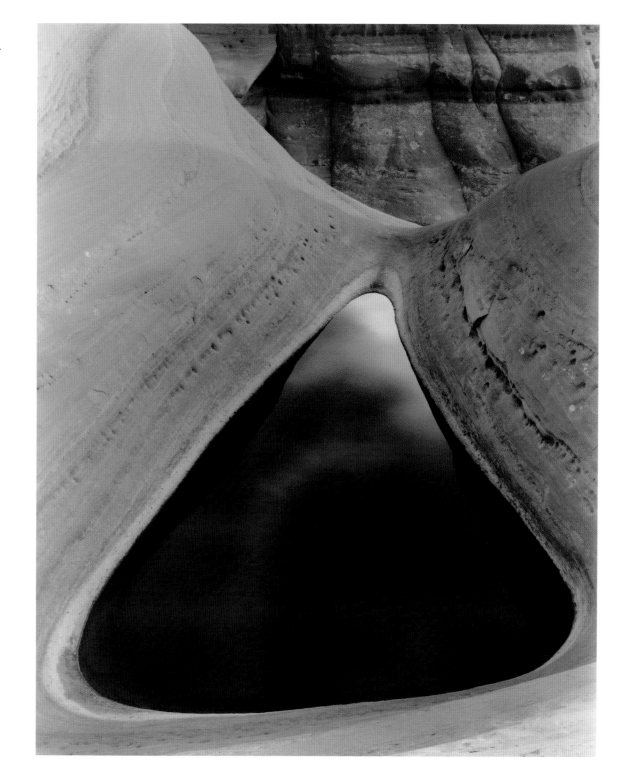

In my third year of college, on a whim, I bought a 99-cent toy plastic camera. Everything on the Diana is cheap plastic, including the lens, which creates an interesting distortion. Over the years I have used this camera for catching the occasional odd scene, and for helping break a photographic block. There have been times when I just wasn't able to take a decent photo, and the frustration can be unbearable. Whenever that happens, I put my main cameras in the closet, and just shoot with the Diana. This has broken more than one visual barrier for me, as the toy camera forces a certain freedom and relaxation. It is hard to be serious when

right

Blondie's

Taken on a road trip, and found next to an old rural highway, this old gas station is a classic example of rural Americana. It was also a perfect subject for the Diana, and was a quick grab shot, taken from my parked car. I knew it hadn't been open for some time, as the gas price was set at 45 cents per gallon.

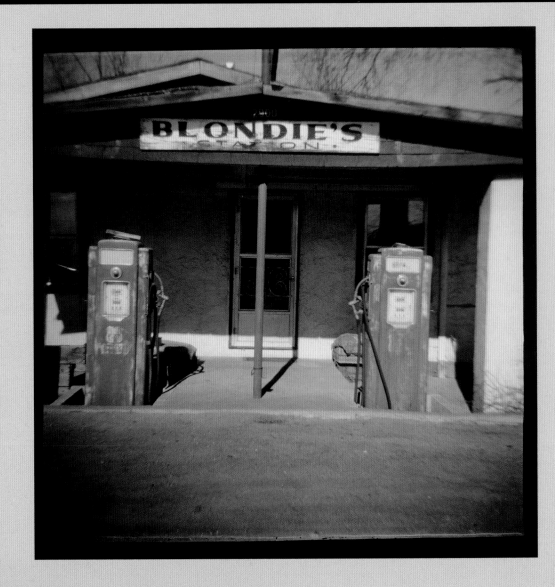

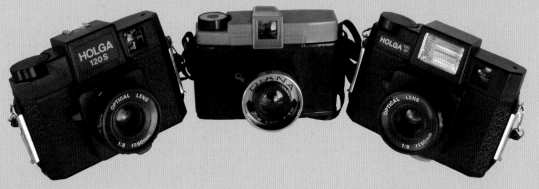

Three plastic cameras
These are my three toy cameras, with the Diana in the centre. The Holgas flank the older camera, one with flash and one without. The flash is my favourite of the two cameras.

your camera lens is melted from sitting on a car dashboard, and you can hear the film peeling off as it is advanced.

Perusing Dianas on the Internet recently, I was shocked at the prices they command. Refusing to pay $60, I ordered a different toy camera. The Holga is similar to the Diana, but seems to be of higher quality, which is not a good thing when it comes to toy cameras. This problem was quickly alleviated with a small piece of sandpaper and some petroleum jelly. Sanding the edges of the lens and then smearing it with a light coat of the jelly seemed to solve the problem of superior quality, making the Holga a fun camera to use. The latest model even has the advantage of a built-in flash, a fun feature that I have been using for fill-in illumination.

I once published a limited-edition book that featured my plastic-camera photos and my daughter's poetry. *Darktown* sold out quickly, and my 15-year-old daughter received her first royalty cheques, which were quite a hit. These cameras are unmitigated fun, and they offer an important counterbalance to my view-camera work.

Exposure time and aperture are fixed, and my usual choice of film is Ilford HP5 Plus.

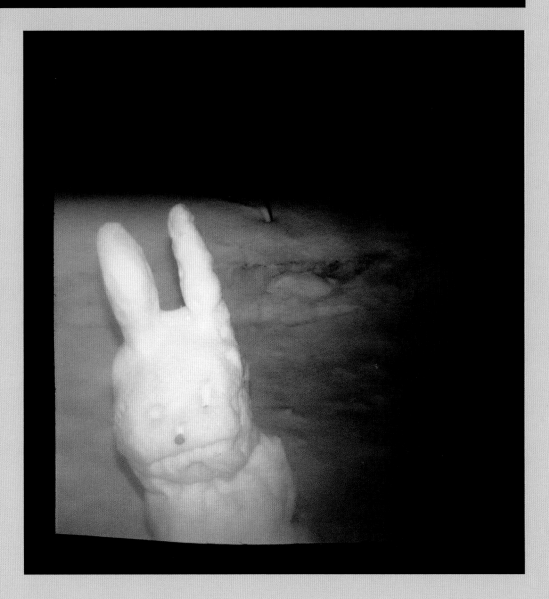

above

Snow Bunny

This is a recent Holga photo, and I made use of the built-in flash to take it. During a winter visit to Bryce Canyon National Park, Utah, I was amazed by the thick layer of snow that blanketed the plateau. Driving into the park before dawn, I noticed this strange snow sculpture, and jumped out for a quick exposure. The bunny had an enigmatic expression, and was slowly tipping over from the warming temperatures.

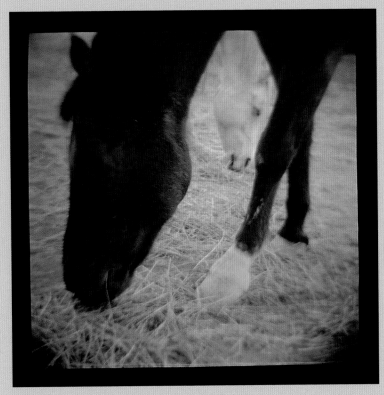

The One-eyed Horse

These horses belong to my wife's riding instructor, and the dark one had developed an eye tumour, necessitating surgical removal. Following them around with the Diana, I exposed a roll. This was the last shot on the roll, and the white horse in the background added a good balance to the composition, as did the layer of hay on the ground.

Lizards' Dance

After peeling old insulation from an outer wall, we found these lizards, which had crawled in seeking shelter, and been crushed. Playing with the Diana, I tried and failed to find a shot. My daughter grabbed some chalk and outlined these two, and this composition appeared.

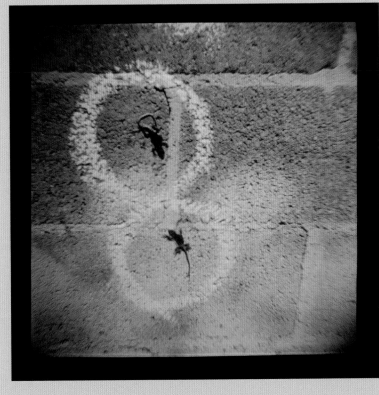

Blind Buffalo

We live in the countryside south of Moab, Utah, and one of our neighbours has a small herd of buffalo. When a calf was born blind, its mother rejected it, and he decided to raise it. After bottle-feeding, the calf imprinted on him, and became his pet. Most afternoons, he and 'Nickel Bill' can be seen walking down our rural road. This was finally too much for me, and I asked if I could take a photo. My first attempts with a medium-format camera failed, and I reshot them with a modified Holga, using the flash for fill-in. I sanded the lens on this camera, and used silver tape to mask the image area, resulting in a very ragged negative edge.

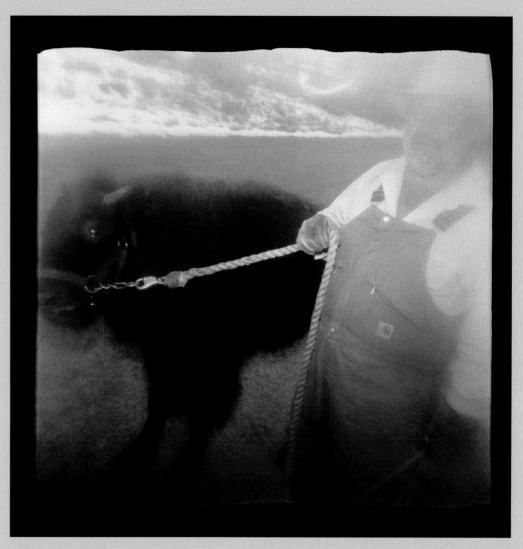

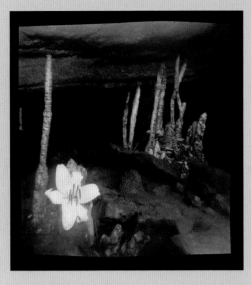

The Offering

This was a new toy camera, and on seeing the first roll I was disappointed by how sharp the lens was. Sandpaper and petroleum jelly solved the problem, and the modification works quite well. This Holga has a built-in flash, and I used it to brighten the flower.

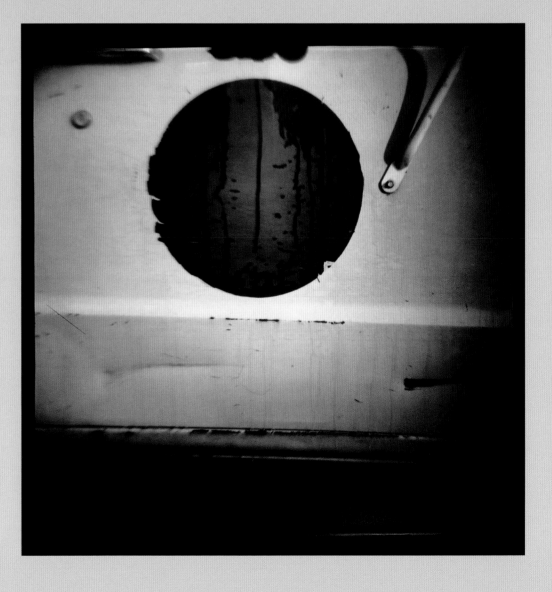

right

The Dark Circle

During the two miserable years that I worked as a clerk in a camera store, my personal work slowly dwindled, both in quality and quantity. At one point, when I was wallowing in misery and self-pity, a friend told me to quit worrying and have some fun. Heeding his advice, I pulled the Diana off the shelf, and began carrying it everywhere. Walking to work one rainy morning, this odd truck door caught my attention, and I snapped off one frame.

Sunroof

Also taken with the Diana, this sunroof and brick wall had been soaked by a hard rain, and then illuminated by the clearing storm. This is a high-key print, and the single dark line forms a strong graphic.

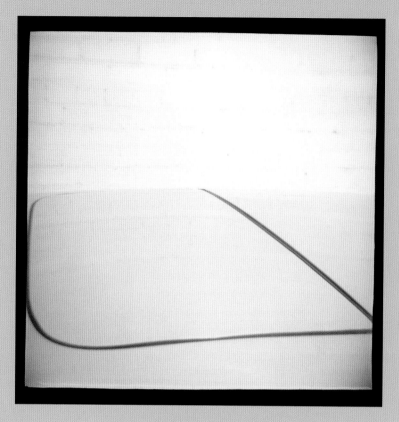

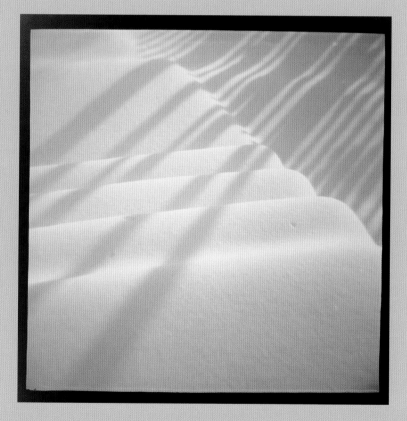

left

Steps & Snow

These were the back steps of my house in Colorado Springs, taken with the Diana early one morning after a heavy fall of snow. A nearby fence was throwing some very graphic shadows across the steps, and the toy camera was perfect for this image.

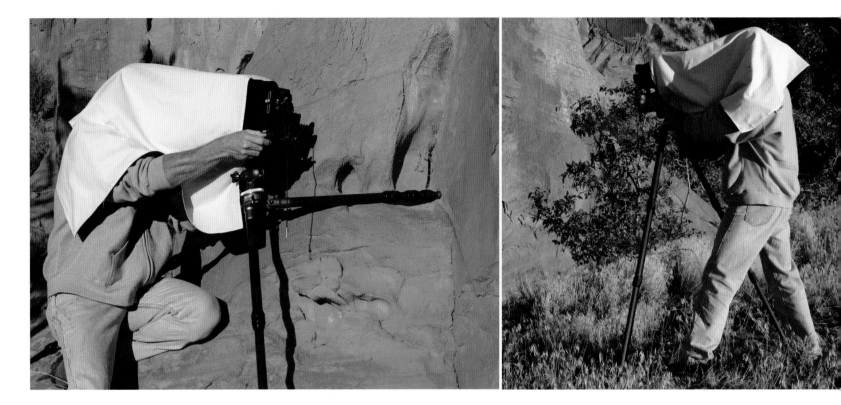

TRIPODS

Tripods can be cumbersome, but they can also greatly improve the quality of your negatives. By allowing the use of a slower shutter speed and a smaller aperture, depth of field can be greatly extended. Extreme exposures can often give very interesting results.

There are several types of tripod available, but many are poorly made. For several years now, my main tripod has been a Gitzo Mountaineer. This equipment is made from carbon fibre, a very light and strong material. Bogen also offers a large range of strong and well-made tripods.

There are several features to look for in this important piece of equipment, and one of the main ones is height. A tripod needs to have the capability to hold a camera at eye level, without any vibration or shake. If the tripod is extended with a camera on it, there shouldn't be any

Tripod contortions
The three photographs above demonstrate the various positions my Gitzo tripod can handle. Above left is an example of the versatility this tripod offers, with one leg set horizontally, allowing the camera to nestle close to the rock face, while the other legs are set at a normal angle. Above right shows the camera and tripod in a normal position, set up at eye level. On the facing page the tripod is set very low, to allow a tight composition on the grasses.

wiggle when you touch the camera body. The legs should sit solidly on the ground, with no discernible bow or bend. The lock-downs for each leg section should be threaded, with large rubber knurls that are easy to tighten and loosen. Lock-downs that stick out from a tripod leg tend to catch on anything around them, and don't tighten down so well. The tips should be a half-ball of rubber, which will further stabilize the legs, avoiding any sliding on slick surfaces. Your tripod needs to be able to handle any situation.

The **HEAD** is the part of the tripod that mounts the camera to the legs, and in recent years I have become convinced that a **BALL HEAD** is the best type to use. This comprises a large ball that swivels freely, with a flat platform to support the camera, and allows for an infinite variety of angles. When clamped down, it forms a solid base for the camera. The other option is a **PAN-**

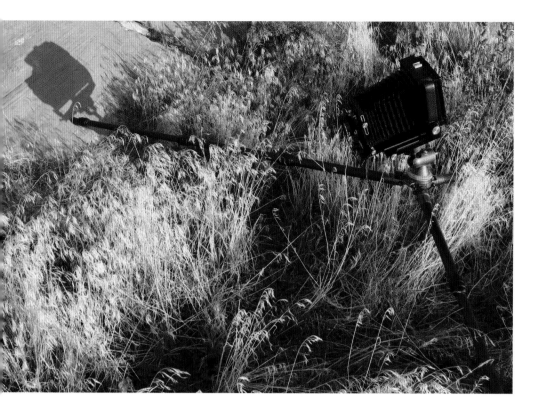

below

Flooded Church

When this lake was created, it displaced an entire town, most of which had gradually succumbed to the encroaching water. The last building standing was this forlorn church, and it too was slowly disintegrating. This was an early trip and my only camera was a trusty 35mm. Using a tripod to steady the camera, I took a meter reading from a nearby shadow, as the church was too far for the in-camera meter. After multiple darkroom sessions, I decided that the photo needed to be printed down, to increase the sombreness of the scene.

Petri 35mm + 50mm lens, Ilford FP4,
1/2 sec at f/22

AND-TILT HEAD with two separate handles, offering tilt in different planes. Though these work well enough, and I used them for many years, the ball head offers much more versatility.

Another important feature is the ability to cope with rough, uneven surfaces at strange angles. I often have two legs on the ground and the third angling up into some odd crevice in a rock face. The legs must have several positions available, with a sturdy clip to lock the angle. I recently took a shot where only one leg was in the normal position, while the other two were set at extreme right angles. A tripod also needs to have the capability to drop the camera down close to the ground. This is important in landscape work, particularly when using near–far compositions, and can also be useful in other situations. If the legs can be made to flare out at a perpendicular angle, this should do the trick.

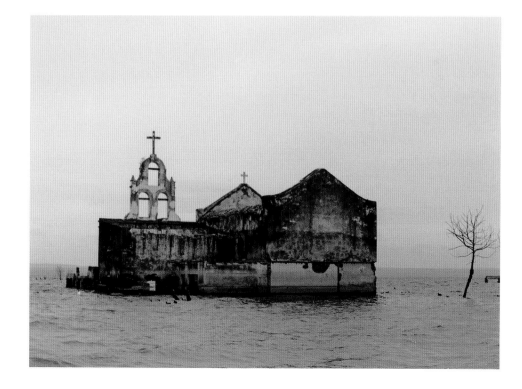

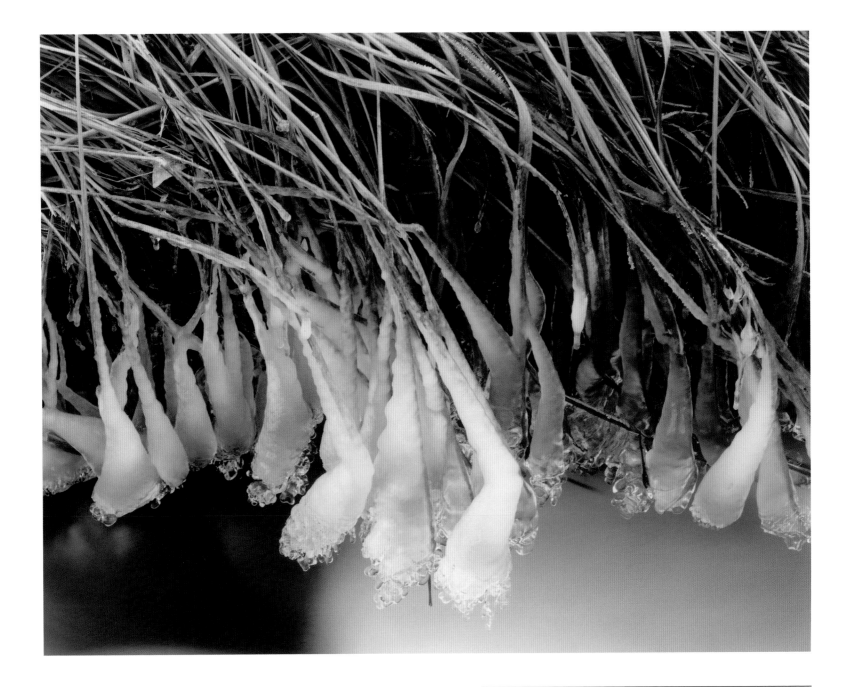

above | **Ice Bells**

After an extended freeze in southern Utah, I walked along this small creek, looking for interesting ice features. The rushing stream had coated some hanging grass, creating these odd formations. Getting the best angle required that I drop the camera as close to the ground as possible – the only other option would have had me standing in the freezing water. A long exposure blurred the water, accentuating the ice bells.

Tachihara 4 x 5in + Fujinon 150mm lens, Ilford FP4 Plus, 8 sec at f/45

FILTERS

Filtration can be useful in black & white photography, and the fact that filters lighten their own colour and darken the opposite colour can be put to good use. A **RED** filter will dramatically darken a blue sky, and will conversely lighten any red areas in a composition. I have used a **GREEN** filter to darken the tones of red sandstone, giving a tonal differentiation between the rock and a white highlight; in this case, the red rock and white stain were giving almost the same meter reading, and a straight exposure would have caused their tones to blend together in the final print, ruining the composition. When shooting still-life settings in a studio, various filters may be employed to alter tones, giving a good tonal separation that would otherwise be difficult to achieve. If yellow and red flowers are placed together, and the meter readings are similar, the tones will be similar. By using a filter, the tonalities can be separated, adding an interesting contrast to the print. A red filter will lighten the red flowers, while a **YELLOW** will bring up the yellow flower tones. A yellow filter will also bring sky tones down slightly, without the extreme density drop caused by a red filter.

A **POLARIZER**, which filters out the polarized light reflected from certain surfaces, offers a control unavailable with other filters, allowing sky densities to be adjusted. By turning the separate rings of the polarizer and watching the sky density as you do so, these densities may be easily modified. This filter can also reduce or eliminate reflections in non-metallic surfaces, again depending upon the degree of polarization applied. Reflections can add great interest to black & white compositions, but there will be times when they need to be reduced or removed to enhance a particular composition.

A neutral **SPLIT-DENSITY FILTER** can reduce excessive contrast by darkening the sky.

below

Shrimp Boat

This was an assignment in college, and the drill was to purposely overfilter a scene. Finding this boat up on the beach, I decided to use it for this project. This was taken at high noon, and both red and polarizing filters were used, with the polarization set at maximum. The resulting sky was pitch-black, and the effect was quite interesting. Though this isn't a technique I would often use, it worked quite well in this case.

Hasselblad + 90mm lens, Ilford FP4 Plus, 1 sec at f/11

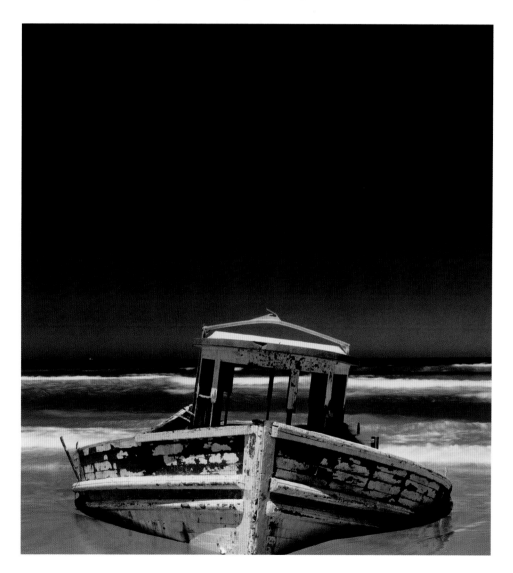

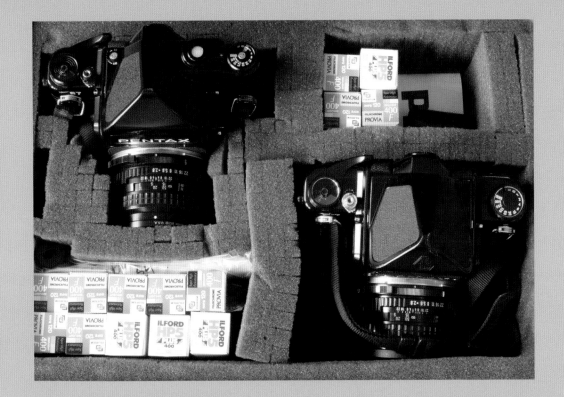

My medium-format case

My kit for aerial photography consists of a pair of Pentax 67s, both with 90mm normal lenses; rather than change lenses, I adjust the composition by means of altitude changes. I use one camera for colour and the other for black & white, relying on the in-camera meter in both cases.

My backpack of choice is a Lowepro Super Trekker (see page 34), the largest camera pack this company makes. It has a good suspension system, including a padded waist belt, and comes with enough adjustable dividers to fit most camera set-ups. It also has a reliable tripod holder, useful for those times when both hands need to be free – usually when I am desperately grabbing rocks and roots, scrambling up some slippery slope.

A Toyo field view 4 x 5in is my main camera, and this is a very tough and reliable piece of equipment, albeit on the heavy side. While on a winter trip with a friend many years ago, I watched his Toyo and tripod topple onto some ice, and assumed that our trip was over. To my surprise, he simply picked it up and kept shooting – an impressive display of camera toughness. Shortly after that trip, I bought a Toyo myself, and it has stood up to ten years of serious abuse.

I carry five lenses, of varying focal lengths:

1 Nikkor 75mm

2 Rodenstock 135mm (my favourite lens)

3 Caltar 150mm (the difference between this and the 135mm is surprising, and there are occasional times when the Rodenstock is slightly too wide)

4 Nikkor 210mm

5 Wollensak 400mm.

My main light meter is a Pentax one-degree spot meter, and I carry an averaging meter as a back-up. A dark cloth serves as extra padding over the lenses, and I have a pocket devoted to survival gear, including waterproof matches, a small solar blanket, a compass, several glow sticks (for signalling), and a heavy-duty rain poncho. Fortunately, I have rarely needed any of this. Several years ago, however, an unexpected flash flood in a narrow canyon trapped me on a high ledge, and this gear proved to be quite helpful during my four-hour isolation.

There are a few filters, including a polarizer, a yellow, and a neutral split-density filter, which can be used to reduce contrast between an over-bright sky and the other elements in a composition.

I carry two small umbrellas in the side pocket, and have often used them to shield the camera during rainy photo sessions.

My tripod is a Gitzo Mountaineer (see pages 42–3), one of their carbon-fibre models. Though this is an expensive tripod, it is strong enough to support a view camera and still amazingly light. It can also put the Toyo in almost any position – an important feature, as I often cram my camera into ridiculously low and tight places.

During my 35mm days, I would carry a small shoulder bag containing an Olympus OM-1, a 28mm lens and several rolls of film. My favourite for years was Kodak Tri-X, and then I shifted to Ilford HP5 (now superseded by HP5 Plus).

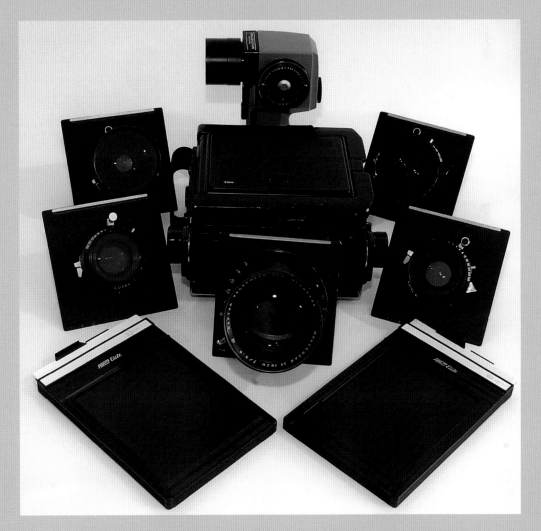

My large-format gear
My 4 x 5in Toyo, folded up for storage, is shown here with the five lenses listed opposite. Behind the camera is my Pentax spot meter, and in the foreground are two 4 x 5in film holders.

Black & White Film

IN BLACK & WHITE, NO LESS THAN IN COLOUR, EACH FILM HAS ITS OWN DISTINCTIVE SIGNATURE. YOU MUST IDENTIFY THOSE THAT WORK FOR YOU, THEN LEARN HOW TO GET THE BEST RESULTS FROM EACH.

Black & white film consists of a layer of light-sensitized silver halide crystals applied to a clear gelatin base. On exposure to light, the crystals undergo a chemical change, forming what is known as a latent image; development makes this image visible, and fixing makes it permanent. The more light that strikes the halide crystals, the thicker they will be after development. This causes the most heavily exposed areas of the negative – which will be the highlights in the final print – to increase in density, and leaves the shadow densities much thinner. A microscopic cross-section of a piece of exposed and developed film would resemble a side view of a small mountain range, the peaks being the highlights, and the valleys being the shadows. A processed negative is a reversed image, with the highlights dark and the shadows clear. These different densities are a signature of the film, and a good film will have a wide density range, with good separation between tones.

FINDING WHAT'S RIGHT FOR YOU

Films are all different, even those of similar speed from different manufacturers. The subtle differences between Kodak's Plus-X and Ilford's FP4 Plus, for example, are surprising, especially when different developers are thrown into the equation. The only way to determine which combination will work best for your own photography is through experimentation. I have now been using the same film and developer

'The only way to determine which combination will work best for your own photography is through experimentation.'

combination for 30 years, and remain pleased with the results even after that length of time. After using a particular combination for several years, you will begin to have an intimate understanding of its capabilities, and this will allow you a great deal of freedom in the field. I can now predict how FP4 Plus will react to any kind of lighting and contrast with a high degree of accuracy, and this knowledge frees me to concentrate on the imagery. The format, or negative size, will also play a large part in film choice, as this has a huge effect on the quality of the final print.

This book is concerned with the use of conventional black & white films. It does not cover the chromogenic or C41 films, which are designed to be processed in the same way as colour film. Chromogenic films are intended primarily for those who do not wish to do their own processing, and they do not offer the personal control which is such a crucial aspect of traditional monochrome work.

One unconventional film which I do use on occasion is Polaroid P/N, a smooth, superfine-grained 4 x 5in instant film that gives both a positive (in essence, a contact print) and a negative. It does not offer the developmental control of conventional films, but in certain lighting conditions it produces a fine negative. Polaroid also make a positive-only 4 x 5in film, and some photographers use this to check composition, focus and exposure during a shoot.

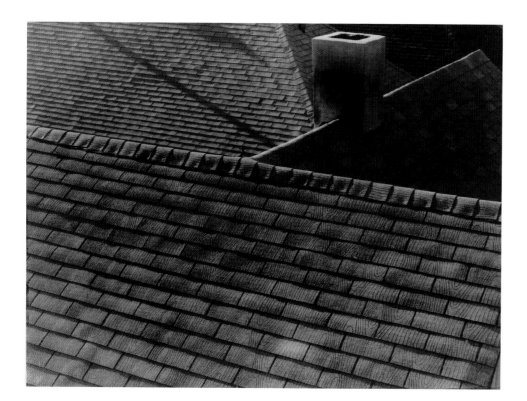

left

Chimney & Rooftops

This photo was taken from a friend's balcony; I noticed this quiet composition during dinner, and exposed two sheets of film after dessert. The repeating patterns of the old shingles contrasted well with the bright highlight around the chimney's top, and a mild telephoto lens cropped out all extraneous design elements. This was taken with Polaroid P/N (positive/negative) film, and the smooth tonalities and superfine grain inherent in this film worked well for this scene.

Tachihara 4 x 5in + Nikkor 210 lens, Polaroid P/N, 1 sec at f/45

right

Circuit Board

This is a studio photo, taken on Kodak's superfine-grained film. With the board lying on a light table and the camera pointing straight down, the various components and circuits were backlit and highlighted. As the details were too fine to give any specific meter readings, I took an averaged reading and corrected the contrast during printing.

Burke & James 4 x 5in studio monorail + Ektar 150mm lens, Kodak Panatomic-X, 1/2 sec at f/22

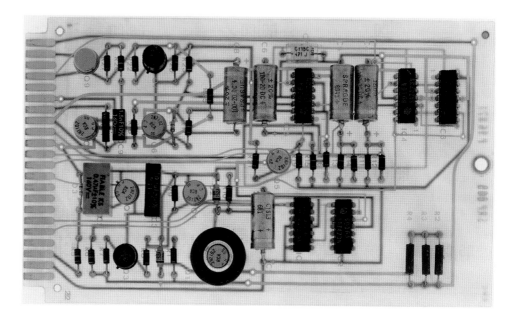

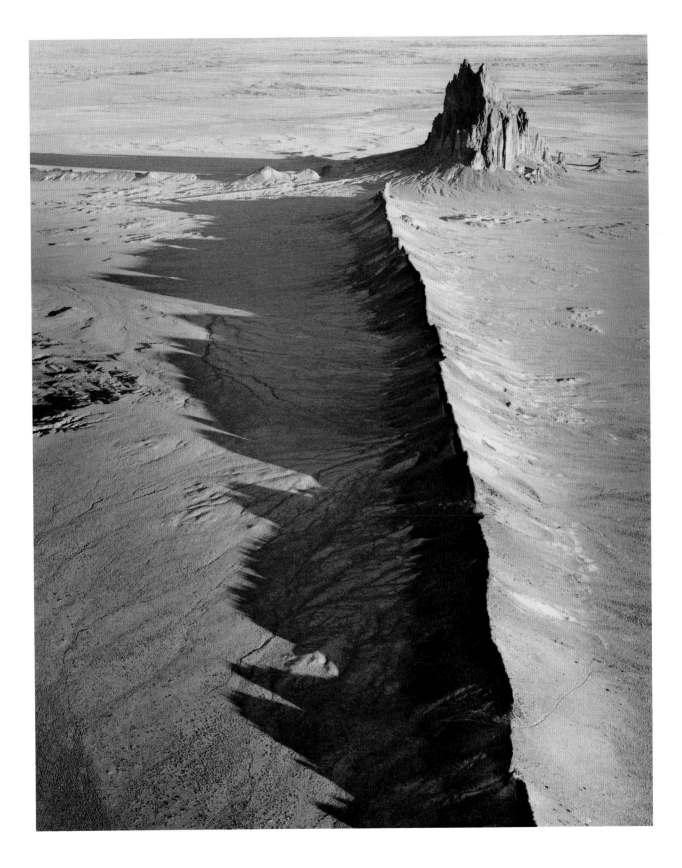

left

Shiprock

This place is sacred to the Navajo tribe in New Mexico, and makes for a dramatic sight rising up from the high desert floor. Shiprock is the eroded remains of an ancient volcano, and the narrow fins are volcanic flows that emanated from the cone. I had never seen this formation from the air before, and the length and thinness of the southern flow was fantastic. A few passes allowed me to pick the composition, and my pilot put the Cessna in good position, tipping the wing at the perfect moment. Fast ISO 400 film is my standard for aerial work.

Pentax 67 + 90mm lens, Ilford HP5 Plus, 1/1000 sec at f/2.8

UNDERSTANDING FILM SPEED

Film speed, as indicated by the film's ISO (International Standards Organization) rating, is a measure of the film's sensitivity to light. A film rated at ISO 25 is slow – not very light-sensitive – and will generally require long exposures. It will have a tight and fine grain pattern, and will enlarge well. By contrast, a rating of ISO 400 indicates a fairly fast film – one that is very sensitive to light, requiring much shorter exposures than the slower film. The faster films will tend to display a large and loose grain pattern. A doubling of the ISO number, e.g. from 50 to 100, denotes a doubling of sensitivity, which translates into a halving of exposure time.

In practice, you will often get better results by giving the film more or less exposure than the ISO value would suggest (see pages 62–5), but the ISO rating will always be the starting point for your experiments.

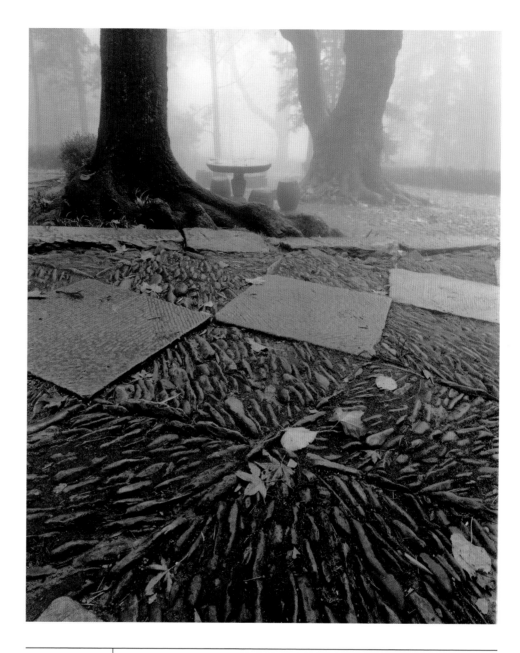

above | **Meilu Villa, China**

This was one of Chairman Mao's retreats, located on the remote and beautiful Cottage Mountain. The stonework in the garden was intricate, and I spent a rewarding hour playing with compositions. This was my final choice. I used rear tilt to help carry the extreme depth of field.

Toyo 4 x 5in field view camera + Nikkor 75mm lens, Ilford FP4 Plus, 12 sec at f/45

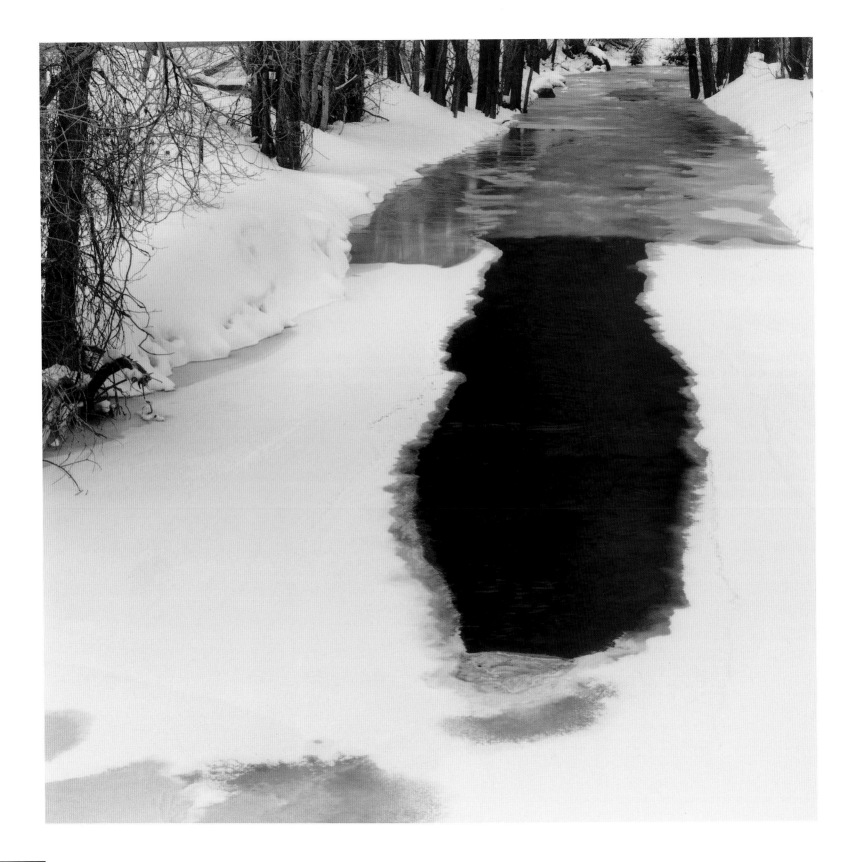

Big Cottonwood Creek

After a long and hard series of freezes in the mountains surrounding Salt Lake City, I found this odd ice pattern up Big Cottonwood Canyon. This is, for me, a rare example where a square format suited the scene perfectly, allowing for a good compositional balance.

Hasselblad + 90mm lens, Iford FP4 Plus, 1 sec at f/22

FAST FILMS

If a fairly fast speed is needed for hand-held work, then a film like Kodak Tri-X or Ilford HP5 Plus can be used. Both are rated ISO 400, which makes them ideal for hand-held work such as photojournalism or street photography. These faster films also work well for aerial photography, for which HP5 Plus is my favourite.

Because these films are fast, the halide crystals have to be large, and this causes graininess in the final image. The effect is even more marked with ultrafast films, up to ISO 3200 or more. Grain can be controlled to some degree through the use of a smoother developer, but is an inescapable fact, inherent in fast films. When properly applied to an appropriate subject, this aspect can add a hard-edged feeling of realism to the final image.

Any film can, if necessary, be 'pushed' to a higher speed, but there is always a corresponding loss of quality with this technique. You push a film by treating it as though it had a higher ISO rating than it really has – for example, an ISO 400 film might be pushed one stop by changing your meter setting to 800, or two stops by setting it at 1600. By doing this you are purposely underexposing the film, which must then be overdeveloped to compensate for the loss of exposure. As a result, shadow detail becomes

below

Cat Shadow

While visiting a friend in Oregon, I was sitting on the back porch, watching his multitude of cats swirl around. Noticing the shadow play, I borrowed his camera and exposed a short roll of film. This cat was playfully stalking another one, and he gave me the best shot from that afternoon.

Canon AE-1 + 24mm lens, Kodak Tri-X, 1/60 sec at f/5.6

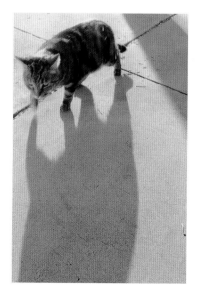

problematic, and with large pushes it can be very difficult to hold any detail at all in the shadows. This makes the negatives difficult to print, as the loss of shadow densities must be repaired (insofar as it can be) during printing, and the difficulty rises exponentially with the degree of push that has been used.

MID-SPEED FILMS

Mid-speed films have many points going for them, as the speed still allows some freedom, but the grain is much smaller, allowing for smoother tonal transitions in the print. These films generally have an ISO between 100 and 200, offering a good compromise between the faster films and the very slow, fine-grained ones. The tighter grain pattern allows more freedom during enlargement. The standard films in this range are Kodak Plus-X and Ilford FP4 Plus; the latter has been my mainstay for almost 30 years.

These films are very versatile, able to handle a wide range of applications. Through the use of a tripod, they will work wonderfully for any slow-paced, thoughtful type of work, such as most types of landscape. They also have enough speed for hand-held work in many situations, allowing for a decent-quality negative without using a tripod. Mid-speed films will also work quite well for still-life and studio work, as well as most types of portraiture.

SLOW FILMS

The super-slow films usually have an ISO value around 25 to 50, and have extremely limited applications. Their speed demands that a tripod be used under most circumstances, and also that the subject matter be static. When enlargement needs to be extreme, the tight grain pattern of slow film can be an advantage.

Compared to traditional silver halide film, infrared offers a very different perspective. Anything that is reflecting or emitting infrared light will translate as a highlight, while anything that hasn't absorbed this part of the light spectrum will print as a darker tone. Foliage is a strong refelector of infrared, and always ends up as a highlight. Tree trunks and water, on the other hand, tend to absorb this light, and will print as darker tones. Clear skies will tend to go deep black.

This film is notoriously hard to handle, and must be exposed through a deep red or opaque filter. Figuring ISO and exposure is largely a matter of guesswork, and development is also difficult, relying on trial and error, with the emphasis on error.

During college I made an infrared portfolio on trees for an Advanced Studies class. Though I enjoyed putting the portfolio together, I came to dislike the film, considering it too finicky. I experimented with several developers, but never really found one that was reliable with this difficult film. Among its many other eccentricities, infrared should always be loaded and unloaded in total darkness, even when packed in 35mm cassettes.

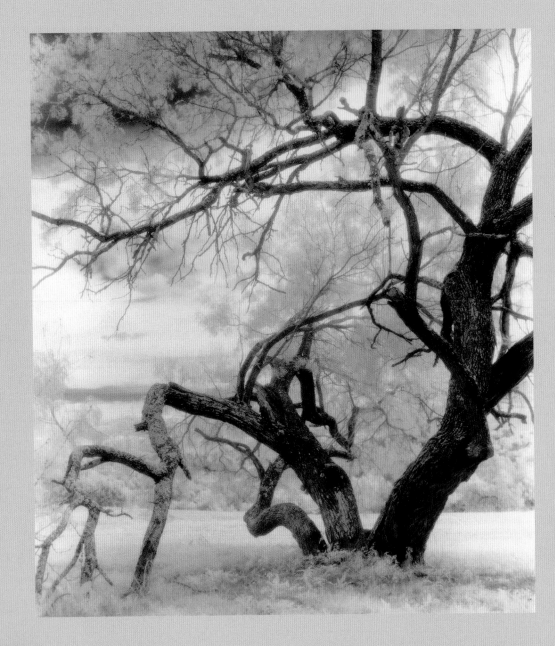

left

Tree

This photo was part of my tree portfolio, and made use of an overcast day to accentuate the tree trunk. The upper left corner, which is cloudless, demonstrates how sky will go black with this film, a trait that is distasteful to me, and never worked well for this series.

Wista 4 x 5in + Caltar 150mm lens, Kodak infrared film, 1 sec at f/32

As long as the negatives have good tonal information, it should be possible to make a decent print by using the split-contrast printing method (see pages 136–140), and adjusting the two base controls to fit the infrared. The directions that come with Kodak infrared should be followed, but with serious reservations. I began with these, and gradually moved past them, developing my own methods. Of course, this has been my standard technique for photography, as I have never been very good at following directions.

right

Oak Tree

This was the centrepiece of my tree portfolio, and was my best-selling print for several years. This is a fantastic tree, and I shot it numerous times under different conditions, experimenting with various films. By exposing infrared film on an overcast day, the dark shape of the trunk was emphasized, while the clouds, foliage and grasses went towards the upper scale. As with all the negatives from this series, it is hard to print, and has to be sent to Peg Land, my ace retoucher, as the spotting required is far beyond my meagre abilities (see pages 164–167).

Wista 4 x 5in + Caltar 150mm lens, Kodak infrared film, 4 sec at f/45

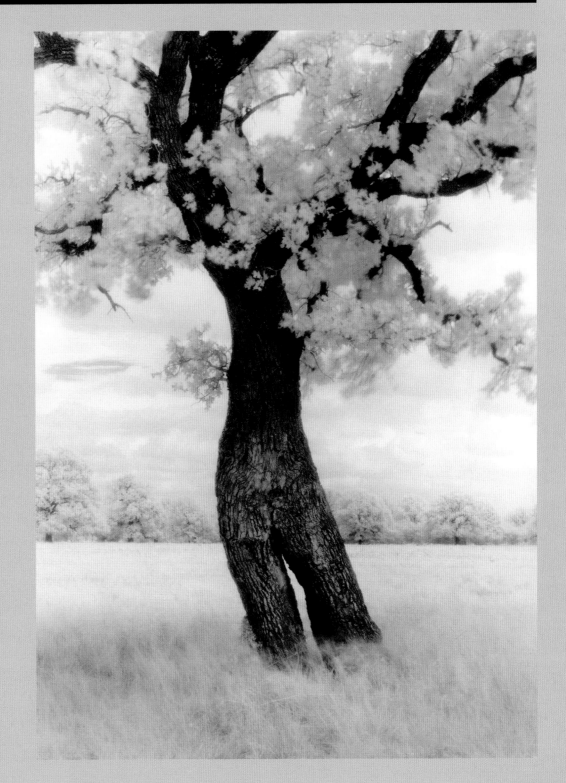

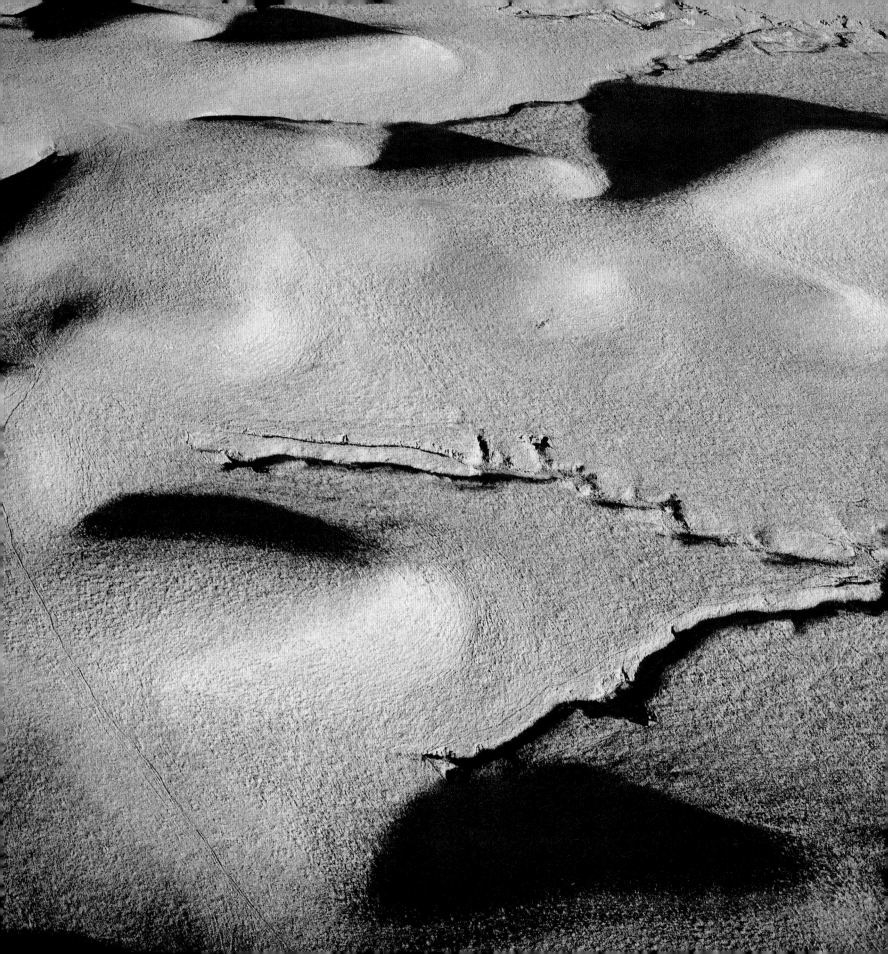

Chapter 2

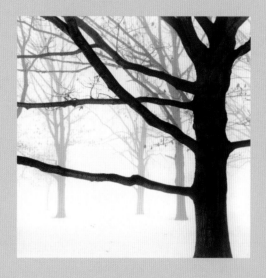

Exposure & Development

Why Exposure Matters

PROPER EXPOSURE OF THE NEGATIVE IS PARAMOUNT – PERHAPS THE MOST IMPORTANT STEP IN THE WHOLE BLACK & WHITE PROCESS. FORTUNATELY, CORRECT EXPOSURE IS RELATIVELY EASY TO LEARN.

page 56

Tallgrass Prairie

This is Konza Prairie in Kansas, one of my favourite prairies in the US. During the late fall, the prairies turn a brilliant gold, which added an attractive light tonal range to this shot. Having my pilot do a series of low circles, I finally isolated this composition. I wanted to emphasize these odd hills, and contrast them against the small eroded channels.

Pentax 67 + 90mm lens, Ilford HP5 Plus, 1/1000 sec at f/2.8; development normal −1

Though most mistakes in the black & white process are fixable, poor film exposure is often irreparable. When film is underexposed (given too little light for the conditions), the negatives lose shadow detail, and this is a problem that cannot be fixed. When overexposed (given too much light), the overall density of the negative is increased, rendering it difficult to print. Though there are some possible solutions to this, accurate exposure will make it very much easier to achieve the desired results when printing.

APERTURE AND SHUTTER SPEED

The **APERTURE** controls the amount of light that passes through the lens, while the **SHUTTER SPEED** controls the length of time during which light is exposed onto the film.

Apertures are measured in **F-STOPS**, and the standard f-stop sequence runs as follows (modern lenses may offer intermediate settings):

f/2 f/2.8 f/4 f/5.6 f/8 f/11 f/16 f/22 f/32 f/45 f/64

F-stops represent a fraction of the focal length of the lens (f/4 is 1/4 of the focal length), which means that the smaller the number, the larger the aperture through which light is admitted. Fast lenses on 35mm cameras may open wider than f/2, while apertures smaller than f/22 are generally available only on larger-format lenses.

Shutter speeds are measured in fractions of a second, but are marked on the camera as whole numbers: for example, 1/8 sec is marked as '8'. A typical sequence is:

1 2 4 8 15 30 60 125 250 500 1000

– that is, from 1 sec to 1/1000 sec – though modern cameras may have both faster and slower settings. The B (bulb) setting allows for exposures longer than 1 sec, the shutter staying open as long as the cable release is held down; older cameras may also have a T (time) setting, where the shutter stays open until the release is pressed for a second time. For speeds slower than 1/30 sec, a tripod and cable release should always be used, as depressing the exposure button on the camera itself will cause vibration, degrading the sharpness of the image.

Everything involved with these controls is done in halves and doubles. A one-f-stop change either cuts the light in half or increases it by a factor of two; a jump to the next faster shutter speed cuts the duration of light in half, while a drop to the next slower will double it.

The relationship between aperture and shutter speed is reciprocal: if aperture is closed down by one stop, for example, shutter speed must be set one stop slower if the same overall exposure is to be maintained. This means that a setting of, say, 1 sec at f/11 admits the same amount of light as 1/2 sec at f/8 or 1/4 sec at f/5.6.

right

Mill Creek

This small waterfall is located on one of the scenic prairie drives in central Kansas, and was taken while I was photographing for a colour landscape book on this state. At the end of a hot and frustrating day, driving down an endless dirt road, I noticed this small waterfall out of the corner of my eye. This was an enchanting little creek, and the late afternoon light was being softly filtered by a stand of elm trees.

This is a combination of a long exposure and moving water, with the added compositional element of water running off the foreground rock. The upper-left shadow was so deep that my spot meter wouldn't give a reading, and so I let it go 'paper black' (the darkest black available on the paper), as small areas like this can go dark without detracting from the overall image. When the highlight is blurred water, the negative can be tricky to print, as holding detail can be hard. This print needed some delicate burning (see pages 144–145), particularly in the central highlight.

Toyo 4 x 5in field view camera + Rodenstock 135mm lens, Ilford FP4 Plus, 5 sec at f/64; development normal –2

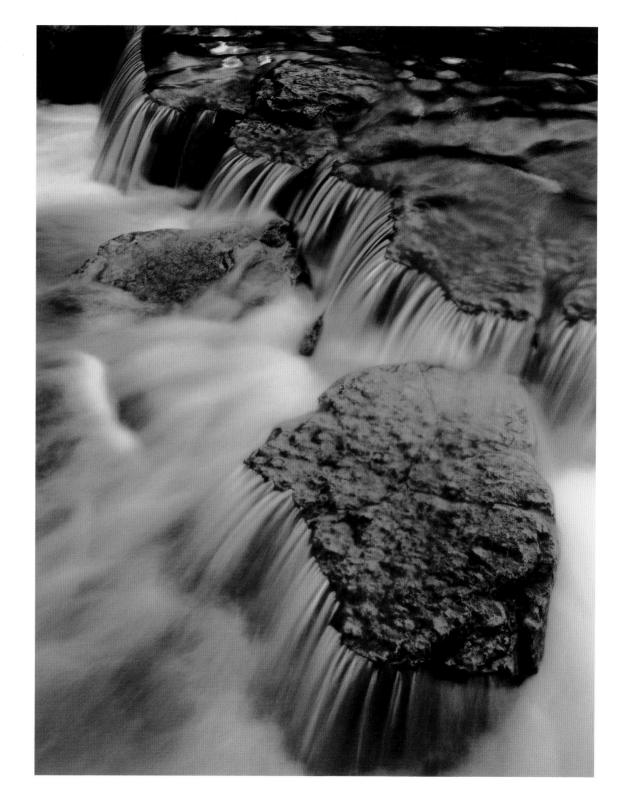

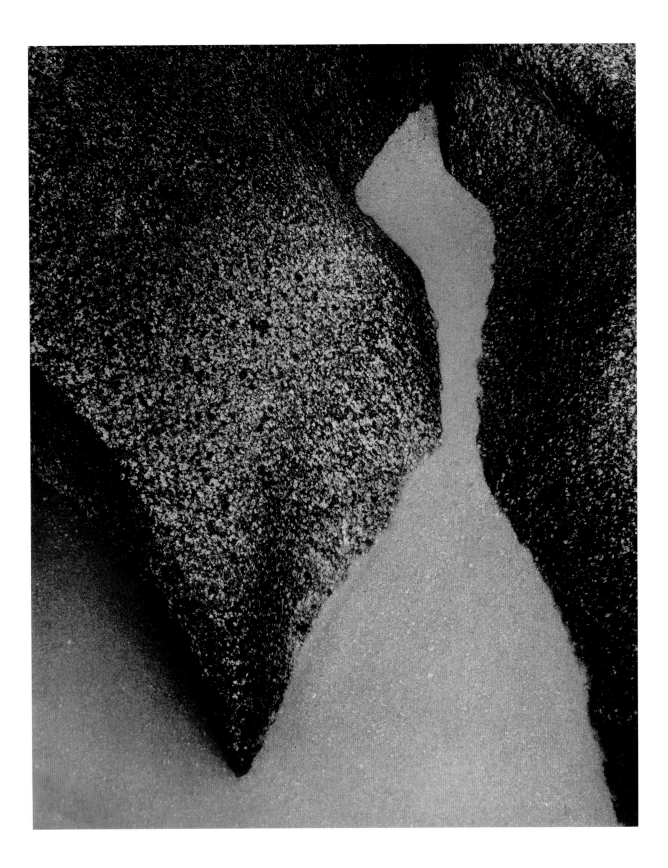

Beach Rock

The Baja peninsula in Mexico is one of my favourite places, not least because I met my wife there. The landscape also holds great allure, and I have spent many enjoyable weeks exploring and shooting this pristine place. While camping on a remote southern beach, I found and photographed this detail. The stone was extremely granular, with black grains interspersed among white ones. The composition jumped off the ground glass of my view camera, and was easy to set. Metering the scene was more difficult, as the small grains precluded the use of spot readings. After several attempts, I relied on my old standby, and guessed at the exposure and development.

Toyo 4 x 5in field view camera + Rodenstock 135mm lens, Ilford FP4 Plus, 4sec at f/45; development normal −2

RECIPROCITY

This reciprocal relationship between aperture and shutter speed is one of the most valuable tools available to the photographer. Large apertures give little depth of field (see pages 112–113), enabling a distracting background or foreground to be thrown out of focus, while small apertures permit the whole scene to be sharp. Slow shutter speeds cause moving objects to blur, while fast speeds freeze motion. Aperture and shutter speed can therefore be traded off against one another to produce the desired effect. This is one reason why the tripod is such an important tool: the small apertures which are needed to obtain maximum depth of field normally entail slower shutter speeds than can be used when the camera is hand-held.

LONG EXPOSURES

Long exposures of moving subjects can create an aura of mystery, and low-level light readings are easy to figure with most hand-held meters. However, at exposures longer than 1 second, **RECIPROCITY FAILURE** begins to occur. The usual relationship between aperture and shutter speed no longer holds, and exposure time must be increased, an indicated 2-second exposure becoming 4 seconds, 4 seconds becoming 8, 8 seconds becoming 20, and on to 1 minute becoming 3; as the exposures become longer, so do the corrections. A 5-minute exposure will need to be corrected up to 20 minutes, to obtain sufficient detail in the negative. These longer exposures should be bracketed, with the times adjusted accordingly. (**BRACKETING** is the practice of taking additional photographs of the same subject, giving slightly more and slightly less exposure than is judged to be correct, to allow for possible errors.) Development time will need to be cut, because extended exposure time tends to increase highlight densities.

LIGHT METERS

Meters, whether built-in or hand-held, are of two main types: **AVERAGING METERS**, which take a generalized reading of the light reflected by the whole scene, and **SPOT METERS**, which measure the light reflected from one small area of the subject, allowing you to read highlights, shadows and midtones separately, even at a distance from the subject. (Incident-light metering – measuring the light falling on the subject, rather than reflected from it – is not used in the system outlined here.) While a spot meter will save you some walking, it isn't a necessary tool; any meter will work.

Cameras with fully automatic exposure are not suitable for the method outlined in this chapter. It is best to use one with a manual mode, where the meter gives readings for both shutter speed and aperture. Aperture-priority or shutter-priority modes (see page 21) will work; of the two, shutter priority is best, as a constant shutter speed is used for the purpose of calculating exposure, while the aperture settings are varied. (Having worked out a suitable exposure, you can then adjust your settings for the actual shot if necessary, as in the examples on pages 68 and 69.)

METERING FOR FILTERS

Whenever filtration is used, metering should always be done through the filter. All filters will subtract from the amount of light reaching the film, and this is the easiest way to avoid exposure problems. If an in-camera meter is used, the filter should remain on the lens. If a separate, hand-held meter is used, take the filter off the lens and hold it close to the meter, being careful to read only the light coming through the filter. Polarizers and red filters will have a large effect on the meter reading, and exposure will have to be greatly increased.

The Zone System

THE ZONE SYSTEM IS A METHODICAL WAY OF JUDGING FILM EXPOSURE TO ENSURE THAT SHADOWS, HIGHLIGHTS AND INTERMEDIATE TONES APPEAR EXACTLY AS THE PHOTOGRAPHER WISHES THEM TO APPEAR.

The system revolves around two precepts: shadow detail is controlled by film exposure, and highlight densities by film development. Through use of this system, proper film exposure is easy to ascertain, ensuring good detail in shadow areas. By metering highlights and adjusting development accordingly, the upper tonalities can also be tightly controlled. The Zone System gives the photographer an amazing degree of control, allowing for great freedom of expression.

The Zone System has been made to seem ridiculously complicated, but is actually a relatively simple methodology. The system is based on the following determinations: zone III is a strong shadow detail, zone V is a middle grey (equivalent to Kodak's 18% grey card), and zone VII is a strong highlight detail. Zone II is barely perceptible shadow detail (almost black), and zone VIII is barely perceptible highlight detail

The zone scale

In the fullest version of the Zone System there are 11 zones, numbered 0–X, but the extreme light and dark tones are seldom used except in very small areas. It is rare that a large section of paper black (which is essentially what zones 0 and I are) will enhance a scene. Similarly, paper white (essentially zones IX and X) usually works best in the form of tiny specular highlights.

(almost paper white). These are flexible definitions, as tonal detail within a black & white photo can run a wide spectrum; however, a majority of shadows will need strong detail, as will most highlights. Certain subjects won't always need this detail, but generally, larger tonal areas will require some detail, otherwise the photo will be exceedingly harsh, and difficult to appreciate. The remaining upper and lower zones don't really come into play, as they are a straight black and pure white. Small areas of these extreme tonalities will naturally appear in most well-printed negatives.

DETERMINING FILM SPEED

The manufacturer's ISO rating for any given film (see page 51) provides a starting point for meter readings, but to do full justice to your subjects you need to find the speed rating which gives the optimum results for that particular film in your camera, with your metering technique. There are sundry and complicated ways to arrive at this, but there is also a quick and simple method. First, find a scene with a large dark area where you would want strong shadow detail to appear in the print (this would be a zone III). The subject matter is immaterial, as long as there is a large shadowed area, with some kind of detail in it that will show up strongly in the negative. The scene doesn't need to contain any other tonalities, as the film speed will be determined only by the shadows.

The full zone scale

0 I II III IV V VI VII VIII IX X

The texture range

above | **Linden**

If the foreground tree were solid black, this would be an
exercise in graphic design. If the highlights were pure white,
the scene would be too harsh. Utilizing the fine variations
between the upper and lower zones added some subtle detail.

*Toyo 4 x 5in field view camera + Nikkor 210mm lens,
Ilford FP4 Plus, 20 sec at f/45; development normal −2
(extreme underdevelopment)*

Wings

On the bank of the Niobrara, a fantastic river in Nebraska, I found the remains of a wild turkey that had been caught by a predator, probably a coyote. All that was left was the two wings, lying forlornly next to the river. The sheen of water running over the sandstone was nice, and the range of tones within the wings was beautiful.

Toyo 4 x 5in field view camera + Rodenstock 135mm lens, Ilford FP4 Plus, 1 sec at f/32

```
                    at 1 sec
    III      IV      V       VI      VII     VIII
    f/32  <  f/22  <  f/16
                    f/90  >  f/64  >  f/45  >  f/32
                                   <    <   f/32
```

For the highlights to fall on zone VII, the film contrast must be compressed through a one-zone cut in development. This scene had a surprising contrast range just within the feathers, which were the only readings I took. The bottom of the wings was placed on zone III, while the highlights of the feathers were put on zone VII.

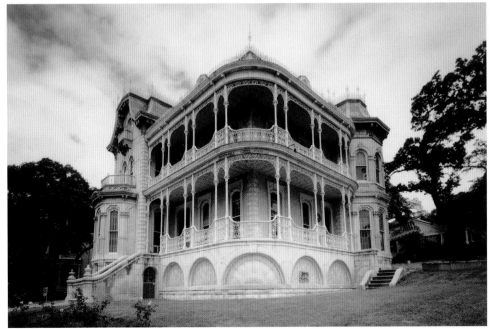

Texas Mansion

This was taken for an assignment in an architectural photography class, and was my first experience with a view camera. Dumb luck came into play (which is something I still count on), and a decent negative came from the shoot. The photo has to be cropped, as I inadvertently caught the tip of the camera's monorail in the negative, but this picture works well enough as an extended horizontal.

My shadow reading for perceptible detail was the upper porch, and because the film was Polaroid P/N, which gives a positive and a negative, there was no need for a highlight reading. The development for this film is set, and cannot be modified. Despite this, the scene's contrast was close to normal, and the negative prints without too many histrionics.

Burke & James 4 x 5in monorail + 65mm lens, Polaroid P/N, 1 sec at f/32

```
                 at 1 sec
  III      IV       V
  f/32  <  f/22  <  f/16
```

All meters are calibrated to a medium grey, which corresponds to zone V. Whether your subject is brightest white or darkest black, it will appear mid-grey on the film if you use the straight meter reading without any adjustment. With this knowledge, you can combine ISO determination with your first zone III shadow readings. Place your meter close enough to the shadow area to avoid any spillover reading from lighter areas. If you are using an in-camera meter, just stick the camera right up to the shadow, set the camera on manual, and take a reading. Choose a shutter speed which results in a middle aperture setting, such as f/8. Use a tripod, so you don't have to worry about the effects of long shutter speeds.

If you were to use this reading as it is, the negative would be overexposed, as the meter will interpret the shadow as middle grey, and place this area on zone V. You must therefore override the suggested reading, and close down two f-stops. This will place the metered shadow in zone III, giving strong detail. I have used the following diagram for 30 years, and have always found it reliable:

```
                 at
  III      IV       V        VI      VII
  f/
```

The 'at' in the top line represents your chosen shutter speed, and the bottom line is for the aperture settings. Suppose your uncorrected meter reading – taken straight off the meter dial, reading only the shadows – was 1 sec at f/8. Insert the figures into the diagram like this:

```
                 at 1 sec
  III      IV       V        VI      VII
  f/16  <  f/11  <  f/8
```

The shutter speed, 1 second, is placed on the top line, and this figure will always stay the same. The aperture, f/8, is placed under the zone V

figure, as this is where the tone would be if you used the uncorrected shadow meter reading (remember that most meters are calibrated to average any reading to middle grey). By closing down the aperture two stops, as indicated by the left-facing arrows in the diagram, you will place the shadow reading on zone III, which is where you want your shadow area to be. You have thereby corrected the meter reading through purposeful underexposure. This diagram will work for any scene, and will correct any reading. The simple key to shadow reading is to meter the correct area, and always close down two f-stops.

To determine the best speed for your film, meter a large shadow area at the recommended ISO, and close down two stops. If the corrected exposure is 1 sec at f/16 (which means the uncorrected reading was 1 sec at f/8) at the recommended ISO (which we will assume to be 100, for the purpose of this test), shoot that frame, and then bracket one stop above (1 sec at f/11) and one below (1 sec at f/22). Develop the film at the manufacturer's recommended time and dilution. Film development time has no effect on shadow densities, and will have no bearing on this test.

After development, look at the negatives and decide which exposure shows good detail without too much density. This may not be immediately obvious, but will become clear after some study. A strong shadow in the negative will contain enough density for the detail to print well, but will also be fairly thin. If the best detail was shot at f/16, your speed rating for this film is 100. If f/22 looks better, your rating is 200, and if the f/11 frame is best, the rating is 50. This is a simplistic way to figure film speed, and can be refined by further experimentation, but in the end it will give an accurate film speed. If you continue to shoot at this speed, and find that the negatives print with good shadow detail, then your chosen film speed is working.

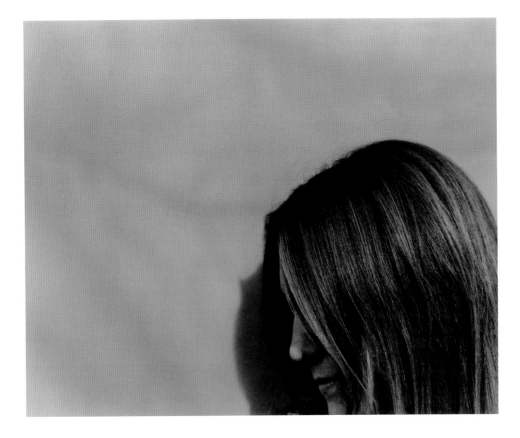

above

Jan

This portrait was made in the mid-morning, with a slight overcast softening the light. Both meter readings were taken from the hair: the shadow from the dark upper section, and the highlight from the centre-back area. I usually place white skin tone on zone VI, but in this case the hair juxtaposed against the background wall is what caught my eye, and the skin tones were of less importance. Because the hair was the main subject, a wide aperture was used, throwing most of the image out of focus. The wall shadows are important, but subtle.

Tachihara 4 x 5in + Caltar 150mm lens, Kodak Tri-X, 1/4 sec at f/5.6; development normal

```
            at 1/4 sec
    III     IV     V      VI     VII
  f/5.6  <  f/4  <  f/2.8
                   f/11  >  f/8  >  f/5.6
```

Zone III and zone VII readings balance out, and normal development is indicated.

EXPOSE FOR THE SHADOWS

The cornerstone of the Zone System is 'Expose for the shadows and develop for the highlights.' Insurance should always be taken, with exposures bracketed one stop over and one under the estimated exposure.

The exposure will determine the shadow densities, which need – for nice detail and tonal gradation in the print – to be within a certain range. **TONAL GRADATION** is my term for the edges between similar tonalities, and these density lines are important in a quality print. By using an appropriate speed rating, and by underexposing by two f-stops with respect to the meter reading, the shadows will be dropped into zone III.

So, if the uncorrected shadow reading is 1/2 sec at f/11, the diagram will look like this:

```
            at 1/2 sec
  III      IV     V      VI     VII
 f/22  <  f/16  <  f/11   (base shadow reading)
```

The corrected exposure, which will place the metered area in zone III, is thus 1/2 sec at f/22.

The keys to shadow detail in a print are simple: the meter reading must encompass only the area that will be zone III, and this base reading must be closed down two stops, to override the meter's proclivity towards middle grey.

To give one more example, if the uncorrected reading was 1/500 sec at f/4...

```
            at 1/500 sec
  III      IV     V      VI     VII
 f/8  <  f/5.6  <  f/4
```

...the corrected exposure will be 1/500 sec at f/8.

below

Lettuce

This was taken in college, and the assignment was food photography. The teacher probably expected a typical food shot, but mine, of course, ended up being odd. Slicing the end off a head of lettuce, I laid it on a lightbox. The shadow reading was taken along the dark inside edge, and placed on zone III. There really wasn't a good place to read a highlight, as the background had to be paper white. The outside edges of the lettuce needed slight burning.

Burke & James 4 x 5in studio camera + 150mm lens, Kodak Tri-X, 1 sec at f/32; development normal

```
                  at 1 sec
   III     IV     V       VI      VII
   f/32  <  f/22  <  f/16
```

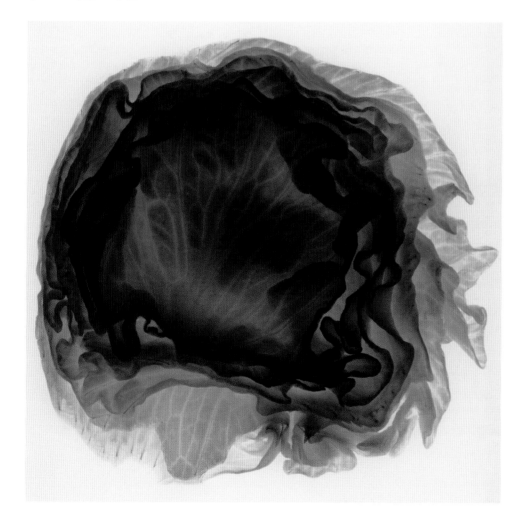

With the correct exposure time figured, the development time must be determined. While exposure sets shadow densities, development totally controls highlight densities.

The first step is to decide the duration of development: whether it should be normal, pushed, or cut. Pushing development increases highlight density, while cutting time lessens it. To figure this, the same diagram may be used. After metering the highlight in which you want to have strong detail (which will be zone VII), insert the uncorrected figure into the diagram:

```
                  at 1 sec
   III     IV     V       VI      VII
                  f/22
```

The reading here is 1 sec at f/22, which will place the highlight on zone V, a middle grey. To correct this, use the right-hand side of the diagram:

```
                  at 1 sec
   III     IV     V       VI      VII
                  f/22  >  f/16  >  f/11
```

The corrected reading, placing the highlight on zone VII, with strong detail, is 1 sec at f/11. You have overridden the base meter reading by opening up two f-stops. In essence, you are overexposing the film by two f-stops, increasing the highlight density, pushing it up to a zone VII. By combining both the shadow and highlight readings, the development time will be determined. If the shadow reading was 1 sec at f/5.6, with a highlight reading of 1 sec at f/22, the full diagram will look like this:

```
                  at 1 sec
   III     IV     V       VI      VII
   f/11  <  f/8  <  f/5.6
                  f/22  >  f/16  >  f/11
```

below

Arch & Pool

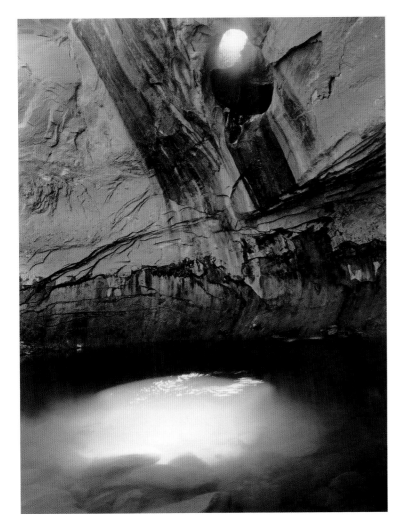

Toyo 4 x 5in field view camera + Nikkor 75mm lens, Ilford FP4 Plus, 1 sec at f/16; development normal –2

```
                        at 1 sec
        III       IV        V         VI        VII       VIII      IX
        f/16  <  f/11  <  f/8      (shadow reading)
(highlight reading)        f/64  >  f/45  >  f/32  >  f/22  >  f/16
                        (two-zone cut)       <         <         <   f/16
```

This picture and the next are two views, at different seasons, of the same subject, in Windwhistle Canyon, Utah. Although they are dissimilar, the exposure and development for both pictures were consistent. The first time I found this wonderful arch and pool was in late spring, and the sun was in the northern sky. As I studied the scene, a sunbeam started to come through the arch. As I quickly set up, a glowing disc of light appeared on the pool, completing the composition.

Taking several shadow readings, I decided to place the darker parts of the wall in zone III, which also held detail in the foreground water. Just looking at the contrast range gave me a headache, and I knew it would need a big cut in development time. Metering the upper section of the arch made it clear that detail would be impossible there, as no adjustment in development would be sufficient. I chose the circle in the pool as my highlight reading, as this was within the realms of possibility.

After a few printing sessions, I decided that the highlight in the arch worked as a pure white, countering the pool highlight, and keeping the composition in balance. Although I have returned several times, and exposed more film, this remains my favourite Windwhistle photo.

This scene required a two-zone cut in development, to compress the detail highlight from zone IX down to zone VII, and so prevent loss of detail. In the chart, the aperture under zone III (strong shadow detail) must be the same as the highlight aperture. In this case the film needed a big cut in development time to achieve this. My normal time for FP4 developed in HC-110 (diluted 1 + 15) is 8 minutes, which I cut down to 4¹/₂ minutes.

Although the chart shows 1 sec at f/16 (because a standardized exposure time makes the chart easier to use), the actual exposure was 8 sec at f/45, corrected for reciprocity failure to 25 sec at f/45. This is an equivalent exposure to 1 sec at f/16, but gives much greater depth of field. The shadow and highlight densities are well balanced, and the print only needs mild dodging and burning.

below

Frozen Waterfall

One of my return trips was during the winter, after an unusual stretch of cold weather. Walking up the canyon, I was surprised to see a giant ice column pouring from the arch. As the sun was far in the southern sky, the alcove was much darker than before, with only reflected light; this is why the meter readings are based on a 4-second exposure, instead of my usual 1 second. My first reading was taken on the shadow to the right of the column, and was placed on zone III. The highlight reading was taken on the piece of ice in the upper arch, which proved to be a mistake. By placing that area on zone VII, I inadvertently lowered the tones of the lower ice column – which is the dominant feature of this photo – to zone VI. If I had read the lower column as zone VII, and given a one-zone cut in development, the final negative would have been much easier to print. The upper ice would have needed some burning down at the printing stage, but this would have been a much easier task than the delicate dodging which is now needed to lighten the tone of the ice column. To further accentuate the frozen waterfall, I used some slight spot-burning to bring the lower highlights down. (Burning and dodging are explained on pages 142–149.)

The uncorrected shadow reading of 4 sec at f/8 was dropped (closed down two stops) to f/16, shifting it from zone V to zone III. The uncorrected highlight reading of 4 sec at f/64 was corrected from zone IX to zone VII, through a two-stop cut in development. This photo would have been better served if I had metered the lower area of ice, which would have given 4 sec at f/45, indicating a normal minus one development. The brightest highlight isn't always going to be the best zone VII for every image, a lesson I still seem to be learning.

In place of the indicated exposure of 4 sec at f/16, an equivalent exposure of 8 sec at f/32 (corrected to 25 seconds to compensate for reciprocity failure) was used, for added depth of field.

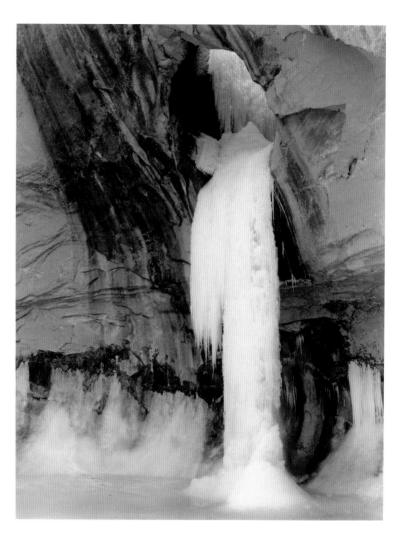

FROZEN WATERFALL:
Toyo 4 x 5in field vew camera + Rodenstock 135mm lens, Ilford FP4 Plus, 10 sec at f/16; development normal −2 (but should have been normal −1)

at 4 sec (corrected to 10 sec)

III	IV	V	VI	VII	VIII	IX
f/16 <	f/11 <	f/8				
		f/64 >	f/45 >	f/32 >	f/22 >	f/16
			<	<	<	f/16

Stalactites

This is part of my continuing series on these esoteric formations near my home town. This small section caught my eye, and I love the gaps between the upper and lower forms, with only a few completing the connection. The background rock was placed on zone III, and the fattest stalagmite at the bottom (which was the only one my spot meter could read) was placed on zone VII. When a highlight or shadow is too small, it can be difficult to meter, but often there will be a similar tone closer to hand, that will give an equivalent reading. This subject is in a small alcove, with rich light bouncing off the opposite wall. The range was confusing, and some of the smaller highlights were too bright in the print, requiring some delicate burn-down.

Toyo 4 x 5in field view camera + Rodenstock 135mm lens, Ilford FP4 Plus, 1 sec at f/16; development normal −2

at 1 sec

III	IV	V	VI	VII	VIII	IX
f/16 <	f/11 <	f/8				
		f/64 >	f/45 >	f/32 >	f/22 >	f/16
			<	<	<	f/16

This was a contrasty scene, requiring a two-zone contraction in development to compress the highlight down to zone VII.

You adjust the highlight reading by opening up the indicated exposure by two f-stops – the opposite of the procedure for shadow readings. This will correct the initial reading, moving it from zone V (middle grey) to zone VII (strongly detailed highlight). This chart indicates that normal development will place the highlights on zone VII. When the aperture indicated at zone III in the diagram is the same as that for zone VII, normal development is called for.

ADJUSTING DEVELOPMENT TIMES

If the readings don't balance out in this way, an adjusted development time is required. For example, if the shadow reading was 1 sec at f/11 and the unadjusted highlight reading was 1 sec at f/64, the diagram would look like this:

```
                 at 1 sec
III      IV       V        VI      VII     VIII
f/22  <  f/16  <  f/11
                  f/64  >  f/45  >  f/32  >  f/22
```

This indicates a one-zone cut in development, as a normal time will place the highlight on zone VIII, which will be too white, lacking strong detail. By cutting the time, here is what happens:

```
                 at 1 sec
III      IV       V        VI      VII     VIII
f/22  <  f/16  <  f/11
                  f/64  >  f/45  >  f/32  >  f/22
                                   <   <   f/22
```

Instead of being on zone VIII, the highlight reading at f/22 now moves down to zone VII, which is where you want the highlights to be. In essence, the upper zones are being compressed, forcing the highlight tones down, placing them in a lower zone.

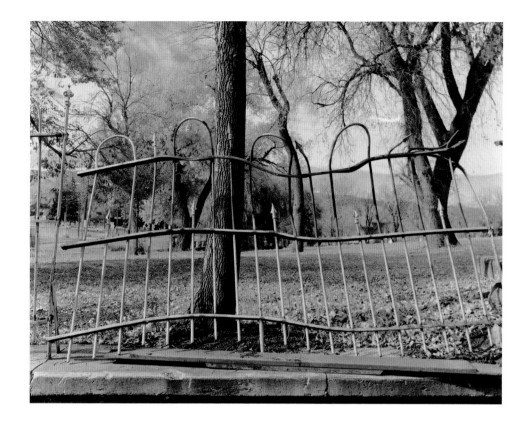

above | **Twisted Fence**

Whatever happened to this fence, it certainly makes an interesting subject. It was very whimsical, and I photographed it several times. This shot was made with a square-format camera, but the upper trees detracted from the composition, so I cropped it to a rectangle. Using a larger aperture softened the background slightly, drawing attention to the fence. I metered the shadowed side of the foreground tree, putting it on zone III, and took several highlight readings, finally placing the brightest leaves on zone VII.

Hasselblad + 90mm lens, Kodak Plus-X, 1/2 sec at f/11; development normal −1

```
                  at 1/2 sec
III      IV       V        VI       VII      VIII
f/11  <  f/8   <  f/5.6
                  f/32  >  f/22  >  f/16  >  f/11
                                    <    <  f/11
```

above

Dan McCabe

This was taken in a makeshift studio in my living room, using the type of portrait illumination called 'kicker lighting'. This technique employs two lights hitting either side of the subject's face, and makes for a dramatic portrait. My friend Dan is a gentle soul, but this lighting technique makes him appear fierce and intimidating. In portraits, I will usually take a meter reading from skin tones, adjust it to zone VI, and use it for the exposure (as opposed to metering for the shadows, which is the Zone System standard).

Burke & James 4 x 5in monorail + Fujinon 150mm lens, Polaroid P/N, 1/2sec at f/16

A two-zone cut would be called for if the shadow reading was 1 sec at f/5.6 and the highlight was 1 sec at f/45. The chart would look like this:

```
                 at 1 sec
  III    IV     V     VI    VII    VIII   IX
f/11 < f/8 < f/5.6
              f/45 > f/32 > f/22 > f/16 > f/11
```

If a normal time were used, the highlight would be on zone IX, which is paper white. A two-zone cut in development will bring the highlight reading (f/11) down to zone VII. The corrected chart would look like this:

```
                 at 1 sec
  III    IV     V     VI    VII    VIII   IX
f/11 < f/8 < f/5.6
              f/45 > f/32 > f/22 > f/16 > f/11
                         <    <    <    f/11
```

By compressing the scale two zones, the highlight reading is dropped into zone VII, which will give the desired strong detail.

While a two-zone cut in development will work well, any further cut in time will usually cause a muddiness in the highlights. When the tonal scale is compressed past a certain point, the highlight scale will be crushed in the negative, rendering it very difficult to print.

When contrast is low, with flat lighting creating a tighter tonal range, the readings might be 1 sec at f/5.6 for the shadows, and 1 sec at f/16 for the highlights, and the diagram would look like this:

```
                at 1 sec
  III    IV     V     VI    VII
f/11  <  f/8  <  f/5.6
                f/16  >  f/11
```

If given a normal development, the highlight would be on zone VI, which is a light grey. This would give muddy highlights, taking tonal clarity away from the final image. To correct the reading, the chart would do this:

```
                at 1 sec
  III     IV     V     VI    VII
f/11  <  f/8  <  f/5.6
                f/16  >  f/11
                        f/11  >  >
```

The scale would be pushed, forcing the highlight reading up to zone VII. This indicates a one-zone push in development.

A scene requiring a two-zone push would look like this, with the shadow reading 1 sec at f/5.6, and the highlight 1 sec at f/11:

```
                at 1 sec
  III     IV     V     VI    VII
f/11  <  f/8  <  f/5.6
                f/11
```

With these readings, the highlight will fall on zone V, and a normally developed negative will be very flat. Here is the corrected diagram:

```
                at 1 sec
  III     IV     V     VI    VII
f/11  <  f/8  <  f/5.6
                f/11  >  >  >
```

This indicates a two-zone expansion in development, which will push the highlight up to zone VII. In essence, you are forcing the highlights up, expanding them far beyond where they would be in a normally developed negative.

The degree of control inherent in the Zone System is astounding, allowing for a huge manipulation of tonal placement. By altering shadow and highlight readings, and by adjusting film development accordingly, print tonalities can be modified at your whim.

When shooting rollfilm, different development times can be problematical. One solution is to load short lengths of film, using each roll for a particular shot. If this isn't possible, then development times must be averaged, and compensation made during printing. It is always easier, however, to correct a negative's densities through development rather than printing.

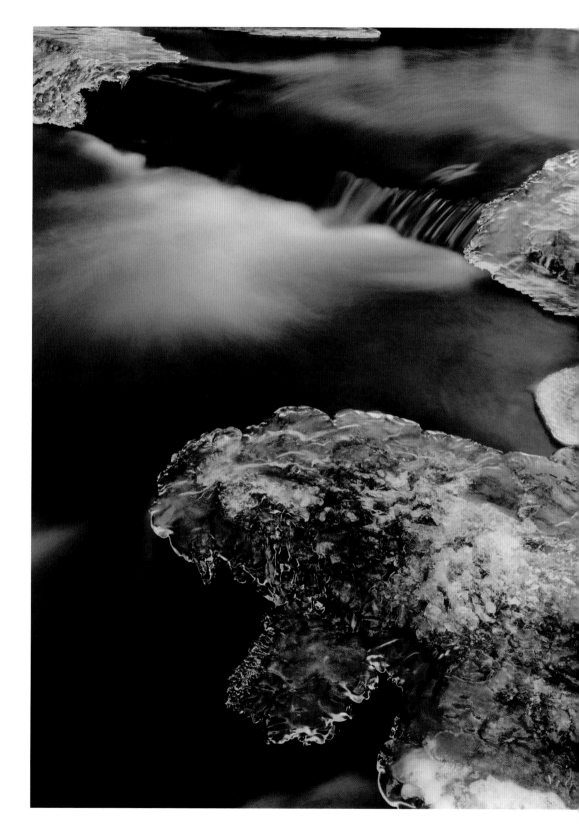

right

Ice

This photograph taught me two important lessons. The first was to always go hiking along a creek after a hard freeze, and the second was to seal my waterproof boots every fall. After finding and composing this scene, I metered the small upper waterfall for the shadow reading, and read the highlights in the ice at the bottom. The foreground ice cap had formed from water splashing onto a large rock, eventually coating it. This gave the composition a very nice base, with the dark water offering an interesting counterbalance. After standing in the creek for several minutes, I noticed that my 'waterproof' boots weren't – and was forced to endure a long, cold and squishy walk back to my car.

Tachihara 4 x 5in + Super Angulon 90mm lens, Ilford FP4 Plus, 1sec at f/22; development normal –1

		at 1 sec			
III	IV	V	VI	VII	VIII
f/22 <	f/16 <	f/11			
		f/64 >	f/45 >	f/32 >	f/22
				< <	f/22

For greater depth of field, and to soften the water, an equivalent exposure of 4 sec (corrected to 10) at f/45 was used.

Developing your Film

PRINTING EXPERIENCE IS THE BEST WAY TO ARRIVE AT CORRECT FILM DEVELOPMENT. ANY PROBLEMS IN THIS AREA QUICKLY BECOME EVIDENT IN THE DARKROOM, WHETHER THE MISTAKE IS IN EXPOSURE, DEVELOPMENT, OR THE REQUIRED BALANCE BETWEEN THE TWO.

DEVELOPER CHARACTERISTICS

Different developers will give varying results, and the choice will depend on your desired effect. My favourite is Kodak HC-110, both because of the long, smooth tonal scale it offers, and for the fact that it gives very subtle separation between similar tones. This is particularly evident in the shadows, where it allows fine edges to show in the lower zones.

This developer suits me, because most of my work is landscape, especially landscape details, and these characteristics are excellent for my genre of photography. My chosen film/developer combination emerged after four months of misery, testing, reading and graphing endless rolls of film in college. At the end of this course, I decided that Ilford FP4 (now FP4 Plus) and Kodak HC-110 worked well together, and they have been my mainstay for 30 years.

For my medium-format aerial work, I use Ilford HP5 Plus, also with HC-110. This ISO 400 film gives a useful amount of extra speed (even slow aircraft travel at a fast rate, and I like to be as low as possible), and I use the HC-110 to smooth out the tonal separations.

Film/developer combination is a very personal choice, and you need to find one that works well for your photography. If street photography is your pleasure, you may want to exaggerate grain by using a fast film, such as HP5 Plus or Kodak Tri-X, and combine it with a harsher developer, such as Kodak D-76. The opposite effect can be reached by using a fine-grained film with a smoother developer. Through this combination, and by using a tripod and a small aperture, a smooth, rich print can be achieved even with 35mm. The film choices available today are somewhat limited, as manufacturers rationalize in the face of competition from digital imaging, but there are still several decent products on the market. Experimentation is the key, both with film and developers.

right

Cattails

Long exposures can work well with smooth water, especially when there are strong design elements involved. This is a small lake in eastern Kansas, and the photo was taken 30 minutes before sunrise, facing towards the east. The cattails and their reflections offered a beautifully balanced composition, and the tonal change in the water was the final ingredient needed for a satisfying result. A telephoto lens was necessary to frame this scene on the ground glass, because if I had waded into the lake, the glassy reflections would have been disturbed. This image reflects the placidity of that morning, and was the highlight of my trip. As the exposure was exceedingly long, I gave a big cut in development time to compensate for the inevitable gain in contrast.

Toyo 4 x 5in field view camera + Nikkor 210mm lens, Ilford FP4 Plus, 2 min at f/45; development normal −2

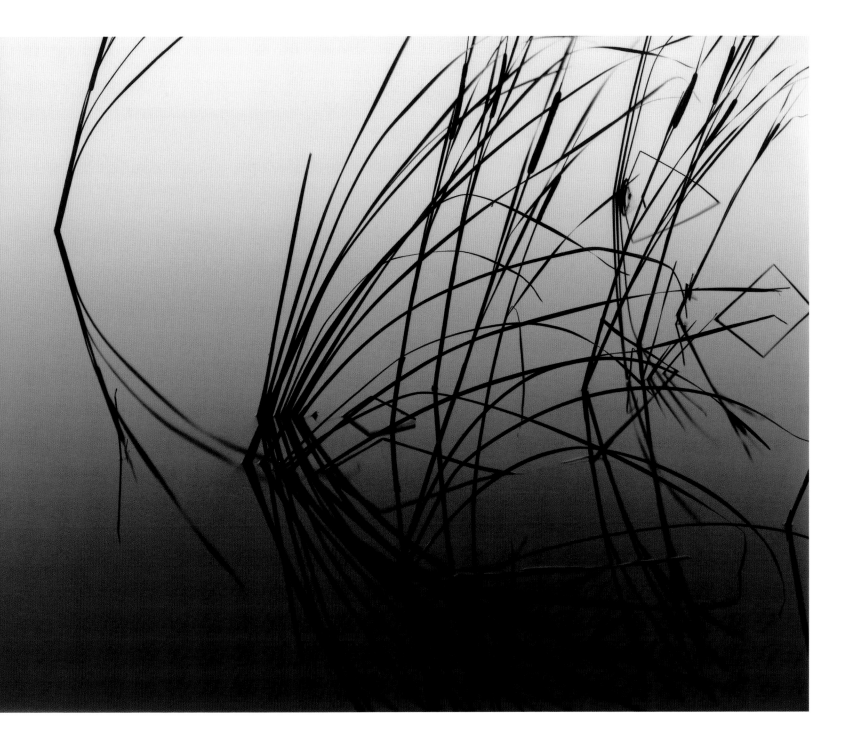

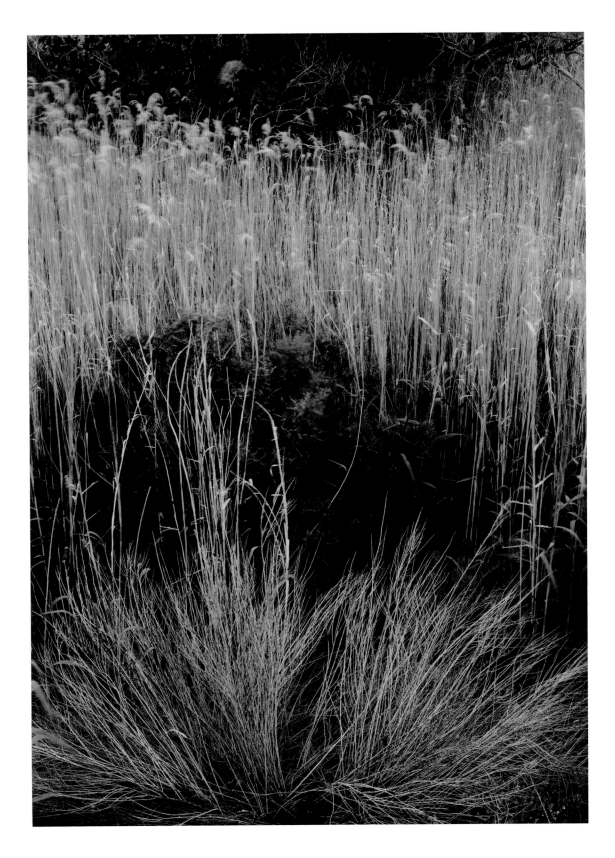

Common Reed

On a high-water river patrol during my time as a river guide, we slowly motored our Zodiac inflatable up a flooded side canyon, searching for a campsite. While setting up our tents in a clearing, the scene on the opposite bank began to attract me, and I snapped off two sheets after dinner. The canyon was in deep shade, and the flat light was perfect for the image. A slight underexposure dropped the shadows down, and a small push in development exaggerated the highlights.

A small breeze was wiggling the delicate plant tops, and this was annoying during the exposures. After printing the negative, however, I decided that the slight blurring actually helps the composition.

Wista 4 x 5in + Nikkor 210mm lens, Ilford FP4 Plus, 1 sec at f/45; development normal +1

HC-110 TIMES AND DILUTIONS

HC-110 is my favourite film developer, and with different dilutions it can give a large range, both for cut and pushed development. A personal speed rating will need to be determined for each film, and after that has been decided, the times given opposite should be fairly accurate.

The higher dilution makes possible larger cuts in development time, and should only be used when a time cut is indicated. These are the times I have used for 30 years with FP4 and FP4 Plus, and they have always worked well. On those occasions when I have used a different film, this chart has also held true.

When development is cut by more than two zones, the result will tend to be muddy, as the highlight range is being compressed too much. For those scenes where a larger cut is indicated, normal minus two should be used, and the highlights can be brought down further by burning in during printing (see pages 144–145). This will avoid any muddiness in the upper scale, allowing for a full tonal range.

CHEMICAL STORAGE

The different chemicals involved in the black & white process have varying handling and storage needs. As my standard print session needs 2 US gallons (7.6 litres) of fixer and one gallon (3.8 litres) of developer, mixing is quick and easy. Though I used to buy the fancy opaque brown jugs, these days the simple containers that distilled water comes in are my mainstay.

The shelf life of any given chemical should be printed on the label, and this can vary wildly from one type to the next. HC-110 comes in a concentrated syrup, and mixes up to make half a gallon (1.9 litres) of stock solution. This is then

Film development times in HC-110

Stock solution diluted 1 + 7 (in minutes at 21°C) N=normal

FILM	N	N+1	N+2	N−1
Tri-X	6	10	–	4.5
Plus-X	4	5.5	10	–
FP4	5.5	8	10	4.5
HP5	6	8	11	4

Stock solution diluted 1 + 15

FILM	N	N−1	N−2
Tri-X	10	8	6.5
Plus-X	8	6.5	5.5
FP4	10	8	6.5

diluted, to either 1 + 7 or 1 + 15, just before developing the film. The stock solution will last quite a long time, and to further extend its life, I store it in two separate containers, keeping one sealed until the first is empty. I have kept and used mixed HC-110 far beyond its indicated shelf life, and have never noticed any degradation in film quality. On the other hand, I have had some print developer go obviously bad long before the recommended cut-off, so, for printing, my rule of thumb is to mix the chemistry shortly before it is needed. But for the most part, in my experience, black & white chemistry will last a reasonable amount of time, and unmixed powders should never go bad.

TIME AND TEMPERATURE

The manufacturer's recommended film development time is a good starting point, and will probably be close to your normal time. If negatives done at this time seem too harsh, gradually cut the time until you are satisfied with the contrast. Once this is established, expansion and contraction times are fairly easy to figure out.

If the normal time is 8 minutes, a one-zone cut will be around 6 minutes, while a two-zone contraction will be approximately $4\frac{1}{2}$ minutes. These times, like your normal time, will need to be tweaked experimentally until consistently satisfactory negatives come out of the developer.

'with time spent developing and printing negatives,

it will become obvious which times are working'

Again assuming a normal time of 8 minutes, a one-zone push will be around 10 minutes, with a two-zone expansion landing at $11\frac{1}{2}$ minutes. These are rough figures, but with time spent developing and printing negatives, it will become obvious which times are working.

below

Fractured Sandstone

During my six-year career as a commercial river guide, it was impractical to take a view camera on trips, as there was no extra space on the raft. But I would always take a 35mm – usually my trusty Olympus OM-1 – and a small tripod.

Arriving early at camp above the first rapid, I had some rare spare time. After settling the passengers into their tents, I began to walk along the river. Finding this fractured sandstone boulder, I put a wideangle on the Olympus and composed a shot. It was impossible to get any shadow or highlight readings with the in-camera meter, so I settled for an average reading. Since this would be the only shot on the roll, recognizing how flat the contrast was, I marked it as a normal plus two development.

Considering how fast and loose I played with the exposure, this negative prints well, and the developmental push was definitely needed.

Olympus OM-1, 28mm lens, Kodak Tri-X, 1 sec at f/16; development normal +2

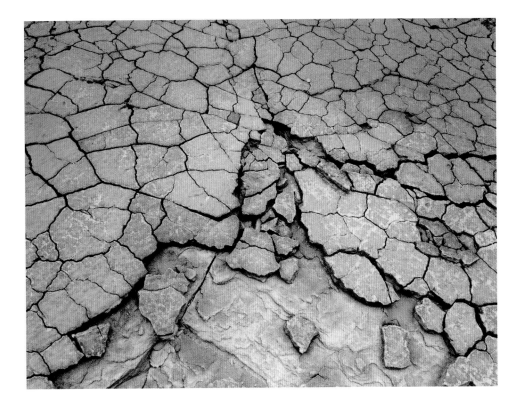

During the entire process – from film development through to the final fixer for the print – all chemistry should be kept at 21°C (70°F). This is particularly important during film development, as a fluctuation in developer temperature will have an adverse effect on the negative's tonal range. During printing, temperature is not so important, but the developers still need to be kept within a few degrees of 21°C. One method is to use a water bath for each tray – generally placing it in the next larger size of tray – adjusting the water's temperature as the session progresses. During film development, I use a water bath for the developer, whether using tray or tank development. In both cases I use a larger tray for the water bath, using more water for a tank and less for tray development (to avoid the risk of water sloshing into the developer, affecting the dilution). Steel developing tanks respond quickly to the temperature in a water bath, making them the best choice for rollfilm development.

All chemicals involved in film development (except fixer) need to be mixed with distilled water. To further salve my paranoia, I run the developer through a superfine filter before putting any film into it. These steps will save hours of retouching, helping to create the cleanest negative possible. There is an amazing amount of crud in tap water, and it is a law of the universe that the largest piece will affix itself to the worst possible place on any given negative. For printing, tap water may be used, as the paper surface is sealed, and nothing can stick to it.

DISPOSAL OF CHEMICALS

Before pouring used chemicals down the drain, check with your local water board, who will be able to inform you of any local regulations concerning their disposal.

LOADING ROLLFILM

There are several types of tank available, but I highly recommend using stainless steel reels and tanks. They are simple and durable tools, and will hold chemistry temperatures steady. The ratchet system used in plastic reels is bulky, and tends to restrict the flow of developer over the film surface. With smooth and even development, the printing aspect of the process will be greatly simplified.

Loading rollfilm (whether 35mm or medium format) onto a metal reel requires some practice, because if film is tweaked during loading, small half-moon density marks appear. These are a form of stress fracture in the emulsion, easily caused by rough handling, and cannot be eradicated. Most steel reels have some type of starting guide where the film is initially inserted in the centre. Using an unwanted roll, practise feeding it onto the reel with your eyes closed; with repetition, this will become a simple task. Rollfilm should always be developed with the emulsion facing inwards when it is loaded on a reel, and sheet film should face upwards when developed in a tray. Rollfilm always has the emulsion on the inward-facing part of the film, and will tend to have a slight edgeways curve inwards. This bend will aid in loading the film onto the reel, as it makes the initial insertion into the central clip much easier. The glossy, outward-facing part of the film is the base, while the opposite, matt side is the emulsion.

After a roll of 35mm film is exposed and rewound back into the cartridge, a standard can or bottle opener may be used to pop the end off the cartridge. This must be done in total darkness, as the raw film is then exposed. Sliding the film out of the opened cartridge, cut the tongue off the leader with scissors, leaving a straight edge. Gently increasing the curve of the film, feed the end into the centre of the reel,

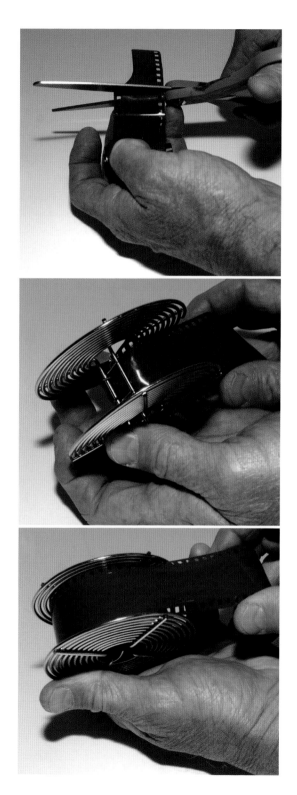

Trimming and loading film

After taking 35mm film out of the cartridge, locate the end, and carefully trim the tongue away, as close to the full-width section of film as possible. There is some leeway here, as the first 4–5in (100–130mm) of 35mm film doesn't have anything on it. When loading medium-format film, carefully separate the paper backing, and locate by feel where the film is taped to the backing. Trim the film away as close as possible to the tape, as most medium-format cameras place the last exposure very close to the film's end.

All of these steps must be carried out in total darkness. A good pair of scissors should be set aside specifically for trimming film.

connecting it to the clip. Then feed the film onto the reel with a slow and continuous turning of the reel, maintaining the bend in the film. This technique should be practised repeatedly in a lighted room with a throwaway roll of film, until it becomes a natural and fluid process. When the film is loaded, cut the end just before the tape that holds it onto the centre spool, and drop the loaded reel into the tank, firmly closing the top.

Medium-format film is sealed after exposure with the strip of tape attached to the end of the backing paper, and this must be carefully slit open in total darkness. After opening, gently unroll the paper backing until the film is reached. It should then be carefully separated from the backing paper. The film will roll up with the emulsion facing inwards. After reaching the end, cut the film from the backing, just before the tape that holds it to the paper. Lifting the end of the film away from the roll, carefully increase its natural curvature and feed it into the

clip at the centre of the reel. Medium-format film is more delicate than 35mm, and must be carefully loaded, or density half-moons will appear on the negatives.

When loading either size of film, your left hand will handle the reel, while the right feeds the film. While the reel is slowly turned, the film will be gently fed into it, still maintaining a slight bend. This curve will naturally feed the film into the dividers. Left-handed people will reverse this technique, as the dominant hand will handle the film. Feeling when film is correctly loaded becomes easy with practice, but can be very frustrating at first. Practice rolls are the rule of the day, the more the better. Start by watching the series of steps being employed, then run through the process with your eyes closed. When the film makes a slight popping noise during loading, the emulsion is being stressed, and unsightly (and permanent) density lines will appear in the final negatives.

Circular Weed

My first photo course was taken during my second year in high school, when I was 15 years old and we were living in Washington, DC. With a recently purchased Petri 35mm always hanging from my neck, I would wander the fields around the school, incessantly snapping. As I didn't have a tripod, all the photos were hand-held – usually snapshots of any subject that caught my attention.

During one walk home after school, I stopped and photographed this odd dead weed. After trying and failing to print it several times in the school darkroom, I gave up and forgot about it. Approximately 35 years later, I once again printed this vexatious negative, only this time using a split-contrast printing technique. By dropping the shadow tones down and exaggerating the light tones of the weed, I managed to pull a decent print, despite the poor quality of the negative.

Petri 35mm + 50mm lens, Kodak Tri-X, 1/60 sec at f/8; development normal

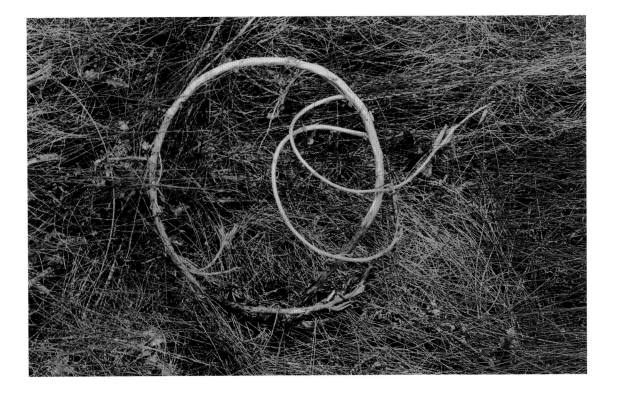

THE DEVELOPMENT PROCESS

Most developing tanks have two lids. The first renders the tank light-tight, so all remaining operations can be carried out in daylight; the second is a watertight lid which enables the tank to be inverted without spilling. The first step will always be a **PRE-SOAK** with distilled water, and this will last 30 seconds with constant agitation. The film is loaded into an empty tank, then the pre-soak is poured into the spout in a steady, strong flow. Holding the tank at arm's length, a steady upside-down/right-side-up motion is used, each complete reversal taking one second. Pre-soaking prepares the film for the shock of the developer, and will prevent density streaks, which can occur when developer hits dry film.

Once the pre-soak has been dumped, the **DEVELOPER** is poured in. The same agitation cycle is used for the first 30 seconds, followed by a 10-second cycle at the end of each minute. After each cycle, the bottom of the tank should be gently bumped to dislodge any air bubbles.

The next step is the **STOP BATH**, and this is also done with distilled water. This step saves the developed film from the shock of being hit by fixer. After 30 seconds of steady agitation, the water is dumped, and the **FIXER** poured in. Another 30 seconds of constant agitation is followed by 10 seconds for every minute, with the same bump after each agitation cycle. The manufacturer's recommended fixing time can be used, as long as the film remains in the fix for at least 3½ minutes. Over-fixing will degrade the silver, taking density away from the highlights.

After fixing, the film needs to be flushed with water several times, and then rinsed in a **HYPO-CLEARING AGENT**. (Hypo is an obsolete name for sodium thiosulphate, used as an ingredient in fixers.) There are several hypo-clears available, and any will do a good job. This step lasts one

Agitation technique

Starting with the tank in an upright position, it is given a 180-degree flip, and then returned to the upright position. This operation is performed in a strong and steady movement.

The stainless-steel cap of my tank tended to stick, so I have replaced it with a rubber sink plug.

minute, with steady agitation. It neutralizes the remaining fix, allowing it to be easily washed off. The film now needs to be washed, in a constantly changing water bath, for at least 5 minutes. There are several types of film washer available, but I have always washed mine in the developing tank, with constant dumping and filling of water during the five-minute cycle. Now that the film has been fixed, tap water may safely be used, as it is no longer susceptible to dirt.

After washing, a quick dip in a weak **WETTING AGENT** (basically a weak soap solution) ensures that most junk is flushed from the negatives. Then clothes-pin the film to a nylon string and allow it to air-dry. (Never use any type of string that sheds fibres, as they will certainly end up on the best shot.) A second clothes-peg on the bottom will prevent curling. When thoroughly dry, the negatives should be stored in clear plastic archival sleeves.

DEVELOPING SHEET FILM

The technique for large-format sheet film is similar, but is carried out in darkness in open trays. The trays should be one size larger than the film, with 4 x 5in film being developed in 5 x 7in trays. This makes the film much easier to handle during processing. A series of trays is set up in the sink, beginning with the pre-soak, then developer, stop (water bath), fixer, and holding bath (a tray of tap water).

A constant interleaving motion is used, lifting the top sheet and sliding it to the bottom. Sheet film must be handled by the corners only, and the interleaving should be delicate and slow. Ten sheets is the maximum that I can handle, as more is cumbersome, and the risk of damage becomes too great. The emulsion side must always be face up, with the film base down. To check this, make sure that the film notches are in the upper right corner when the film is placed in the first tray.

The film must be put into the initial pre-soak one sheet at a time. Holding the unloaded sheets in your left hand, with a small towel hanging at your waist, place each sheet in the water, laying it down directly on top of the film already in the water, submerging it totally before moving to the next sheet. Interleaving does not start until all the sheets are submerged in the water bath. Before reaching for each separate sheet, your right hand must be dried on the towel. If the sheets get wet before entering the pre-soak, they will stick together like glue, and this will ruin the negatives, stripping the emulsion. The water bath lasts 30 seconds, and the fixer lasts 3½ minutes, all with constant interleaving.

After a full cycle of all ten sheets, the film is carefully lifted out of the tray, turned around, and interleaved again from the opposite side, ensuring even development.

facing page

Basaseachic River

After exploring the fantastic Copper Canyon region of Mexico, Tom Till and I began driving north towards home. Noticing a national park on the map, we decided, on a whim, to spend the night there. Upon our arrival, we found huge cliffs surrounding a narrow canyon, the sheer walls very reminiscent of Yosemite Valley. Also like Yosemite, a tall waterfall drifted down to the valley, but with one major difference: at the top, almost hanging over the precipice, a small arch spanned the river. The possibilities were amazing, but the execution was very hard. The only angle that framed the shot was from a large chokestone just upstream from the arch, caught between the rock walls that channelled the Basaseachic River to the 1000ft (300m) drop into the valley. To reach the top of the boulder required a short jump from the bank; however, the rounded boulder was wet and slippery, and the price for a mistake was extreme. After a few practice leaps sans gear, I began to ferry camera and pack onto the rock. Carefully setting the camera up, I kept the tripod low, so I could sit, hoping my butt would hold me on the rock. The scene was, of course, hard to meter. The far trees were hazed by the mist floating in the air, and gave an unreliable reading. The base of the arch provided a good shadow reading, and the top gave a good highlight reading. I decided to let the small pool of water on top of the arch go higher than zone VII, and realized that the long exposure would necessitate some print work to bring out the river tonalities.

This was a very difficult photo to shoot, but the result exceeded my expectations. The long exposure added to the mystery by blurring the water.

Toyo 4 x 5in field view camera + Super Angulon 90mm lens, Ilford FP4 Plus, 1 sec at f/16; development normal –2

		at 1 sec				
III	IV	V	VI	VII	VIII	IX
f/16 <	f/11 <	f/8				
		f/64 >	f/45 >	f/32 >	f/22 >	f/16
			<	<	<	f/16

The chart gave an exposure of 1 sec at f/16. An equivalent exposure of 8 sec at f/45, corrected to 20 sec to allow for reciprocity failure, was used, both for the added depth of field, and to blur the rushing river as much as possible.

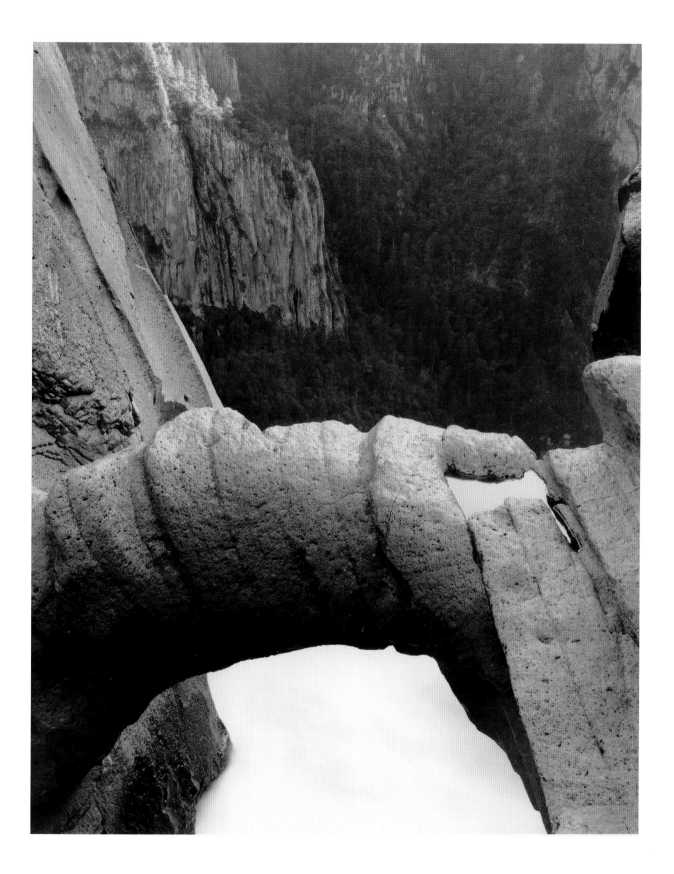

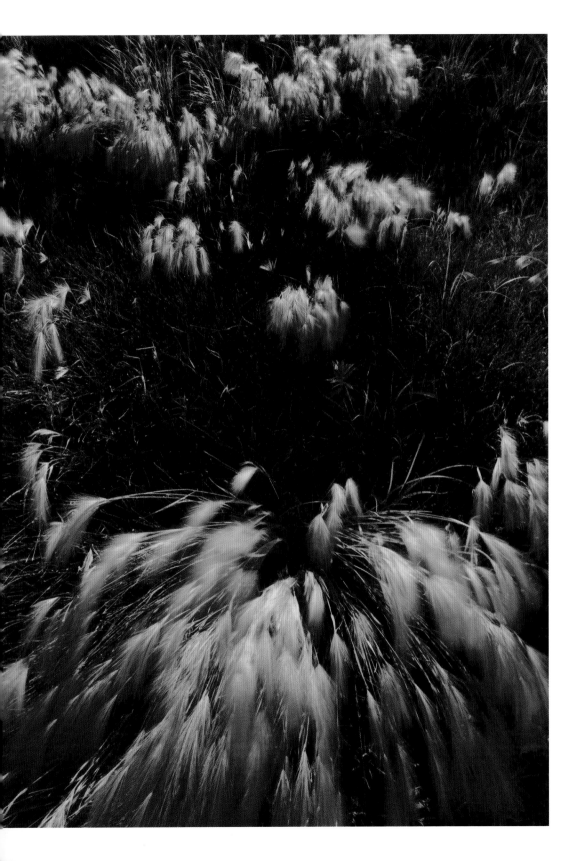

Foxtail

The tallgrass ecosystem once covered the centre of America in a blanket of lush prairie grasses, until farming ploughed most of it under. The remnants of the 'inland ocean' are among my favourite subjects, and I am always searching for new pieces of the tallgrass.

Ordway Prairie, South Dakota, is a wonderful piece of this mosaic, and after a fine day wandering through it, I found this little clump of foxtail. The last rays of sunlight were illuminating these grasses, and they were surrounded by deep shade. Placing these shadows in zone III, I then metered the foxtail for zone VII, and worked out the exposure. There were tiny local wind bursts, and a 1 sec exposure gave the foreground a nice degree of movement.

This is a tricky negative, and it took some time to figure out. Even with a cut in development, the highlights are dense, and it could only be printed with my split-contrast technique (see pages 136–140), combining a very short hard exposure (0.7 sec) with a long soft exposure (23 sec). This saved the tonal range, bringing it within the paper's capabilities.

Toyo 4 x 5in field view camera + Nikkor 90mm lens, Ilford FP4 Plus, 1 sec at f/22; development normal −2

		at 1 sec				
III	IV	V	VI	VII	VIII	IX
f/22 <	f/16 <	f/11				
		f/90 >	f/64 >	f/45 >	f/32 >	f/22
			<	<	<	f/22

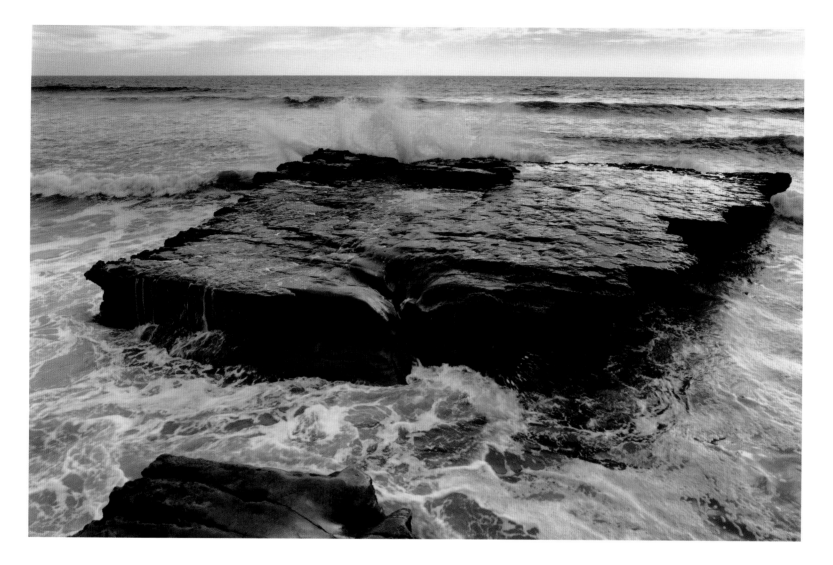

above

Flat Rock

This unusual rock at Torrey Pines, California, is a great subject. Making extreme use of rear tilt, and combining that with the great depth of field inherent in my widest lens, I shot with the fastest shutter speed possible under the circumstances. As it was sunset, the scene was backlit and contrasty, and difficult to meter. Some of the shadows were hopelessly deep, and I let them go paper black, instead placing the foreground rock on zone III. I didn't bother with a highlight reading, as a huge development cut was clearly required. Waiting for a nice wave to explode over the rock, I managed one exposure. The tide must have been receding, as no more waves came along.

The negative is fine, albeit a total pain in the printing. The contrast range is huge, even despite the enormous cut in development, and this picture needs a lot of burning down.

Toyo 4 x 5in field view camera + Nikkor 75mm lens, Ilford FP4 Plus, 1/30 sec at f/16; development normal −2

	at 1/30 sec			
III	IV	V	VI	VII
f/16	f/11	f/8		

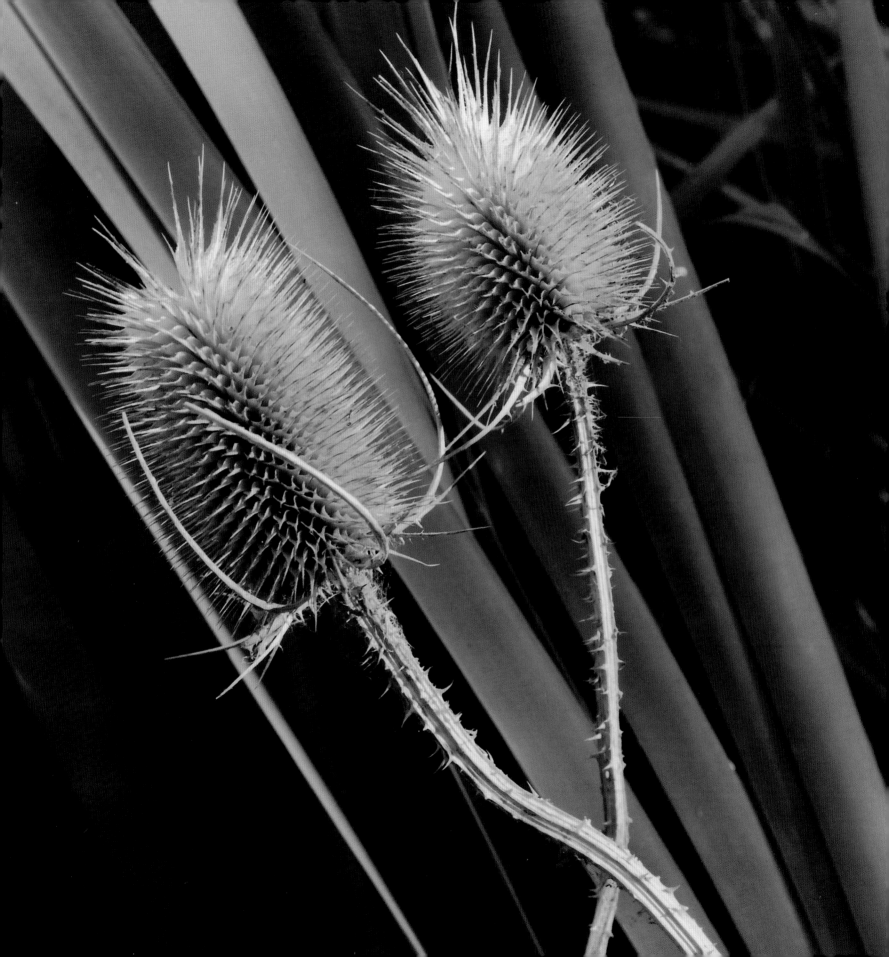

Chapter 3

Composition

The Art of Composition

IF A PRINT DISPLAYS A HIGH LEVEL OF TECHNICAL EXPERTISE, IT HAS PASSED THE FIRST MILESTONE OF BLACK & WHITE PHOTOGRAPHY. THE NEXT HURDLE IS COMPOSITION, AND IT IS HARD TO STRESS JUST HOW IMPORTANT THIS ASPECT IS TO THE PROCESS.

No matter what the level of technical photographic expertise, if the composition and subject matter fall short, the final image will fail. As with any other creative endeavour, there has to be a balance between creation and execution, and between reality and intuition.

CROPPING

A photograph is a carefully selected excerpt from the world around us. Determining the boundaries of the scene is a major component of the art of photography, and should be done in-camera whenever possible. If the composition is set when you expose the film, the printing becomes that much easier – and making full use of the negative is good sense. However, if the negative ends up with too much compositional information, the cropping must be adjusted during printing. I still have the occasional negative that presents this problem, and requires additional cropping in the darkroom. This is always frustrating, as it is more difficult to correct a composition after the exposure, forcing you to second-guess yourself, as it were.

There are times when it is impossible to crop satisfactorily in-camera, such as when you don't have a lens of the exact focal length that a certain scene requires. In these circumstances, cropping must be done during printing.

TYPES OF COMPOSITION

There are many classical compositional styles, each with innumerable variations, and you will be able to spot many examples of these on the following pages. The **S-CURVE** is an elegant and often beautiful technique, whether used as a single element or a repeating motif. This is a classic composition for sand-dune photos, but also forms an element in many man-made scenes. When doing architectural work, I often looked for curving stairways and balustrades, using them to balance the right angles inherent in modern buildings.

DIAGONALS, either single or repeated, can be dramatic – especially in black & white, with its extreme control over tonalities. Diagonal lines are ubiquitous, both in the natural and man-made world. In many styles of street photography, these lines can add to the elemental arrangement within an image, highlighting and dramatizing the subject matter.

THE RULE OF THIRDS is taught in every basic photo course as a means of achieving a spatial balance, either in tones or shapes, within the image. The idea is to divide the photograph into a series of squares or rectangles, and then note how the different sections play against each other. The divisions can be horizontal or vertical, or can form a series of right-angled boxes.

page 86

Thistle

These thistles were growing in a small wetland preserve in Colorado, and their intertwined stems offered an interesting composition.

Toyo 4 x 5in field view camera + Rodenstock 135mm lens, Ilford FP4 Plus, 1 sec at f/45; development normal −1

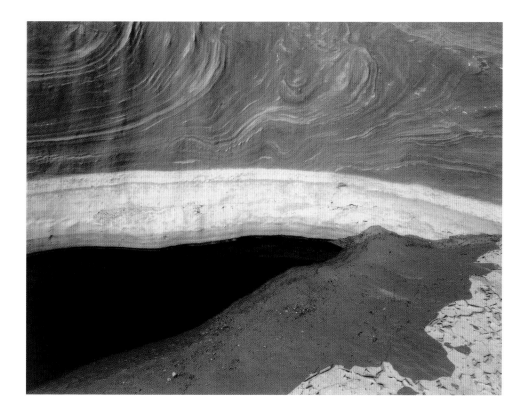

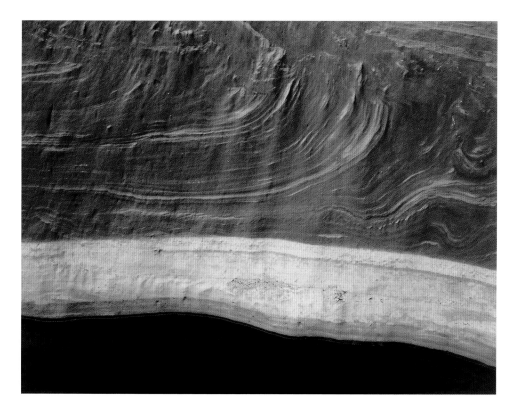

left and below left

Seep Pool

This is a natural water seep at the head of a small drainage in Canyonlands National Park, Utah. During my five-year tenure as a River Ranger, my off-time was spent exploring the myriad canyons along the Colorado River. Early one afternoon I hiked the length of Jasper Canyon, and found this ephemeral pool. The water level in these desert ponds changes dramatically, and this pool was down, leaving a bleached stripe of sandstone. For some inexplicable reason, this water was unusually dark, giving a stark contrast against the white stripe. At first my eye was caught by the mud at the base of the wall, and I focused on that. After making two exposures, I decided that the better composition might be to isolate the wall and pool, cropping out the mud. This would also structure the photo around the delicate fluting of the sandstone arrayed against the contrasting tonalities of the stain and pool. As it turned out, the closer composition worked far better, as the mud in the first shot detracts from the more important elements of wall and water. This is a variant of a diagonal composition, with the lines running almost horizontally through the image.

Toyo 4 x 5in field view camera + Caltar 150mm lens, Ilford FP4 Plus, 30 sec at f/45; development normal −2

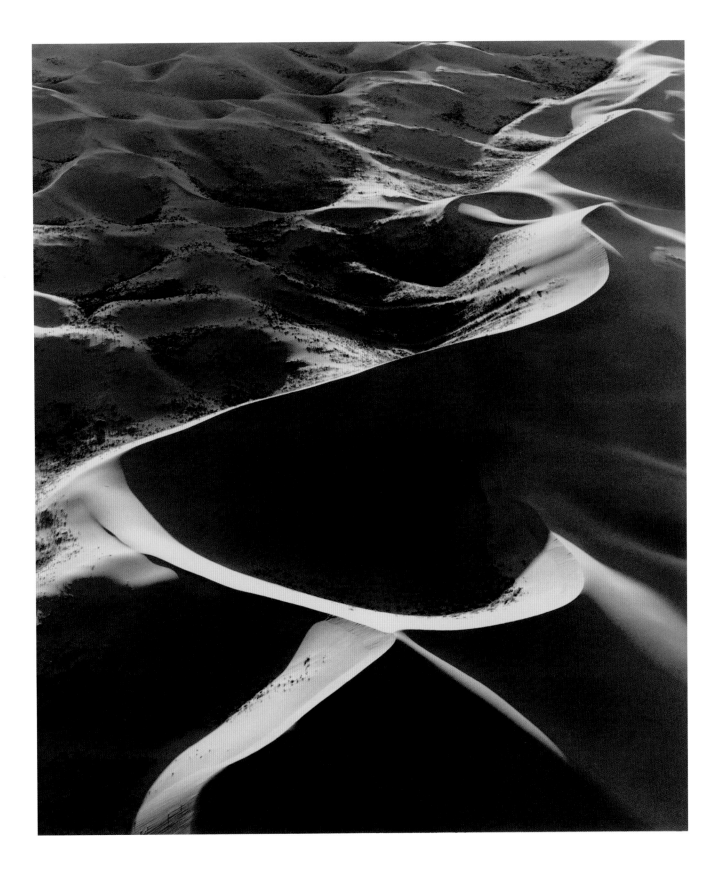

facing page

Little Sahara Dunes

Flying over these remote central Utah dunes in the late afternoon, I was very disappointed. All-terrain vehicles had ripped through the dunes, rendering them impossible to photograph. Noticing my agitation, the pilot mentioned that there was one small area closed to these infernal machines. After we reached it, I immediately noticed one odd dune that was untrammelled. A few passes allowed me to decide on a composition, and the resulting negative lived up to my expectations. This is a variation on an S-curve composition, and the shape of the dune is unlike any I have seen.

Pentax 67 + 90mm lens, Ilford HP5 Plus, 1/500 sec at f/2.8; development normal +1

right

Pothole

This small pothole in the sandstone is on the top of a small mesa (tableland) near my home. A thin film of ice covered half the water's surface, and this wavy white line was the demarcation between water and ice. The pothole had steep sides, and it was difficult to get the angle I wanted. After nearly slipping into the hole several times, I decided to back off and use a telephoto. It was impossible to get the composition I wanted, except by cropping the negative. The combination of S-curve and diagonal gives the touch of mystery that I seek in my images. A mild rear tilt carried the focus, despite using a telephoto so close to the scene.

Toyo 4 x 5in field view camera + Nikkor 210mm lens, Ilford FP4 Plus, 10 sec at f/45; development normal −2

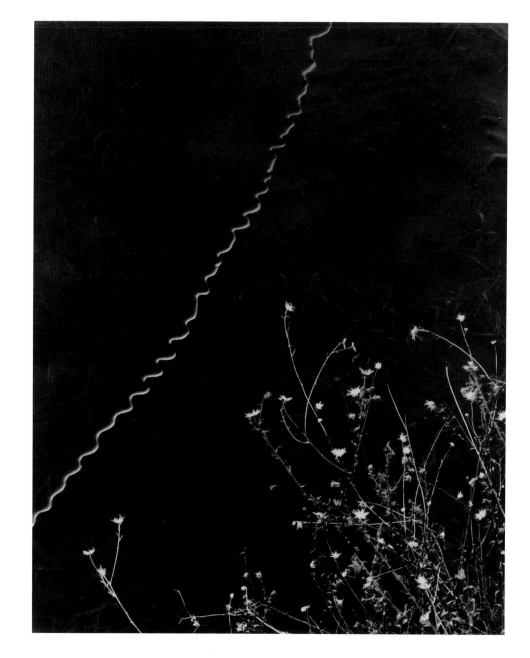

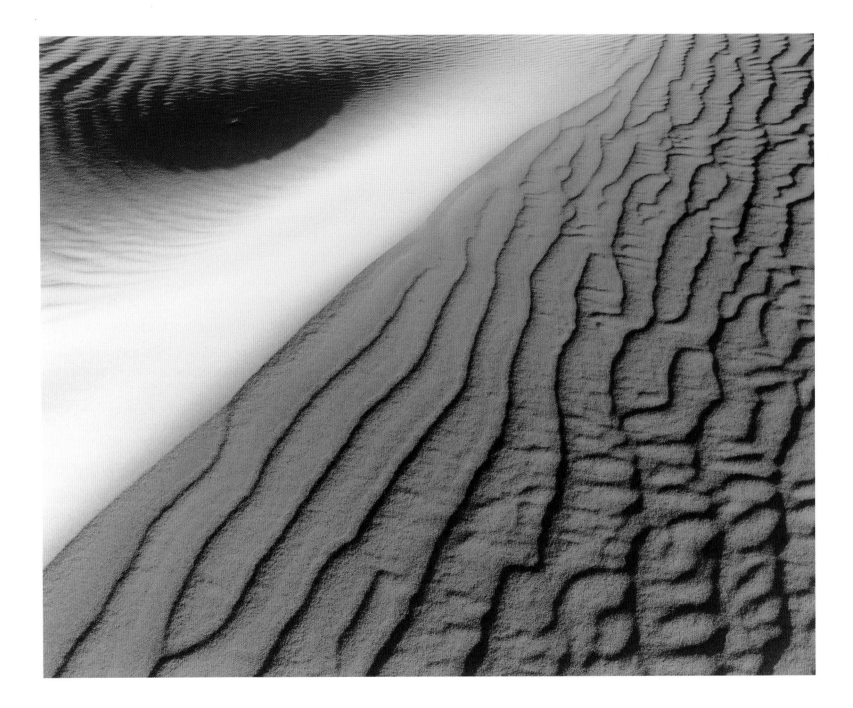

left

Tree & Building

This was taken on assignment during my brief career as an architectural photographer, and shows the side of a library in Denver, Colorado. The tree adds an interesting element to the reflections, breaking up the structured window divisions. This classic 'rule of thirds' composition was well received by the client.

Burke & James 4 x 5in monorail + Caltar 150mm lens, Kodak Tri-X, 1 sec at f/32; development normal –2

INTUITION IN COMPOSITION

Beyond the accepted classical compositional schemes, there are many unusual and eclectic styles which are difficult to define. What I call 'intuition' plays a part in all compositions, particularly those that travel outside accepted standards but 'just work'. Intuition is an ability that can be nurtured and developed.

Everyone has some level of intuition, though it is not a trait that is valued or encouraged in modern times. My dictionary describes it as 'the supposed power of the mind to grasp a truth without reason', and the addition of 'supposed' renders it a very negative definition. It is my opinion that intuition is an invaluable and very real ability, particularly relevant to photography. There must be a gut reaction to any given composition, and this reflex is a strong form of intuition. Thirty years ago, I made up for the lack of this ability by shooting ridiculous amounts of film; these days I am very picky about film use, and rely on a visceral reaction to any given scene. Experience will help develop intuition, and over time, this instinct becomes natural.

left | **Dune**

Canyon De Chelly, in northern Arizona, has been a favourite subject for photographers ever since Timothy O'Sullivan shot White House Ruin in the 1870s. After walking into the canyon and taking the required photo of the ruin, I headed back into the small reservation town of Chinle. Noticing a small group of sand dunes, I parked nearby and explored the area, eventually shooting this detail. The foreground ripples contrasted nicely with the upper circle, and I made two exposures.

This is a classic diagonal composition, with the effect heightened by the tonal shift between the upper and lower parts of the image. Some delicate dodging (see pages 142–144) lightened the highlight tones, exaggerating the compositional division.

Tachihara 4 x 5in + Caltar 150mm lens, Ilford FP4 Plus, 4 sec at f/64; development normal –2

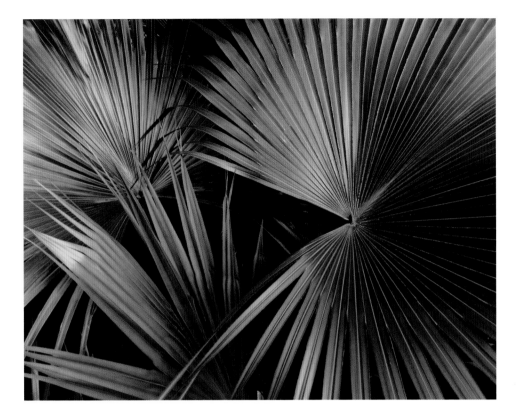

above

Palmetto

Wandering around Everglades National Park in Florida early one morning, I chanced on this intriguing clump of palmetto. It had rained the night before, and the damp leaves were picking up a nice glow from the bright eastern horizon. Knowing that the sun would be rising within two minutes, and direct light would ruin the scene, I quickly set up. The composition leapt out on the ground glass, and a wideangle lens accentuated the arrangement of the leaves. I exposed two sheets of film before the sun jumped over the horizon, ruining this delicate composition.

This is a good example of a flaring composition, and this style combines well with the delicate tonalities in the leaves. This image has held its appeal for me, and is one of my favourite Everglades photographs.

Toyo 4 x 5in field view camera + Nikkor 75mm lens, Ilford FP4 Plus, 4 sec at f/45; development normal −2

ALTERNATIVE STYLES

Although it is a less established style, **FLARE COMPOSITION** is one of my favourites. This involves linear elements radiating throughout the image from a central point. Strong use of this technique will give an illusion of explosion and movement, and it makes for a very dynamic composition. There are many variations of this to be found throughout the natural world, and it is a design that I actively seek out.

Another personal favourite of mine, and one that is completely lacking in structure, the **HODGEPODGE COMPOSITION** takes advantage of the chaotic tendency often displayed by the natural world. By offering limited clues about the subject matter, this technique slides along the line between realism and abstraction. Although such a composition may appear confusing at first glance, with study it should offer a certain cohesion and elegance. By giving limited and disparate clues as to what the subject matter is, and by combining other compositional styles within the scene, this can be a very strong and useful technique.

REPEATING PATTERNS can be very attractive, especially with judicious cropping. Such patterns are ubiquitous, and can be combined with a near–far composition, giving the viewer a strong feeling of 'falling into' the image. This style presents endless possibilities, both in nature and in man-made scenes. The pattern of a cobblestone street can be as effective as a close-up of tree leaves, or striations in a rock face.

Frozen Lake

During an early winter flight over Utah's Uintah Mountains, we found these odd ice patterns. A series of early freezes and thaws had caused these wonderful patterns, but their chaotic nature made a composition difficult to isolate. None of the negatives looked very good, but it nagged me to think that I had missed such a great opportunity, so I took a harder look. This last frame, taken in desperation, was the only one that included the lake shore, which gave a base to the composition. Although it required some artful cropping, and several darkroom sessions, the final print held some fulfilment of the morning's promise.

This hodgepodge composition displays the chaotic nature of the ice. The snow and dark rocks of the shore anchor the bottom edge of the photo, as well as offering a clue to the subject matter, saving it from total abstraction.

Pentax 67 + 90mm lens, Ilford HP5 Plus, 1/1000 sec at f/2.8; development normal +1

Travertine

This is a strange cold-water geyser along the Green River, a central Utah waterway. The minerals in the water have formed this delicate travertine, which runs from the geyser down to the river. On the last day of a photo trip, I stopped here late in the afternoon. After looking for half an hour, I couldn't find a composition, and was becoming quite frustrated. As I looked through the camera at this stretch of travertine, a dark cloud crossed in front of the sun, creating this brief opportunity. When the light vanished, this small white cloud was instantly reflected in the water running over the travertine, completing the composition.

This variation on the repetition technique makes multiple use of reflections, with the dark cloud reflection balancing against the white one. Because of the extreme contrast, this is a difficult negative to print, and essentially requires two separate exposures: one for the upper section with the river, and a different one for the bottom three-quarters of the image.

Toyo 4 x 5in field view camera + Rodenstock 135mm lens, Ilford FP4 Plus, 4 sec at f/45; development normal −2

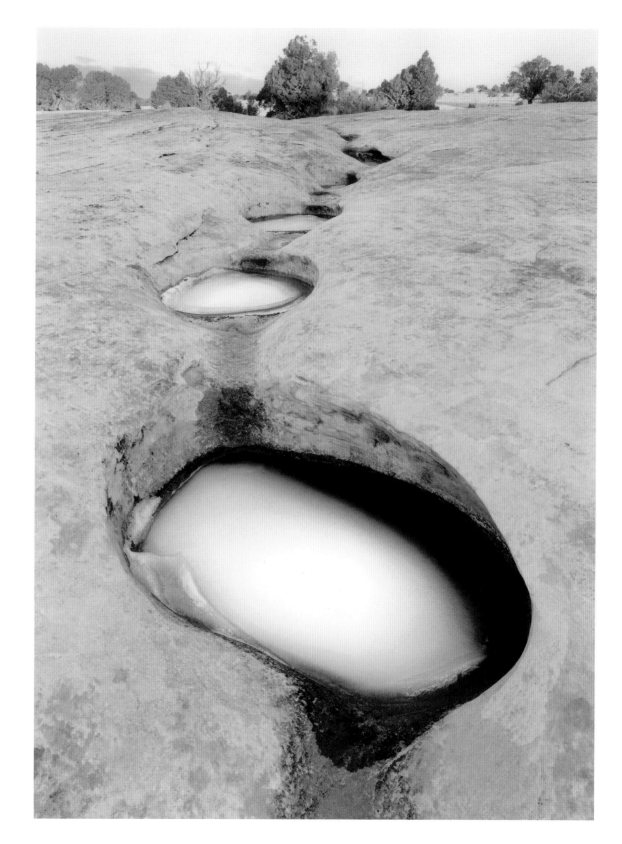

Quarry Ridge

After a disappointing afternoon searching for some elusive dinosaur tracks, I gave up and began the long walk back to the parking lot. Along the way, as the last light faded, these frozen potholes appeared. The pothole ice was reflecting the bright sky, and the distant trees added a nice element to the composition. A wideangle lens, combined with a near–far composition, helped to exaggerate the receding effect of the potholes. The repeating pattern is accentuated by the highlights in the foreground potholes.

Toyo 4 x 5in field view camera + Nikkor 75mm lens, Ilford FP4 Plus, 10 sec at f/45; development normal –1

CHAPTER THREE Composition

Foam

This is a juxtaposition of two photos, one a detail and the other an aerial. Both are examples of a repeating pattern, and they are shown together to demonstrate two very different ways of using this style of composition, varying greatly in scale.

On a wonderful trip to China, I found this small clump of foam (*left*) in a pool at the base of Yellow Mountain. There was a slight breeze, and the foam was moving. Waiting for a break, and using my rear tilt to increase the depth of field, I managed to make one exposure, after which the foam broke up and vanished – a metaphor for landscape photography in general.

Years later, while flying over Everglades National Park in Florida, I noticed this beautiful group of mangrove islands (*right*). Several circles and a drop in altitude helped me find the right angle. The contrast change from top to bottom surprised me, rendering this a difficult negative to print.

While editing photos for a previous book, I noticed that these two photos worked well together. The combination of microcosm and overview offered in this pairing is appealing, and this is something I look for when sequencing photos, either for a book or an exhibition.

Toyo 4 x 5in field view camera + Rodenstock 135mm lens, Ilford FP4 Plus, 1 sec at f/32; development normal −2

Ten Thousand Islands

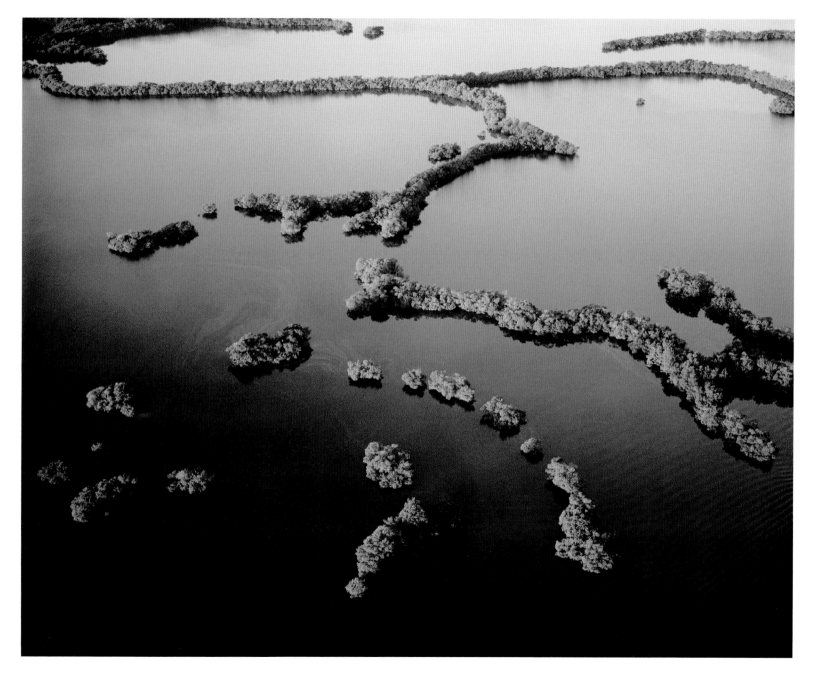

Pentax 67 + 90mm lens, Ilford HP5 Plus, 1/1000 sec at f/2.8; development normal +1

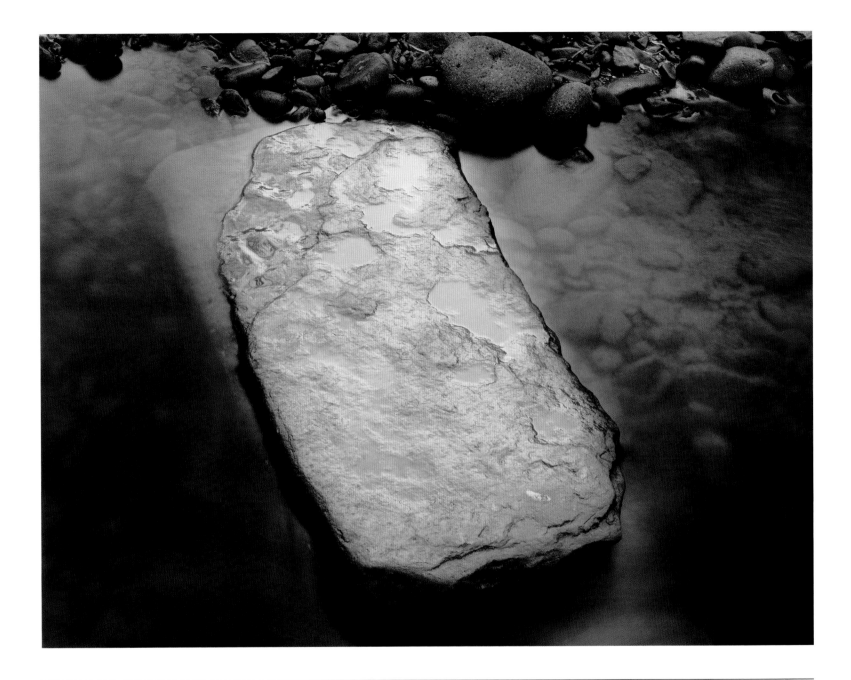

above | **Sandstone Slab**

This flat slab of sandstone, wet from a rainstorm, was reflecting the bright northern sky. Setting up on the opposite bank, and dropping my tripod down to the angle that picked up the brightest glow on the rock, I exposed two sheets of film. This was one of the most effervescent reflections I have ever seen, and is a good example of a sky highlight bouncing off a wet surface.

Wista 4 x 5in + Fujinon 150mm lens, Ilford FP4 Plus, 1 sec at f/45; development normal −1

REFLECTIONS can be used to wonderful effect within a composition, and they can be found everywhere. Still pools of water, no matter how small, will add little accents within a scene, helping to set off the main subject. Larger bodies of water often produce fascinating reflections, and these can become a worthwhile subject in and of themselves. Glass surfaces frequently mirror nearby objects, and multi-windowed buildings, when the light is correctly used, become fantastic reflecting screens, illuminating nearby subjects. Particularly delicate and fine highlights can be found when a wet surface reflects a bright sky, an effect which often occurs after a hard rain.

below

Salem

Salem's caravan was old, with odd circular windows and weathered aluminium sides. The window combines well with his profile, and makes for an unusual composition. I printed the highlights down more than usual.

Hasselblad + 90mm lens, Ilford FP4 Plus, 1/2 sec at f/22; development normal

FINDING A PERSONAL VISION

These days, in my personal work, there must be a certain amount of mystery and metaphor. Total abstraction generally fails for me, as does complete realism. When an image is completely abstract, it appears disjointed, and becomes far too personal, offering little to attract a viewer's attention. At the other end of the spectrum, harsh realism is simply a form of documentation, and reveals nothing about the photographer's own philosophy.

The natural world is a vast enigma, and this is an element I actively search for. After moving to southern Utah 20 years ago, I began to explore and shoot the myriad canyons surrounding Moab. While working as a river guide, I was living on the banks of Courthouse Wash, a serpentine canyon that cuts through Arches National Park. After long days guiding on the Colorado River, I would walk up the wash, exploring the intricate details along the small stream and on the ancient canyon walls. I count this canyon as the place where my personal vision and my photographic intuition began to blossom. Concentrating in this way on one particular area and style will help develop and hone your compositional instincts, and will improve any photographer's craft and intuition.

Compositional possibilities run a wide gamut, from extreme realism to total abstraction. This spectrum is virtually limitless, as are the various styles and techniques available. As with camera selection, it depends completely on the individual photographer, and on which methodology they choose to pursue.

My favourite type of portraiture involves placing people in situations or places with which they have some relationship. This can involve their work or hobbies, or it can be some aspect of the natural world that reflects their lifestyle. Lighting for these shoots, as a rule, is natural, a reflector being the only equipment I will use. Since I don't have any real lighting equipment, a white sheet is my usual reflector, and this primitive technique works well enough in most cases. This type of portrait is usually more interesting than a standard studio shot, as it offers more information about the people and their personalities.

left

Bob Spaulding & his Favourite Tractor

After working with Bob Spaulding for several years at a river tour company, I came to realize that he was an amazing mechanic, able to fix any piece of broken equipment. This antique tractor was his favourite vehicle, and was in perfect running order. He would use it several times every week, and it never failed to start first time. As he loved this tractor, it seemed natural to take a portrait of him sitting on it, with his usual jovial smile.

Tachihara 4 x 5in + Super Angulon 90mm lens, Ilford FP4 Plus, 1 sec at f/45; development normal −2

right

The Birthing Rock

The Birthing Rock in Grand County, Utah, is a large boulder covered with prehistoric rock art, the dominant image being a depiction of a birth. My wife wanted a generational portrait, and we decided to set it up under the rock. Placing my wife Vicki, our daughter Alyssa, and my wife's grandmother Julia Surrick under the birthing panel, and using a sheet to reflect the late afternoon light up into their faces, I made several exposures.

This view of three generations sitting under a prehistoric birthing scene appealed to me, and resulted in one of my best portraits.

Toyo 4 x 5in field view camera, Rodenstock 135mm lens, Ilford FP4 Plus, 1 sec at f/32; development normal

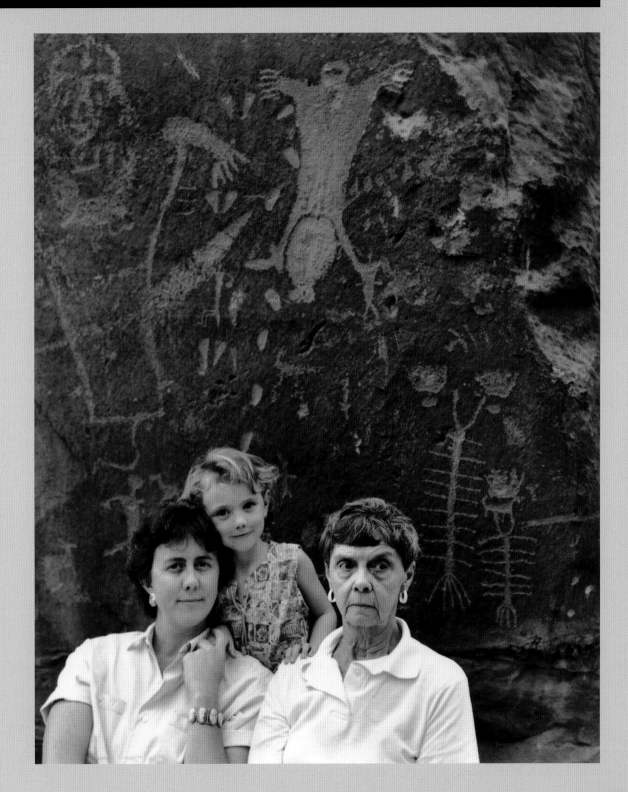

Understanding Light

LIGHT IS AN ACTIVELY CHANGING FORCE. CLOSE ATTENTION MUST BE PAID TO THE LIGHT IN ANY GIVEN SCENE, AS IT CAN MAKE OR BREAK A PHOTOGRAPH. AS WITH OTHER COMPOSITIONAL CONSIDERATIONS, THE VARIOUS TYPES OF LIGHT OFFER A HUGE RANGE OF POSSIBILITIES.

'There is no illumination quite as lush as sunlight bouncing off steep canyon walls.'

REFLECTED LIGHT is one of my favourites, and is common in the canyons around my home town in Utah. There is no illumination quite as lush as sunlight bouncing off steep canyon walls. This lighting can be found in many different situations, and walls of buildings also provide fine surfaces to reflect light onto an opposite subject. This is an extremely warm light, tending towards the red end of the colour spectrum. In terms of black & white, reflected light softens contrast, and tends to spread out tonal ranges. This is excellent for details, as it often gives a rich glow, accentuating subtle gradations within the different tones. Reflected light can provide excellent illumination for portraits, eliminating harsh shadows and enhancing skin tones.

In some instances, **LOW-ANGLE LIGHT** can work very well. This also tends towards the warm end of the colour spectrum, though it gives a harsher contrast than reflected light. Because the angle of the sun is almost perpendicular to the subject, shadows tend to be especially deep, and this light source always requires some serious contrast reduction through a cut in film development. Though this type of illumination is harsher than reflected light, it still tends to be warm. It is a fairly diffuse light, and allows for a decent tonal range. Low-angle light is wonderful for aerial photography, as it highlights the ripples and folds of the earth's surface. Dawn and sunset provide brief bursts of low-angle light, often creating long and interesting shadows. While these times of day provide a beautiful source of light, both for aerials and for ground photography, care should be taken not to overuse this illumination. These 'magic minutes' are beautiful, but an entire portfolio lit in this way will become tedious.

One variation that I often use to advantage is **FLAT LIGHT**. This illumination is extremely diffuse, often to the point of disguising the angle of the sun. Generally occuring on overcast days, it varies greatly in brightness, and its intensity will depend on the thickness of the cloud cover. It gives good illumination for details, but works poorly for larger views, where it tends to give an ugly tonality in the sky, detracting from the rest of the image. Flat light is neutral on the colour scale, and often this flatness will be apparent in a black & white print. Details may need to be manipulated, both in development and in printing, to extend the contrast range. Pushing contrast will work well, but must be done with care; a severe push will create an unattractive and hard contrast.

Although technically difficult to work with, **BACKLIGHTING** – where the light comes from behind the subject – can often succeed. This will depend completely on the composition, and will always require some extra printing adjustments. This type of light will produce negatives that are

hard to print, as the tonal range tends to be compact and harsh. Backlighting is hard and hot, tending to compress contrast ranges; the middle-grey scale is liable to disappear, leaving only highlights and deep shadows. When this range is controlled using split-contrast printing (see pages 136–141), and some mid-grey tones are introduced into the image, backlighting can be beautiful, and is one of the more interesting types of illumination available.

STORM LIGHT can offer fantastic opportunities, especially when it coincides with dawn or sunset. During these periods, it is a very warm light, although it tends to offer a fairly short contrast range. When the sun peeks out from under a layer of heavy and ominous clouds, a rare and amazing burst of luminosity occurs. This is a very elusive lighting situation, and can occur at any time, occasionally even during the middle of the day. **SPOT LIGHTING** is a variation which occurs when a hole appears in heavy clouds, throwing a bright shaft of sun onto a portion of the landscape. This causes harsher contrast, as the spotlit area will be much 'hotter' (it will have more contrast) than the surrounding shaded part. As with backlighting, steps must be taken to control this, and an attempt made to introduce middle tones to the scene. This light is ephemeral, and requires quick reflexes on the photographer's part.

EXTREME LOW-LEVEL LIGHT can put wonderful mystery into an image, but can also add technical troubles. This is a severely diffuse form of illumination, and modifications are needed in order to use it successfully. Shadow detail becomes problematical, and must often be sacrificed. Sometimes this loss will work in the composition, but large areas of undifferentiated shadow in a print often become detrimental. The long exposures needed also cause reciprocity failure, requiring adjustment of the indicated exposure time (see page 61).

below

Town Lake

This photo could only have worked with backlighting. The sun reflecting off the distant lake adds a specular highlight, gaving another dimension to the composition.

Hasselblad + 50mm lens, Kodak Plus-X, 1/2 sec at f/22; development normal −2

Perhaps the most difficult to use, **MIDDAY SUN** is a harsh, unforgiving light which compresses tonal ranges and often creates deep shadows that are hard to print. It also washes detail out of highlights, and these many troubles combine to make for a very difficult negative. There are those rare subjects, however, that will work with this illumination. When a scene requires harsh light, compensations must be made in exposure, development and printing, as explored in Chapters 2 and 4. This sharp light can be quite appropriate in some forms of street photography, as the harsh edges will increase the immediacy of this genre.

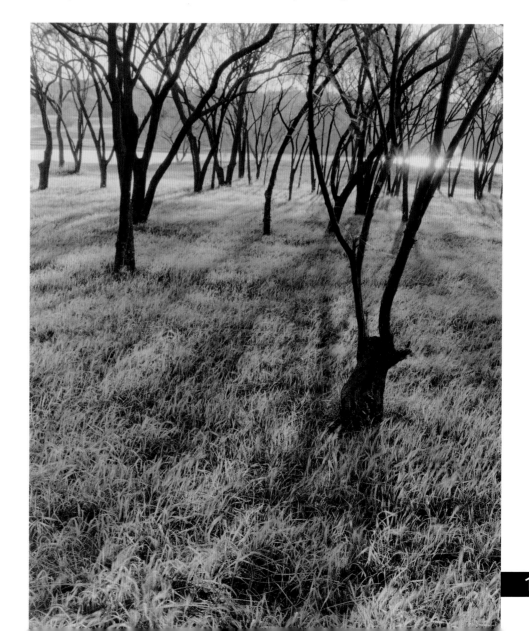

Worm Tracks

This photo was taken in seriously harsh midday sun. Worms had etched trails beneath the bark of this branch, eventually killing the tree. After falling into the river, time and water stripped the bark, exposing these esoteric etchings. A moderate exposure exaggerated the light bouncing up from the moving water. The reflections on the river mirror the worm tracks, and add a strong element to the composition, which is a variation of the hodgepodge technique.

Toyo 4 x 5in field view camera + Rodenstock 135mm lens, Ilford FP4 Plus, 1 sec at f/64; development normal −2

Toadstool Badlands

These mud patterns showed some interesting tonal gradations, which combined nicely with the highlight on the curled piece. Metering the shadow under the curl, I guessed at a cut in development. The negative required some serious dodging and burning, but ended up printing well. This is a combination of compositional styles, but the white curl with the dark mud under it offers a nice centre, and the picture is held together by the many surrounding cracks.

Tachihara 4 x 5in + Rodenstock 135mm lens, Ilford FP4 Plus, 5 min at f/32; development normal −1

Driving along the mighty Columbia River on a trip through the Pacific Northwest, I saw this nurse log stuck in the shallows, and pulled over to investigate. A nurse log is a fallen tree that supports a host of smaller plants, a phenomenon that only occurs in wet climates. This huge redwood log had floated down river, eventually being caught in an eddy and coming to rest near the southern bank.

This is an example of noonday illumination, although the light in this area is diffused by the severe humidity. The contrast was still quite harsh, and this is a difficult negative to print, but the midday sun nicely accentuates the plants.

Tachihara 4 x 5in + Fujinon 150mm, Ilford FP4 Plus, 1 sec at f/64; development normal −2

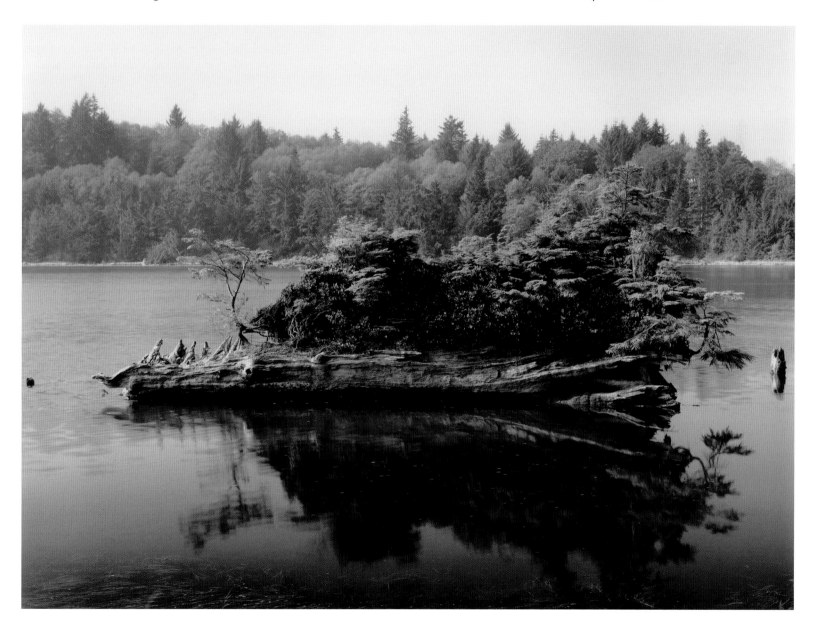

Aerial work has a different set of techniques and requirements, and is a very interesting branch of photography. Small planes and professional pilots can usually be hired for a reasonable amount of money, and the key is to time your flight to coincide with the best angle of light for the subject, staying in the air for as brief a time as possible. As a rule, morning and evening are best, as low side-lighting will accent the folds and forms of the landscape.

The camera should be an SLR, either 35mm or medium-format. All of my aerial work is done with a normal lens, and the altitude of the plane sets the distance between the camera and subject. As the exposures are made at high speed, and precise compositions are difficult to achieve, I often crop out extraneous elements during printing. A good pilot will be able to understand and follow your directions, and will also be able to slow the plane to just above a stall, allowing time to expose the film.

The shutter speed needs to be 1/500 sec or higher, as the speed of the plane will cause blurring in the negative at any slower speeds. The focus will always be set on infinity, and this allows the lens to be set on the widest aperture. When the focal plane is on infinity, depth of field ceases to be a problem.

A high-wing plane should be used, otherwise the wing will intrude into every shot. Cessnas are fine planes for aerial photography, and are ubiquitous around the world. The window should be lifted during the exposures, as shooting through the plastic will affect focus. Cessna windows generally lift up with the removal of one screw, and the slipstream will hold them up during exposures. 'Low and slow' is the aerial photographer's mantra, and a good pilot will be able to accommodate this requirement.

My favourite aerial film is Ilford HP5 Plus in 120 format, which gives a nice, smooth tonal range when developed in Kodak HC-110. Through bitter experience I have learned that, no matter how harsh the contrast of an aerial scene appears, a one-zone push is always required in film development. The reason continues to elude me, as it goes against common sense. This remains one of those 'just because' aspects of photography.

My aerial camera is a Pentax 67, a sturdy workhorse with a wide maximum aperture of f/2.8, and a shutter-speed dial that goes up to 1/1000 sec. The in-camera meter gives a decent averaging reading, which is all you can do for aerial work – the speed and conditions make it virtually impossible to take detailed meter readings. The Pentax 67 is an SLR, and is fairly easy to handle under rough conditions, such as when the plane hits a pocket of dead air, and the camera becomes intimate with your nose.

An added bonus of flying is that it allows you to scout for ground shots, giving a nice overview of the landscape. There have been several times when I noticed a promising area from the air, returning to it later on foot.

facing page

Land's End, Baja, Mexico

The sea arch that marks the end of the Baja peninsula has always intrigued me, but a good vantage point at ground level is impossible because of the ocean tides, and so I decided to try a flight. With some reservations, I hired a pilot and plane. Early the next morning, my doubts were laid to rest, as my young amigo turned out to be one of the best pilots I have ever flown with. The angle I wanted on the arch required that he thread his Cessna between several huge sea stacks, as well as tipping the left wing up at the perfect moment. He performed this complicated manoeuvre several times, always putting me at the perfect angle to shoot El Arco. The reflections on the foreground water were a bonus, and the final print lived up to my expectations.

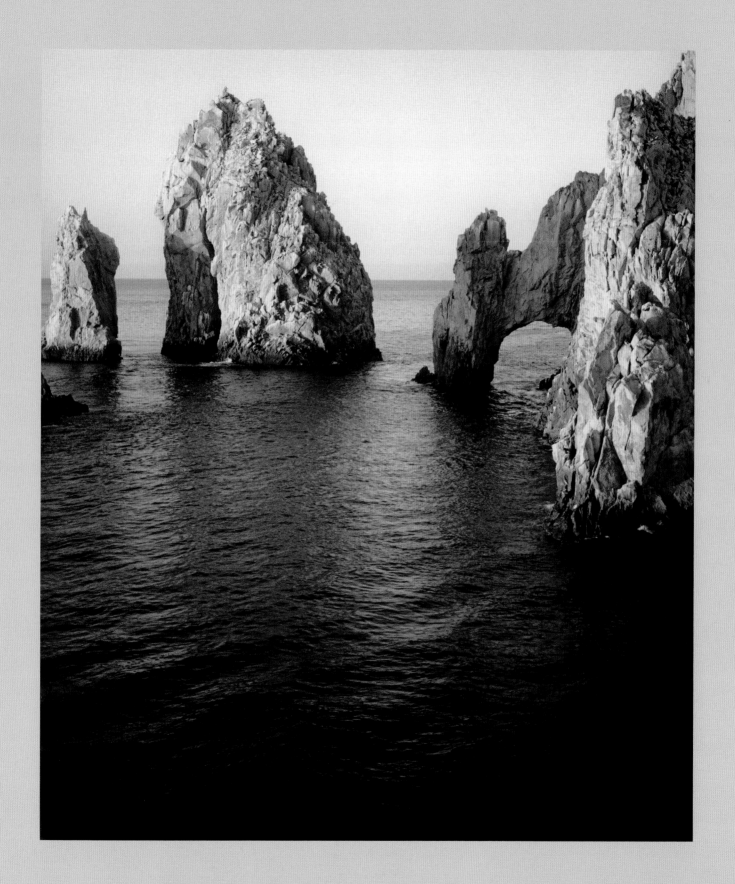

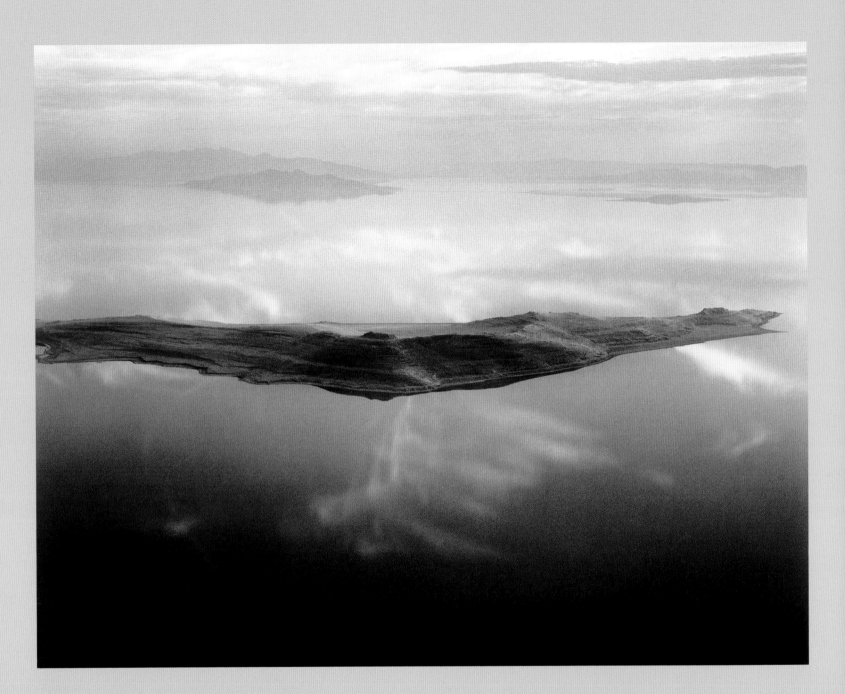

above

Fremont Island

Utah's Great Salt Lake remains one of my favourite subjects, particularly from the air. This small island is in the north end of the lake, and has a distinctive shape. On this flight, the late afternoon clouds were reflecting in the lake, offering a good counterpoint to the island and the dark water. The distant mountains are shrouded in haze, giving a smooth tonal shift from the dark foreground.

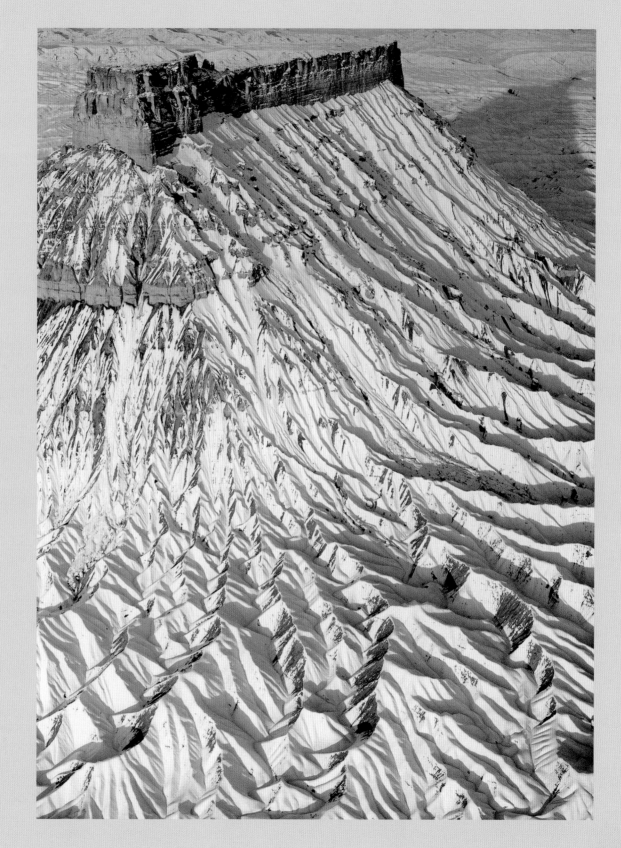

right

Factory Butte

This wonderful formation is located north of Lake Powell, surrounded by some of Utah's most fantastic badlands. During a winter flight, following an unusually heavy storm, the butte's ridges and folds were emphasized by the snowfall. After circling once, I noticed the small shadow being thrown by the top of this formation, and decided to use it in the composition. This place has often been photographed, but this is a different perspective, and I am pleased with the image.

Composition & Camera Technique

COMPOSITION IS DEPENDENT ON CAMERA TECHNIQUE IN MANY RESPECTS. THE MORE YOU ARE IN CONTROL OF THE TECHNICAL ASPECTS OF PHOTOGRAPHY, THE BETTER YOU ARE PLACED TO REALIZE YOUR VISION.

FOCUS

Focus is very important, and the photographer must learn when to carry sharpness to the maximum, and conversely, when to use it selectively. Isolating certain areas within an image, by making them sharp while allowing others to go soft, can be an important compositional element in itself. The extent of sharp focus required will depend on the composition: some scenes will benefit from being soft, while others need to be totally sharp. Portraits are often well served by selective focusing, with only the salient elements of the composition in sharp focus. The key concept here is depth of field.

DEPTH OF FIELD

This is one technical aspect that needs to be understood and mastered by all photographers. Depth of field is the distance between the nearest and furthest elements within the photograph which appear in sharp focus. It is determined by a combination of factors, including the camera format, the lens aperture, the distance between camera and subject, and the focal length of the lens.

A handy rule is that depth of field will extend one-third forward from the point of focus, and carry two-thirds beyond, as shown in the diagram opposite.

In general, the smaller the **CAMERA FORMAT**, the greater the depth of field that can be achieved at any given aperture. The exception to this rule is the large-format view camera, whose rear tilt allows the plane of focus to be adjusted so as to maximize depth of field. By focusing on infinity, then tipping the rear of the camera back until the foreground comes into focus, and combining this with a small aperture, an amazing depth of field can be achieved. Though this works best with a wideangle lens, I have employed this technique with different lenses, ranging from standard up to telephoto.

As the **LENS APERTURE** becomes smaller, the depth of field increases. A view camera will have much greater depth of field at f/45 than at f/16; a 35mm camera will have more at f/16 than at f/2. This, in practical terms, is the most useful means available to the photographer for controlling the extent of focus carry. How far the various apertures will carry can be learned through experience, although many SLR lenses have a depth-of-field preview feature, which closes down the aperture as you look through the viewfinder. Many 35mm lenses also have a depth-of-field chart on their barrel, and these are generally accurate. A tripod allows the use of slow shutter speeds, permitting a smaller aperture to be used. For hand-held work, a faster speed must be used (1/60 sec is the slowest speed most people can manage with a normal lens on a 35mm SLR), with a correspondingly larger aperture and smaller depth of field.

right

Steel Drain Culvert

This is was an exercise in focus carry, and the upward angle of the view camera prevented the use of the rear tilt. By focusing on the fourth row of bolts (the line across the entire top of the culvert), and by closing the aperture completely down, I was able to carry focus over the entire scene. The upper foreground was 3ft (1m) from the lens, and the distant end of the tunnel was at infinity.

Wista 4 x 5in, Rodenstock 135mm lens, Ilford FP4 Plus, 1 sec at f/32; development normal

The greater the **DISTANCE BETWEEN CAMERA AND SUBJECT**, the greater the depth of field for any given aperture. For extreme close-up or macro photography, depth of field may be measured in millimetres.

Depth of field is heavily affected by the **FOCAL LENGTH OF THE LENS**. A wideangle lens gives inherently greater depth of field than a standard lens, while a telephoto offers a very shallow depth of field, combined with an effect of flattened perspective. The near–far style of composition generally requires a wideangle to carry the focus, while distant compositions will call for a longer focal length.

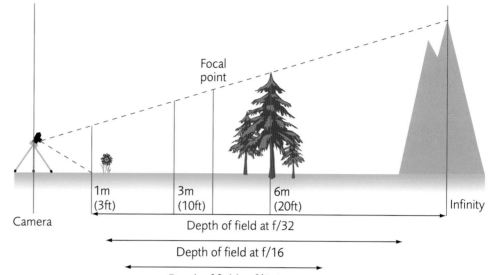

Focal point

	1m (3ft)	3m (10ft)	6m (20ft)	Infinity

Camera

Depth of field at f/32

Depth of field at f/16

Depth of field at f/5.6

Depth of field

The illustration above shows the varying depth of field that will be obtained with different aperture settings. With the lens focused at a given point in the scene, the depth of field will carry forward from that point approximately one-third, and will carry past it approximately two-thirds.
The actual extent of the depth of field will depend on the lens aperture and other factors, as discussed in the text.

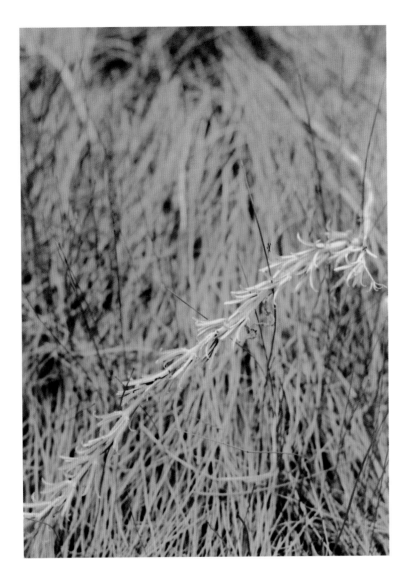 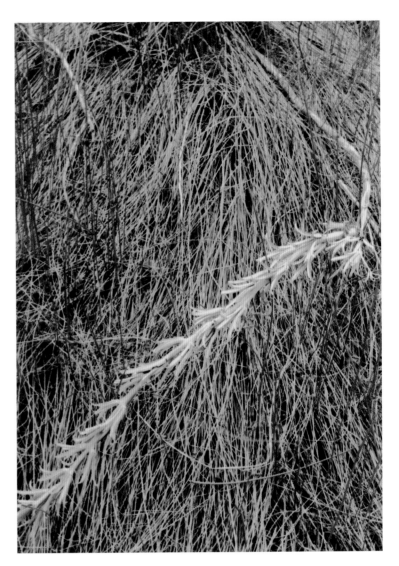

above | **Weed & Grasses**

The left-hand picture shows the depth of field achieved by using f/4 with a 28mm wideangle lens on a 35mm SLR (Canon AE-1). Focus was set at the middle section of the long weed, and little else in the scene appears sharp. The right-hand picture shows what happens when the lens is closed down to f/22, using the same camera, lens and focal point. At this much smaller aperture the depth of field has carried much further, and, despite the fact that both images were exposed from the same viewpoint, the resulting compositions look quite different.

LENS CHOICE

Lens selection is determined by the intended composition. In 35mm, the best all-round focal length will be a **NORMAL** or **STANDARD** 50mm, although a moderate wideangle, such as 28mm, can be very useful. Normal lenses for medium-format cameras range from 75mm for the 6 x 4.5cm format, through 75 or 80mm for 6 x 6 and 90mm for 6 x 7, up to 105mm for 6 x 9cm. A normal lens will, under most circumstances, give a natural-looking perspective – one that does not take the viewer by surprise.

To exaggerate a foreground, and to carry depth of field from near to far, a **WIDEANGLE** lens is required. This effect, however, can easily be overused, and discretion is called for. My favourite 4 x 5in lens is a Rodenstock 135mm, which is only slightly wider than normal (a normal focal length for the 4 x 5in format is 150mm). It works well with a rear tilt, and avoids the distortion that occurs with true wideangles.

TELEPHOTOS are important, although I use them far less than wide and normal lengths. They are valuable for isolating certain elements within a composition, particularly when it is impossible to get close to the subject. As the focal length increases, foreshortening begins to occur: the scene appears to flatten out, taking away the illusion of depth that wider lenses offer.

Try to become thoroughly familiar with the lenses you have. Lens selection and composition are intertwined in a symbiotic relationship; every potential composition requires a particular focal length to bring it off. My first pick for a particular shot will often be correct, but occasionally a different lens will be called for. This becomes obvious as the composition refuses to coalesce on the ground glass. No amount of jockeying will fix this problem, until a more appropriate lens has been selected.

above

Alligator

Sometimes you need a particular lens to complete a composition. Even though this alligator was asleep, I still needed my biggest telephoto, as a shorter lens would have narrowed the distance between us, which didn't seem like a good idea. Deciding on a detail, I locked my big lens on and played with compositions. The semi-abstraction of this one appealed to me, and the two toes add a nice Godzilla-like element to the scene. Though the 4 x 5in format isn't ideal for wildlife photography, it will work when the creature is sound asleep.

Toyo 4 x 5in field view camera + Wollensak 400mm lens, Ilford FP4 Plus, 4 sec at f/32; development normal +1

ANGLES AND VIEWPOINTS

A slight change in approach or angle can alter a composition to a drastic degree, whether you are modifying the distance or the height of the camera in relation to the subject. Taking every photo from eye-level will result in a boring conformity, and will begin to detract from the subject matter. By gradually moving in and experimenting with the perspective, the best possible composition should emerge. Work inwards, circling and stalking the scene, until the best photograph of that subject makes itself known. Street photography, in particular, requires quick reflexes, and this type of compositional ability can only be developed with practice and intuitive ability.

Angles are important, and always come into play during composition. Often the first view of a subject that catches your eye is not the best, and this usually becomes obvious with study. There are, of course, occasional scenes where the first composition seen *was* the best. More than once I have wandered around a subject, finally putting my tripod down at the exact starting point.

If in doubt, move in closer. Cropping out extraneous elements will always improve an image. Composition is an amorphous thing, hard to define and difficult to quantify. Because of these aspects, it is also very personal and subjective. Self-criticism is difficult, but must be practised. The final arbiter of your work, at the end of the day, must be you.

above | **Ricketts Glen**

It is hard to make a successful print with this type of composition, but a large tonal difference helps. In this case, the black branches stand out from the highlights of the waterfall, and the scene has an oriental feel to it. The long exposure added to this atmosphere, accentuating the still branches, and the telephoto isolated the important design elements.

Toyo 4 x 5in field view camera + Wollensak 400mm lens, Ilford FP4 Plus, 4 sec at f/45; development normal −1

left and below left

Alkali Stain

Changing angles can make a huge difference when composing a photograph, and a certain amount of patience will often be rewarded. Coming around a bend during a hike up Day Canyon, Utah, my wife and I found this peculiar white stain. The small stream was high in alkali, and as it had receded, this pattern was left as evidence of the higher water. The photographic possibilities were immediately obvious, and as we had come to it from the downstream angle, this was the first composition I focused on. The stream was picking up a glow from the sunlit canyon wall, and this light worked well with the bulging stain. The arrangement of shapes is nicely balanced, and I was pleased with this photo.

I shouldered my pack, and we headed up-canyon. After walking a little distance, I glanced back, and stopped in my tracks. From above, there was clearly a second, very strong photo of the stain. As my wife heaved a long-suffering sigh, I focused my camera on this second view. This angle was looking downstream, and a wideangle lens gave it a strong 'falling away' feel. As I was shooting away from the bright wall, the water didn't pick up any reflections, and became quite dark. The shape of the stream is accented by the light edging, and the composition is balanced by the large white stain.

Though I still like the first photo from this magical spot, the second is much more powerful, and has been one of my more popular images.

ALKALI STAIN 1: Tachihara 4 x 5in + Caltar 150mm lens, Ilford FP4 Plus, 1 sec at f/64; development normal −2

ALKALI STAIN 2: Tachihara 4 x 5in + Super Angulon 90mm lens, Ilford FP4 Plus, 4 sec at f/64; development normal −1

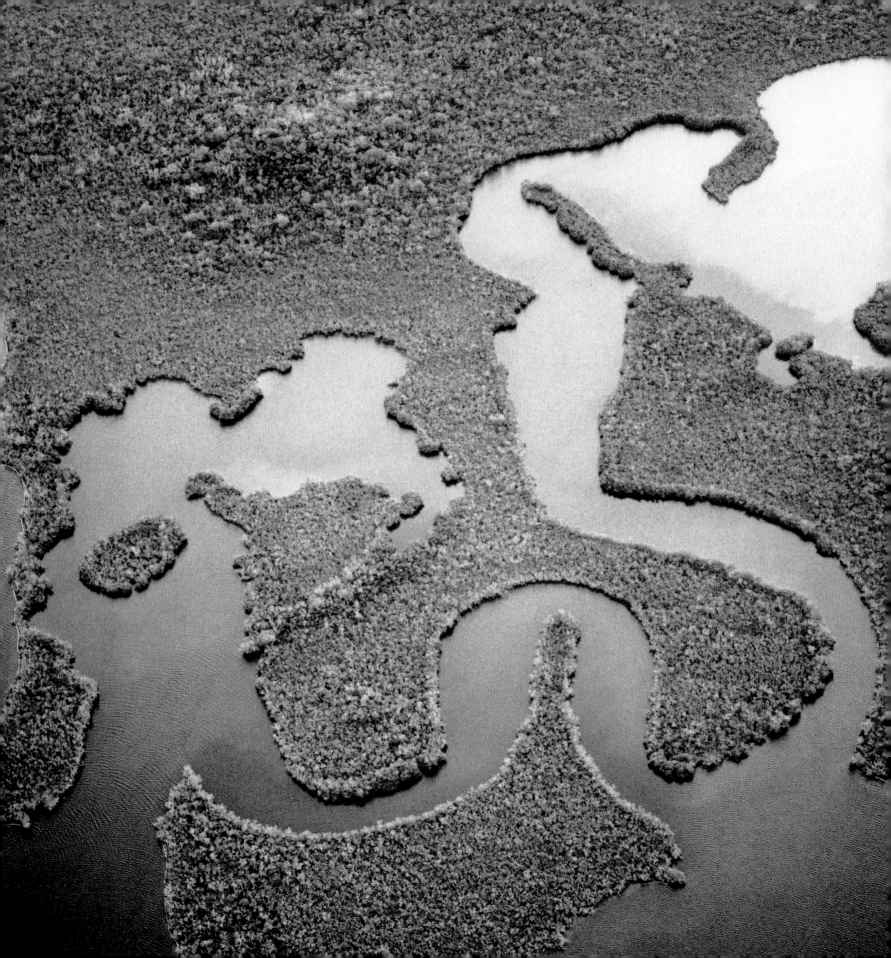

Chapter 4

Printing

Equipment for Printing

BLACK & WHITE PRINTING IS AN EXTREMELY REWARDING PROCESS. THE TECHNIQUES NEEDED TO GET THE BEST FROM YOUR NEGATIVES ARE NOT COMPLICATED, BUT THEY DO REQUIRE CARE AND PATIENCE.

page 118

Hell's Bay

This aerial shot was taken during one of my first Everglades flights. This odd mangrove island caught my fancy, and I had the pilot make several circles around it. The negatives were, for some reason, oddly underexposed, and required some serious machinations in the darkroom.

Pentax 67+ 90mm lens, Ilford HP5 Plus, 1/1000 sec at f/2.8; development normal +1

ENLARGERS

The enlarger is the primary piece of equipment for a darkroom; they come in all shapes and sizes, and can be simple or sophisticated. All consist of five basic components: a flat **BASE**, both for support and as a place to set the easel (the device which holds the photo paper flat and frames the image); a **COLUMN**, to set the height of the head (which determines print size); the **HEAD**, which contains the light source; a **NEGATIVE CARRIER** to suit the size of film being enlarged; and an **ENLARGING LENS**, whose focal length is determined by the film format.

Enlargers are similar in principle to cameras, one difference being that they don't have a shutter – the duration of the exposure is controlled by a separate timer instead. The lens does have an adjustable aperture. The negative is placed in the carrier, which is inserted into a slot between the light source and the lens.

The enlarger has two basic mechanical controls. The main one adjusts the height of the head on the column, which determines the size of the enlargement. The second, smaller control is the focus knob; after the height has been determined, this will sharpen the focus of the image on the easel. There is usually a pair of small, geared rails running beneath the head assembly, controlled by a small side knob, with a lightproof bellows enclosing the space between the head and the lens.

ENLARGER LENSES

Enlarger lenses are simple affairs, and their focal lengths are commensurate with normal-length camera lenses. For 35mm negatives, the enlarging lens will be a 50mm, with a typical aperture range from f/2.8 to f/16 or f/22. A medium-format lens will be around 75–90mm, and a 4 x 5in negative will require a 150mm lens. The mid-range apertures work best for enlarging: they allow for a reasonable exposure time, and are sharp enough to carry the flat-plane focus required. If a negative requires extensive dodging, a smaller aperture can be used to extend the exposure, giving more time for manipulation. Conversely, if the negative is denser than normal, use a larger aperture.

LIGHT SOURCES

There are three basic light sources available for enlarging, my favourite being a **COLD LIGHT**. This form of fluorescent light offers the best contrast control, tends to be less harsh than other types, and spreads out the tonal range of photographic paper. There are several types of cold light available for most types of enlarger, and it is a simple procedure to remove an existing light source and drop in a cold light.

DIFFUSION HEADS also offer contrast control, although not as much as a cold light. This light source consists of a low-wattage lamp in a

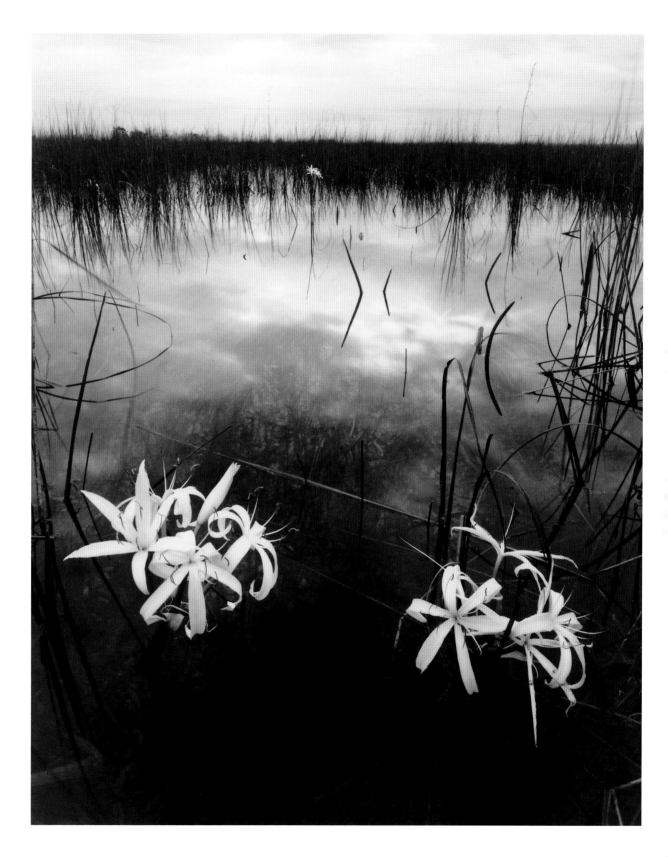

right

Spider Lilies

An example of underexposure

These swamp flowers were far out in the slough, and I had to wade out and set my tripod in the muck, with the camera just above the water's surface. I began to wonder about the hunting habits of the freshwater alligator, and in my nervousness ended up with two very underexposed negatives.

Five minutes in straight selenium (see page 162) improved the density. The hard-contrast exposure was short, due to the thin shadow densities: 1 sec at f/11 on the minimum setting. The second, soft-contrast exposure was 4 sec at f/11, on maximum. This sequence helped control the contrast of this underexposed, overdeveloped negative. A 15-second straight developer bath was followed by 3 min in developer diluted 1 + 8. The cloud reflections needed 6 sec of flash-dodging during the second exposure. Careful flash-burning, on the soft setting, brought the bottom third of the photo down, while holding separation in the shadow tones. The bottom area needs some subtle flash-burning, followed by a brief burn-down of the sky. Since I took detailed notes of all this, subsequent print sessions with this negative have been relatively painless.

CHAPTER FOUR Printing

121

bulbous head, and relies on the light being diffused before it reaches the negative. These enlargers are somewhat out of fashion, but used ones are common, and offer a reasonable alternative to cold light.

CONDENSER HEADS, which contain a series of lenses below the enlarger bulb, tend to make for a contrasty print, with a small tonal range from shadow to highlight. This is a standard light source for many enlargers, but it is a poor substitute for the other, softer sources. There are times, however, where this effect can work; for example, some types of street photography need a certain harshness to exaggerate their feeling of immediacy.

For drawing the maximum tonality from any given paper, the cold light cannot be beaten, and it has the added benefit of smoothing over most negative blemishes. Condenser enlargers, in addition to compressing tonal scales, tend to exaggerate any flaws the negative might have.

My first enlarger was military surplus equipment, and came with directions for dismantlement if enemy capture was imminent. After cleaning it and replacing the condensers with a cold light, I had a very usable and inexpensive enlarger which served me for many years. The reproduction prints for my first book were made on this enlarger, using variable-contrast filters below the lens. (Enlarger filtration is explained on page 129.)

A decent 35mm enlarger can be set up for a very modest amount of money. There is no reason to buy new equipment, especially as you will probably be pulling out the light source and replacing it. My photography was done on a shoestring budget for many years, with no discernible loss of pleasure.

Cold lights

These are two variable-contrast cold lights, both made by Zone VI Studios. Both are designed to drop into existing enlargers, and both come with a split-contrast control unit with high and low contrast settings.

'There is no reason to buy new equipment, especially as you will probably be pulling out the light source and replacing it.'

ANCILLARY EQUIPMENT

Printing can be achieved with a fairly modest amount of equipment, of which the enlarger is the most important piece. Also needed is an adjustable **EASEL**, preferably one that will go up to 11 x 14in. This will allow you to print any size, from a tiny 3 x 5 up to 10 x 13in, and the blades can be adjusted for any size, however odd, in between. This is an important feature, as the standard paper sizes (5 x 7, 8 x 10, 11 x 14in) aren't always going to work, and some images need to have customized dimensions.

The easel holds the paper flat, and gives the print a white border – both very important functions. While 11 x 14in is my standard paper size, the size of the enlargement itself varies wildly, depending on a visceral reaction to the image. Some need to be larger, while others will only work when small.

Another advantage of an adjustable easel is that during printing, at least a 1in (25mm) border should be left around the image area, and fixed easels often don't leave this space. The border will make handling the photo in the chemistry much easier, and will aid in future presentation of unmounted prints. As when mounting a photograph, I like to leave a slightly larger space at the bottom of the image than at the top and sides; this looks more balanced, and makes for a more elegant presentation when showing unmounted prints.

An **ENLARGER TIMER** will be necessary, and it needs to be compatible with the light source. Cold lights need a dedicated timer, one that is set to allow the bulb a warm-up time before the exposure begins. Without this feature, a certain amount of flickering makes exposure times unreliable. Diffusion and condenser lights will work with any timer, and there are a plethora available. As with most photographic equipment,

used timers will generally be adequate. **SPLIT-CONTRAST COLD LIGHT**, which is my favourite light source, will need a split-contrast timer, with low- and high-contrast dials. As a rule, when you buy a split-contrast head, it will come with a compatible timer. The best one made, in my opinion, is the Zone VI. This is available as a complete enlarger, or the light head and timer can be bought separately and inserted into another enlarger.

A **GRAIN FOCUSER** makes accurate focusing very much easier. Once the negative has been focused by eye, the focuser allows you to see an enlarged image of the actual grain of the negative. By adjusting the focus knob while you watch through the eyepiece of the focuser, it will be obvious when the grain is sharply focused.

Six **TRAYS** will be needed, in whatever size you will be printing. Trays come in standard sizes, from 5 x 7, 8 x 10, 11 x 14, 16 x 20, up to 20 x 24in. They also come in different materials and gauges, but a simple set of plastic ones will last many years. Plastic or stainless-steel **PRINT TONGS** reduce the risk of skin irritation and cross-contamination of solutions from tray to tray, though not everyone likes to use them.

While handling undeveloped or unfixed film, complete darkness is a must, but during printing, a **SAFELIGHT** can be used. This consists of a bulb of moderate brightness covered by a red filter, which will allow you to see without fogging the paper. Safelights run a wide gamut of size and cost, but the cheap ones work just as well as the expensive models. I have two: a brighter one mounted on the ceiling, and a milder one located above the enlarger.

A **PRINT-VIEWING LIGHT** is important. Mine is a 25-watt shaded bulb hanging over the final water bath. A brighter light will give a false impression, making shadow detail seem stronger, and

washing out highlights. The cord on mine is looped around a hook in the ceiling, making the height adjustable.

For chemistry, some simple equipment will be needed. Gallon or 5-litre water **JUGS** may be used to hold the developer and fixer, and a permanent marker should delineate which chemical each jug is used for. Once a given chemical has been stored in a container, it should never be used for a different one, or cross-contamination will occur. Three **MEASURING VIALS** will be needed, and these should also be marked. One will be for developer, one for stop and fix, and one for the final step of hypo-clear. I use a pair of plastic open-topped gallon water jugs for the actual dissolving of the developer and fixer powders. These also are marked, to avoid cross-contamination between the developer and fixer.

These components are finished off by the inclusion of several **STIRRING RODS** – plastic handles with a loop at one end – to speed and ease the monotonous chore of mixing chemistry. The chemical powders must be slowly poured into the water with constant agitation, at whatever temperature is recommended by the manufacturer. A sturdy and simple **THERMOMETER** will allow you to set these temperatures, and I recommend a purpose-made photographic thermometer that is encased in metal. Unprotected glass thermometers have a tendency to break under the rugged usage demanded by darkroom work.

During the various stages of paper processing, a second and simpler **TIMER** will be needed. Set next to the sink, this will be used to time the different steps involved in developing the paper. I have used the same Gralab timer for 30 years, and it continues to be a reliable piece of equipment. Choose one with a large face, which is easy to read under the safelight.

Grain focuser

This tool works best at a middle aperture, either f/8 or f/11. A larger aperture makes the mirror too bright, while a small aperture will render it too dark to focus.

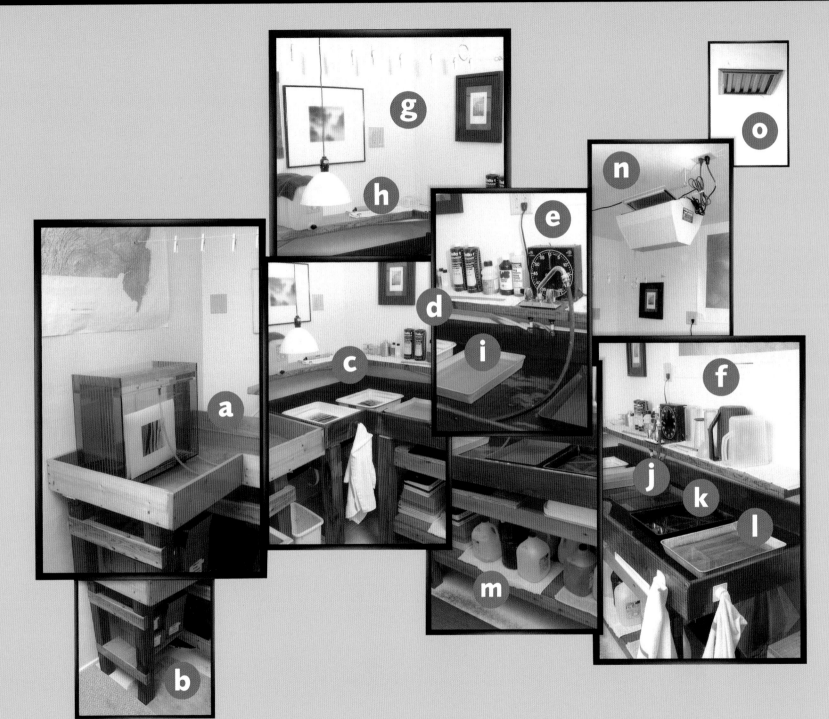

The first sink **(a)** serves mainly to hold the print washer, but also to accommodate trays for making larger prints, 16 x 20in and up. Underneath the first sink is storage for powdered chemicals **(b)**. The timer above this sink (not visible in the photo) is for film development, and is set here so it won't fog the film as it is tray-developed in the next sink.

A container next to this timer (not shown) holds distilled water for film development. The darker sink **(c)** is my main work area, and is 20 years old. After 17 years I had to recoat it with polyurethane varnish, but it has withstood much harsh use. On the shelf above it sits a developing tank **(d)** for 35mm and 120 film, followed by film chemistry: wetting agent, HC-110, stop bath, hypo-clear, and selenium toner. The timer **(e)** is for print development, and is covered during film processing. To the right, various graduates and jugs are used for mixing chemistry **(f)**. Over the sinks, a nylon string has plastic clothespins (pegs) for hanging prints **(g)**, and a print-viewing light **(h)** is set over the final water bath. The far-left tray is the final water bath, the next two are fixer **(i)**, followed by stop bath **(j)**, a dilute developer **(k)**, and on the far right, a tray of straight developer **(l)**. Mixed fixer and print developer are stored under this sink **(m)**, as are the various-sized trays that are not in use. The main safelight is mounted on the ceiling **(n)**, and the exhaust fan **(o)** is vented through the attic.

To the right of the sink, a long work table allows me to pile up whatever things I am using in a session, including boxes of paper. The Zone VI enlarger **(p)** is on the far end of this table, and the auxiliary safelight is mounted on the wall. The small box is the variable-contrast control, and the grain focuser is sitting on the adjustable easel. The print timer **(q)** is mounted on

the wall next to the enlarger, and, as I prefer to print sitting down, I have built a low counter to hold the enlarger. Across from the enlarger, the tall shelving **(r)** is for print storage. Next to these shelves is the print-drying rack **(s)**. I have an affection for good maps **(t)**, and the ones on the darkroom walls are of places I often shoot, and places I hope to visit.

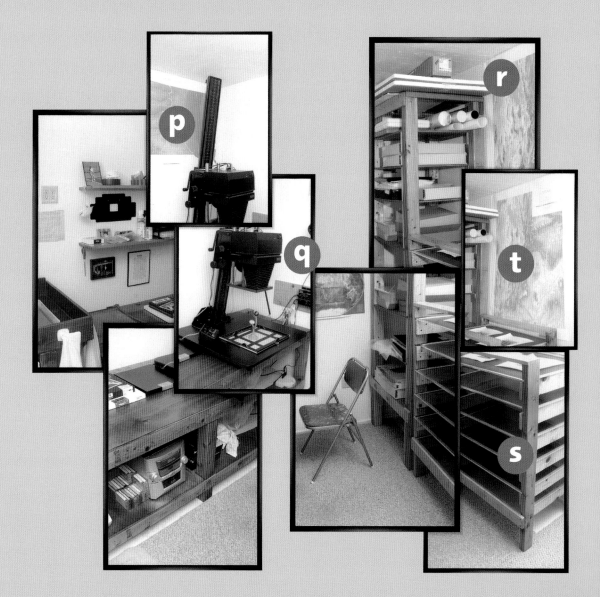

A Darkroom on a Budget

VIRTUALLY ANY ROOM WITH RUNNING WATER CAN BE TRANSFORMED INTO A DARKROOM, AND MOST OF THE EQUIPMENT NEEDED CAN BE BUILT FOR A REASONABLE AMOUNT OF MONEY, FROM ORDINARY MATERIALS.

A workable darkroom can be located almost anywhere, and any room will work at night. I have had darkrooms in bathrooms, kitchens and washrooms. The latter may be the best option, as these rooms tend to be windowless, and have water hook-ups readily available. Bathrooms are usually easy to darken, and a custom wooden sink can fit right over a bathtub. In a cheap rented apartment my wife and I shared at the beginning of our marriage, the kitchen was the only place that would work as a darkroom. After cleaning the dishes, I would put my wooden sink over the kitchen sink, and print until midnight. Though this wasn't an optimal set-up, it did allow me to keep working.

Especially for film, a darkroom needs to be entirely lightproof. There are a number of ways to do this, ranging from simply painting windows black (an effective, but rather permanent method) to using duct tape to affix heavy black plastic over the windows. Another method is to wrap heavy black cloth around foam, stapling it to a slightly smaller board. Cut to size, this device can be firmly fitted into a window, and will effectively block light. Light can be insidious, but patience and a roll of heavy-duty tape will secure any room.

Most of the chemistry involved is relatively benign, but darkrooms need to be well ventilated. This can be done by using a vent installed in the door, in conjunction with an exhaust fan. I have always run the exhaust into the attic, although it can also be vented outside. Mail-order photographic suppliers carry these products, which are lightproof and easy to fit.

Making a sink is cheap and easy, requiring only plywood, screws, wood putty and varnish. I use marine plywood, sealed with polyurethane varnish. After cutting the bottom to size, screw the sides on. My current sinks have 5in (125mm) sides – tall enough to catch splashes, but still comfortable to lean on. After sealing the angles with wood putty and sanding down the plywood, many layers of polyurethane should be laid on the sink's interior. My main sink had 30 layers (one a day for a month), and didn't need any touch-up work for 15 years. This type of sink can easily be put in and taken out.

Counters and stands are also easy to make, especially as their appearance is of minor importance. My carpentry is rough at best, but the counters and sinks I built are still standing.

Ingenuity is the thing when setting up a darkroom. Though my current one is a dream, I have had some in nightmarish locations, but despite this I was always able to keep printing. Printing should be an enjoyable process, as it is the culmination of the photographic journey, and offers the final control over the end product. Darkroom work is very methodical and contemplative, and impossible to rush. When a good print is pulled from the final fix and the light comes on, it is a sublime moment.

right

Yucca

An example of subtle burning and dodging

Hiking around the edge of a small Colorado Springs park, I noticed a cactus growing on the edge of a small pond. As it was early spring, the cattails in the pond were shedding their seeds, leaving a clump in the spines of the yucca. This scene immediately caught my eye, and the metaphoric possibilities were limitless.

After composing and metering, I exposed two negatives. With an extreme cut in development, they were good. The highlight range in the fluff is delicate, and requires some subtle dodging and burning. As always, this flash-dodging and burning work is carefully noted in a diagram. The first, hard-contrast exposure is 2 sec at f/11, at the minimum setting. The soft exposure is 10 sec at f/11, with the dial at the maximum setting. The first, straight print developer bath is 30 sec, followed by 3 min in a 1 + 6 dilution.

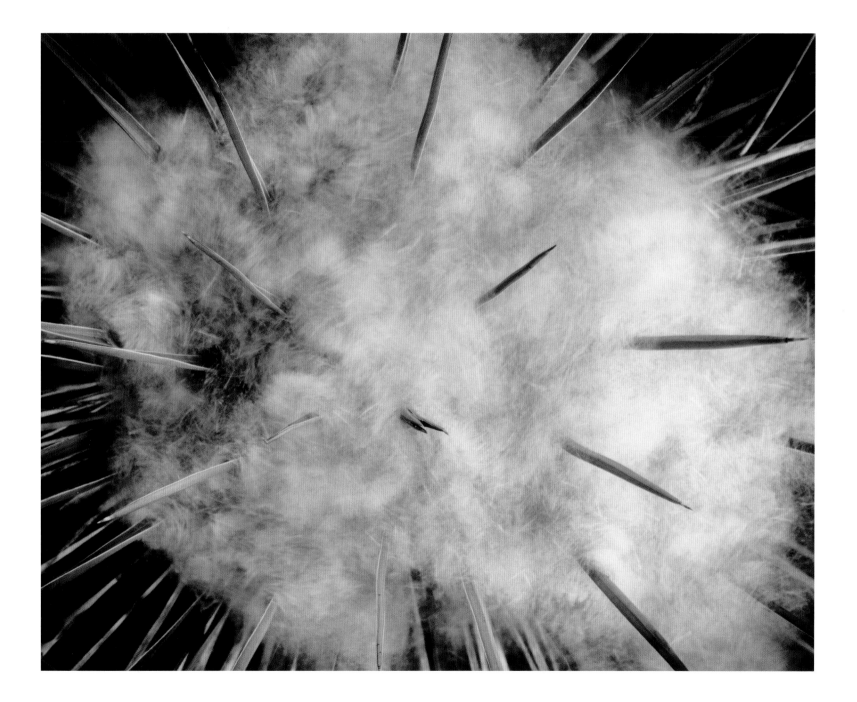

Papers & Chemicals

THERE ARE MANY BLACK & WHITE MATERIALS CURRENTLY AVAILABLE, AND CHOOSING THE BEST IS A VERY PERSONAL DECISION. FINDING WHAT WORKS FOR YOUR PHOTOGRAPHY SIMPLY TAKES EXPERIMENTATION.

In this section I will introduce the materials that work best for me, and offer ideas for combinations to suit other styles of photography. There are several types of silver gelatin paper available, including variable-contrast fibre-based, graded fibre-based, and variable-contrast resin-coated. Several surfaces are also available, ranging from smooth gloss to textured canvas.

SILVER GELATIN PAPER

Silver gelatin paper is coated with a layer of light-sensitive silver halide, and has a useful depth of tone. This means that, because of the thick layer of silver, it gives an illusion of depth to the image. These papers offer a long tonal range, ranging from deep, lustrous shadows across the spectrum to dazzling highlights. They come in several surfaces and colours, and which variety you choose will depend on the desired end result. Double-weight paper should always be used; single-weight is too delicate, and will invariably become wrinkled during the process.

For general use, a neutral **GLOSSY** surface works well, particularly for landscape work. The paper colour can be slightly modified through toning (see page 162); selenium toning will add a subtle warmth, while a brown toner shifts neutral paper to extreme warmth. The smooth surface of these papers increases the illusion of depth, and this is my favourite finish.

WARMTONE PAPER can greatly enhance certain kinds of subject matter, particularly portraits, where it gives a rich lustre to skin tones. It is popular among many photographers for a range of subjects, and can even enhance some types of landscape work, particularly foggy and diffuse shots. The degree of warmth varies from paper to paper, and can range from a subtle warm tone to an exaggerated brown coloration.

There are several **MATT** surfaces available, but this type of paper has a limited use. This finish tends to limit the tonal depth and range, as it absorbs light rather than reflecting it. For some types of extreme manipulation (see page 130), such as the mixing of multiple negatives in one exposure, this surface will help disguise the blended edges where the various images overlap. This type of paper can also have a textured, canvas surface, and is popular for some types of portrait photography. The extreme flatness of these papers detracts from the ultimate richness that is the hallmark of a beautiful and finished black & white photograph.

For several years, my printing mainstay has been Zone VI's Brilliant VC, a smooth-surfaced, silver-rich and adaptable paper that reacts well to mild selenium toning, shifting slightly to the warm side. Ilford Multigrade is also a good paper, and there is always a box of this on my shelf, for those negatives that don't react well with the Brilliant.

Brilliant paper
Brilliant VC, made by Zone VI Studios, is my favourite paper for most purposes.

128

Another nice facet of the Ilford paper is the highlight range, which, unlike most papers, has very little **DRY-DOWN** – that is, the highlight tones seen in the final water bath are very similar to what will appear in the final dried print. This is an attractive feature, especially for images with highlights that are difficult to print. Most photographic papers will dry down, which means that the highlights will darken from what they look like in the final bath, and in some papers the tones will drop dramatically. After gaining experience with a particular paper, this dry-down factor becomes easy to estimate.

Either of these papers will produce a rich and lustrous photograph, and both offer a decent tonal range to work with. Variable-contrast techniques will be discussed later in this chapter.

While these two papers have some similarities, they react quite differently to different developers. All negatives have a certain paper they will work best with, and having a stock of these two will ensure coverage of most needs. The various zonal separations are somewhat different from one paper to another, and this will play a part in determining which will work with any given negative. The Brilliant has better tonal separations in the shadows, and this will help with a negative that has large and important lower-zone areas. Ilford Multigrade has more definitive highlight separations, and this feature, combined with this paper's lack of dry-down, will facilitate the printing of images with large, important highlights.

All of my photos are done on air-dried, glossy-surfaced fibre-based paper; air-drying reduces the sheen of the final print, and gives a beautiful depth to the image, increasing luminosity. For some photos, however, a different surface may work best. For portraiture, in particular, a matt surface on a warm paper may give the most attractive results.

'Most photographic papers will dry down, which means that the highlights will darken from what they look like in the final bath'

GRADED VERSUS VARIABLE-CONTRAST PAPERS

For many years, the printing standard was graded silver gelatin paper. Each type of paper was available in a range of different contrast grades, from hard to soft, and you controlled the contrast of your print by choosing the appropriate grade of paper. This product has gradually been disappearing, however, and seems destined for extinction. This is not a great loss, as modern variable-contrast papers offer the same quality with much more control. The fixed contrast of graded papers can be difficult to work with, requiring more manipulation than variable-contrast papers generally need. The occasions that require graded paper are few and far between, and I no longer keep it in stock.

Variable-contrast paper has an emulsion that reacts differentially to different colours of light, so the contrast of the image can be adjusted by exposing it through different-coloured filters. The more basic enlargers have either a filter holder below the lens, which accepts gelatin filters in plastic mounts, or a filter drawer above the lens, in which squares of gelatin are placed. The filters can be obtained from the same manufacturers as the variable-contrast paper. Grades usually run from 0 (the softest contrast) to 5 (the hardest), in half-grade steps. More sophisticated enlargers have built-in filtration, the required combination being selected by means of a dial or an electronic control unit. Filtration units designed for colour printing may be used successfully for black & white, following the paper manufacturer's recommendations.

My printing notes assume the use of a cold light with electronic controls for hard and soft contrast settings. If using gelatin filters instead, remember that the higher the number, the harder the contrast; typically, no. 2 or no. 3 is considered 'normal' contrast.

Although I normally avoid radical printing techniques, sometimes these methods can create interesting images. There is a definite art to combining different negatives into the same photograph, and the standard method is to use a series of enlargers, each set up with a different negative. By running the paper through the different enlarger stands, and with adroit burning and dodging, some very interesting effects can be created. The wonderful and whimsical photographer Jerry Uelsmann uses this technique to make his mystical images, and he is the undisputed master of multiple-negative printing. In his prints, the areas where the different negatives meet are so expertly blended as to be invisible.

Most people can't afford several enlargers, but the same method can be applied – albeit less conveniently – with a single enlarger. I have made a few multiple-negative prints, and by carefully changing the negatives in the carrier, and with a lot of experimentation, some have actually worked. This demands some serious dodging and burning, as well as a ridiculous amount of patience. With practice, however, this technique offers a fun alternative to single-negative printing.

facing page

Eagle Falls

Accompanying my wife on one of her business trips to Lake Tahoe, California, I wandered around looking for photo opportunities. Finding this waterfall overlooking the lake, I decided to return and shoot it before sunrise. After development, the negative held some promise, but fell short of my expectations. After some thought, I decided to take a total eclipse from another negative, and insert it above the lake.

The sky in the Lake Tahoe negative printed quite light, and I dodged it all the way to white during the first exposure, exposing only the lower nine-tenths of the image. Leaving the paper in the easel, I replaced the first negative with the eclipse. The sun was luckily in the upper part of the negative, and so I simply needed to blend the line where the two negatives intersected by placing it at the base of the distant mountains and blending the intersection with some artful dodging. Many tries later, one of the prints came out of the fixer with a good blend where the negatives met, giving the illusion of a total eclipse over Lake Tahoe.

This is one of my few attempts at multiple-negative printing, and it was done more for the sheer fun of experimentation than for any other reason.

Toyo 4 x 5in field view camera + Nikkor 210mm lens, Ilford FP4 Plus
Main negative: 8 sec at f/45; development normal −2
Eclipse negative: 1 sec at f/22; development normal (pre-exposed, with a short second exposure for the actual eclipse)

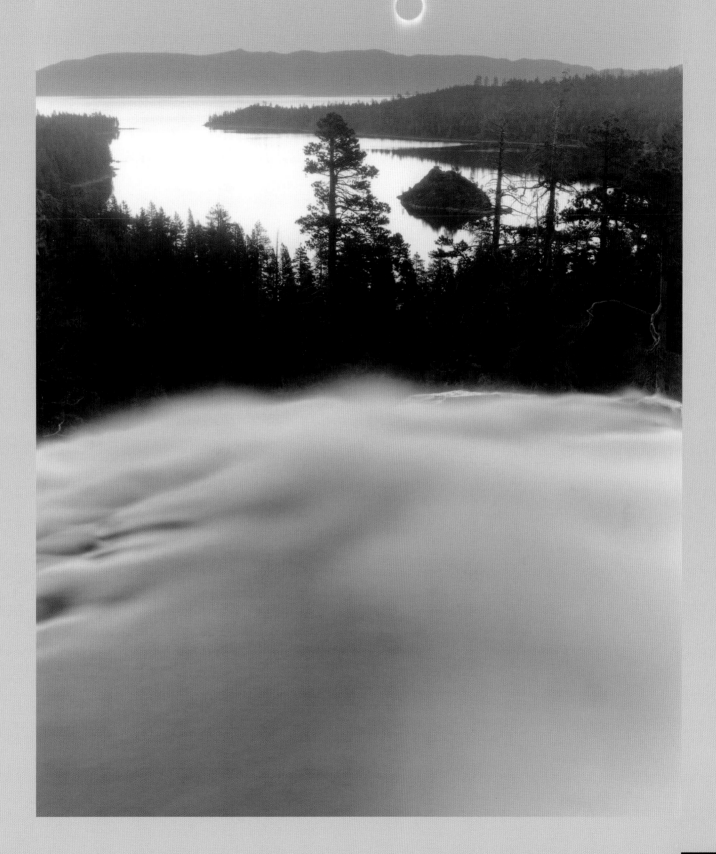

above | **Jan**

Wes

Examples of soft and hard lighting styles

These are printed on Agfa Multicontrast Fine-Grained Matte, a creamy, slightly warm paper, perfect for portraits. After printing, these were run through a solution of Kodak Brown Toner, mixed 1 + 15 (one part toner to 15 parts water), for ten minutes. This caused the paper colour to shift to the warm side, enhancing the natural warmth of this paper.

Jan (*above left*) was made in a studio, using light from a large, north-facing window. The room was white, causing the soft light to bounce everywhere, giving a quiet balance to

the illumination. It was shot on Polaroid P/N film (see page 48), which has a superfine grain and gives exceedingly smooth tonal separation.

Wes (*above right*) makes use of the opposite end of the light spectrum, as it was shot in the noonday sun, with no diffusion or reflection applied. It is a terrible thing to say, but this is something of a fashion shot, not my favourite style of photography. Though this is a somewhat facile photograph, it is a good example of harsh lighting.

FIBRE-BASED VERSUS RESIN-COATED PAPERS

The final choice is between fibre-based (FB) and resin-coated (RC) paper. RC papers are also variable-contrast, but give a compressed tonal scale. While these papers have some uses, mostly for contact printing (see page 135), they are no match for the quality of FB papers. The plastic coating on their surface gives an unattractive finish. I consider the extra cost of FB paper (the difference is not that great) to be a necessary burden, considering the huge quality gap between the two types. RC paper requires less time in the fixer and wash, and this may be useful when large numbers of prints are needed. Some people make their initial work prints on RC, and, after deciding which images have merit, continue wih FB paper for the final prints.

PAPER DEVELOPER CHOICE

The brand of developer used will depend on the desired results. My standard for both baths is Zone VI print developer, but I keep several other brands handy, for those times when the VI doesn't work with a particular negative. The Brilliant paper reacts well with the Zone VI developer, giving a long, smooth tonal range and a beautiful, slightly warm colour. Ilford Multigrade developer works well with my method, particularly with the Ilford paper. Ethol LPD is a reliable back-up, and gives a slightly harsher tonal range; Kodak Dektol is, in my experience, one of the harshest paper developers available.

Different developer/paper combinations will give varying results, affecting both the print colour (which can be an important factor in the look of the final photo) and the tonal range. Only experimentation will help you to decide which combinations will work for you.

below

Pothole

An example of a low-key print

This was taken on a dismal and rainy afternoon, and the first prints I made failed to convey this feeling. Returning to the darkroom, I printed it down, making it darker and more sombre. Even the small highlights are muted, as brighter ones ruined the dark mood I wanted to achieve with this image.

Mood is very important in printing, and not all photos will work with a full tonal range. Sometimes an image will need to be high-key, with a strong emphasis on the upper zones, and occasionally, a photo will need to be brought down, with an emphasis on the lower-register tones. This decision will often be difficult, but a negative will eventually reveal how it needs to be printed.

Preparing to Print

THE SPLIT-CONTRAST METHOD OF PRINTING WHICH I RECOMMEND IS NOT
COMPLICATED, BUT FOR BEST RESULTS THERE ARE A FEW PREPARATORY
STAGES WHICH SHOULD BE CARRIED OUT FIRST.

Ordinary variable-contrast printing uses just one contrast filter for one main exposure. By averaging the contrast requirements of any given negative, a reasonable print can be managed. Usually a middle-grade filter will be used.

Through the use of judicious dodging during the exposure, and post-exposure burning, a good print may be coaxed from most negatives. Burning may be done using a softer filter than

> 'Through the use of judicious dodging during the exposure, and post-exposure burning, a good print may be coaxed from most negatives.'

was used for the primary exposure, to avoid the density lines that tend to build up around the edges of a burned area. (Burning and dodging are explored in depth later in this chapter.)

By making a series of test strips for the shadow and highlight areas, the best filter contrast can be determined. The aim is to achieve the fullest tonal range possible, holding detail in both important shadow and highlight areas. This can best be figured by running test strips over all applicable areas within the image.

The standard chemistry is a tray of developer, usually diluted one part developer to three parts water, followed by a one-minute dip in stop bath, and then three minutes in a fixer bath.

This is the basic method; but, to draw the most out of any negative/paper combination, the split-contrast method described on the following pages is far more effective.

CLEANING THE NEGATIVE

Once the negative has been inserted into the carrier, it needs to be cleaned just prior to enlargement. The best way to do this is with a delicate application of canned air, preferably the type designed for cleaning computer components. The can must be held upright and steady while the air is being released; it is a terrible thing to have a dollop of freon plop onto a negative, an experience I had in college. A static-free photo brush can also be used, but I have found canned air to work best most of the time. Whenever negatives are handled, lint-free gloves should be worn, as the oil from fingers will permanently etch into the film base.

TEST STRIPS

A test strip is a narrow strip of photo paper, exposed and processed just like a full print. By making a series of these instead of full prints, a lot of paper can be saved. I always make several test strips before exposing a full sheet of paper. Cutting a sheet into ten strips, I experiment with different exposure combinations over various parts of the image, gradually narrowing in on a

final series of exposures. This helps me visualize how the tones, from shadow to highlight, will look in the final print, and which paper will work best for any given negative.

CONTACT SHEETS

Contact printing is the process of making unenlarged proof prints, the same size as the negative. The negatives are laid on the paper with a piece of glass over them, and then exposed under the enlarger. The resulting study sheet helps to decide which ones will print best. It will save time, trouble and paper, and is a relatively easy part of the process.

Most commercial contact printers consist of a double-thickness piece of glass hinged to a backing, with a thin layer of foam to hold the film against the glass. The negatives should be left in their sleeves (clear negative preservers should always be used, both for archival reasons and for ease of contact printing), and placed on a sheet of photo paper under the glass. Resin-coated paper is fine for this, as the prints are only for reference. Make a test strip, gradually increasing the exposure by slowly moving a sheet of card across the top of the glass. This is done using the enlarger as a light source, with no negative in the carrier, flashing white light onto the paper, usually at a middle aperture. I use increments of five seconds to get an approximate exposure. Having figured the exposure, slide a full sheet of paper under the negatives, and expose and process it in the usual way.

These proofs can be very handy, showing what information is available in the negative, as well as giving a rough idea of the tonal range and contrast you will be dealing with during enlargement. For portraiture, these sheets will display facial expressions, easing the negative selection process.

below

Frozen Seep Pool

Below are examples of two different kinds of test strips. Strip **a** was made with a no. 3 contrast filter, in increments of 2 sec. The right-hand section received 2 sec at f/11, the next 4 sec, and so on, the last having 8 sec. This shows the best exposure to be around 6 sec.

The other two test strips show a split-contrast series (see page 136), again in 2-sec increments. Strip **b** was done with the soft-contrast setting on minimum contrast, strip **c** with the high-contrast setting on maximum. This suggests a hard-contrast exposure of around 2 sec and a soft exposure around 6 sec, to control the shadow details and hold down the bright highlights.

The final print (*bottom*) was made using the split-contrast method, with a hard-contrast exposure of 2 sec at f/11, and a soft exposure of 7 sec at f/11. This was followed by a 30-second dip in straight developer, and then two minutes in a 1 + 8 dilution.

Split-Contrast Printing

MY PREFERRED PRINTING TECHNIQUE INVOLVES LAYERING EXPOSURES, GRADUALLY BUILDING THE PRINT'S TONAL RANGE UNTIL A FINAL, RICH BALANCE IS ACHIEVED.

Light is slowly layered onto the print through a series of exposures, gradually setting the tonal range, stretching it out to draw the most from any given paper. This technique includes the subtraction of light as well, as dodging – reducing the exposure over a selected area – can make a huge difference to the final print. This gradual tonal layering allows an outstanding level of control, much more than any other style of printing. The control inherent in split-contrast printing is amazing, and this technique will produce a good print from almost any negative.

Split-contrast printing can be applied with almost any enlarger set-up, whether you are using variable-contrast filters below the lens, in a tray above the lens, or a variable-contrast control box. The latter equipment is my current favourite, and the Zone VI VC enlarger works well for this style of printing. This enlarger has a control box with high and low dials, each offering several levels of contrast.

Each negative's printing requirements should be recorded in a notebook; this will save untold time and trouble in future reprinting. After finally understanding a negative – and it can take a huge amount of time and effort, often years – this information is invaluable. I have eight notebooks full of scribbles, diagrams, sketches and hieroglyphics. The main information will be this: the enlarger height and lens, the aperture setting, the paper and developer used (including developer dilution, and the time taken in both straight and diluted solutions), the time and contrast used for both hard and soft base exposures, and diagrams showing what areas have been burned and dodged. I use two types of dodging: flash-dodging, where a small tool is waved over a large area for a certain portion of the exposure, and large-area dodging, where light is subtracted from an area using a large round dodging tool. All these details must be recorded, and examples of how to do this are shown on pages 150–9.

Large-area dodging must be carefully done, because when it is done poorly, it is evident that manipulation was used. I also list any burning done post-exposure, the areas burned, and the times and contrast used. Again, I use two techniques: flash-burning, where a small hole in cardboard is rapidly moved over a bigger area, and large burning, where a large hole in a piece of card is held over an area, adding more light. This technique must also be practised with care, as it quickly becomes evident. Burning and dodging are covered in detail on pages 142–159.

right

Flash Flood

An example of extremely dense highlights

During my tenure as a river ranger in Canyonlands National Park, Utah, a fierce rainstorm sent water rushing down the canyons, creating dozens of ephemeral waterfalls. The sky was overcast, offering an anaemic and flat light, until the sun broke free of the clouds, illuminating this lovely alcove. Taking a shadow reading from the right wall, I exposed two sheets. Despite a large cut in development time, the highlight was extremely dense. I made a long, narrow cut in a piece of card, and used this as a burning tool. After many tries, and with a constant wiggling movement during the extended soft-contrast burning time, I was finally able to bring this highlight down.

The hard exposure is only 1 sec at f/11, with the contrast set at minimum; this gives a base to the shadows, without letting them block up. The soft exposure is 6 sec at f/11, and helps to control the high contrast of this scene. The sunbeam needs an additional 10 seconds of burn, using the same settings as the base soft exposure. This print is fairly contrasty, but this helps emphasize the dramatic feel. In a highlight this large, however, some detail must be retained.

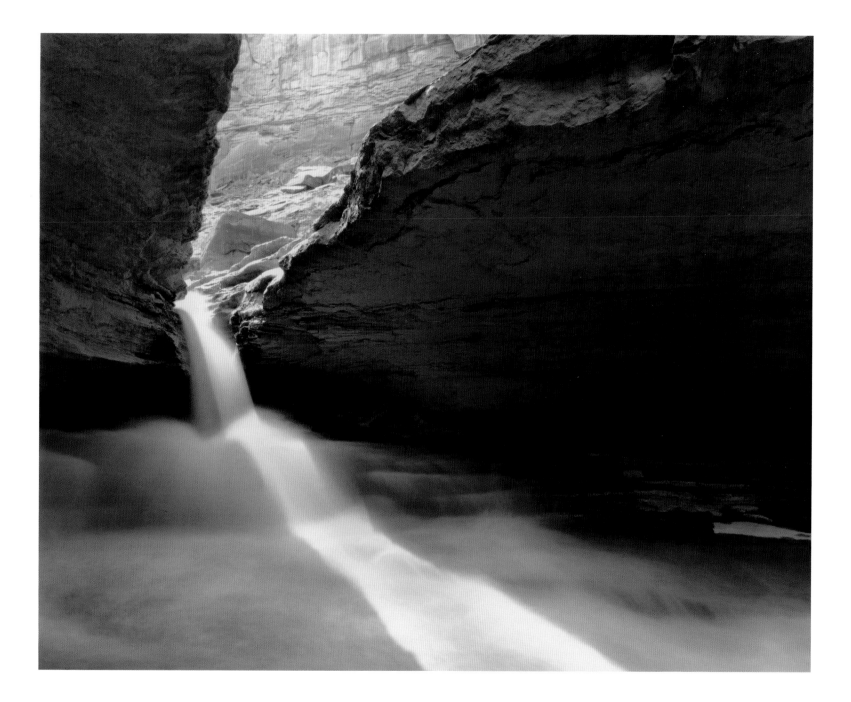

above | Ice

An example of inadequate negative contrast

After a series of freezes and thaws, unusual for canyon country, I found this strange ice pattern in Moonflower Canyon, Utah. After composing the photo, I took some quick meter readings – too quick, as it turned out – and exposed two sheets of film. The resultant negatives were a mess, having been both underexposed and underdeveloped.

I made a test print at my standard contrast and time, with a short hard-contrast exposure followed by a longer soft exposure. The print was totally greyed out, almost enough to make me drop the image. Reversing my normal procedure, I made a soft-contrast exposure of only 0.3 sec at f/11, on the minimum contrast setting, which laid an almost invisible image on the paper, and followed this with a long hard-contrast exposure of 12 sec at f/11 on the maximum contrast setting, which filled in the tones. This was followed by a four-minute immersion in straight Zone VI developer, the dilute mix being skipped altogether. This huge alteration in my usual exposure series saved the scene, adding a big boost in contrast, and bringing up the small specular highlights in the ice.

EXPOSING THE PRINT

The first exposure will be the **HARD-CONTRAST** one, and this will lay the foundation upon which the tonal range will be built. It will give the shadows a strong depth, and is almost always of short duration, usually from one to three seconds. I generally use the middle aperture range on the enlarger lens, either f/8 or f/11, as a standard. These apertures will give a sharp enlargement at reasonable exposure times, long enough for any required dodging to be performed. This exposure will put down a dark ghosting, allowing the following lighter layers to expand upon it. This can be done either with a hard-contrast filter, or with the hard setting on a variable-contrast control box.

The next exposure will be **SOFT CONTRAST**, and will usually be longer, generally averaging 8 to 15 seconds. If you are using a contrast control box, the range within each dial can be helpful, and should be exploited, although I have found these controls to be less important than the length of exposure – varying the base times gives much more control than altering contrast settings. When using contrast filters, duration of exposure will be the only real control available, and is of the utmost importance. This exposure will be done with one of the soft filters, if a control box is not being used.

This soft time will fill in the middle and high tones, finishing the basic exposure series. You are building on the hard exposure by filling in the upper tonalities, and this will draw the maximum range from any given paper.

This also works well with **VARIABLE-CONTRAST FILTERS**. The Ilford Multigrade filters perform well with this technique, and I used these for decades before switching to a variable-contrast control box. The base exposure will be laid down with one of the high-contrast filters,

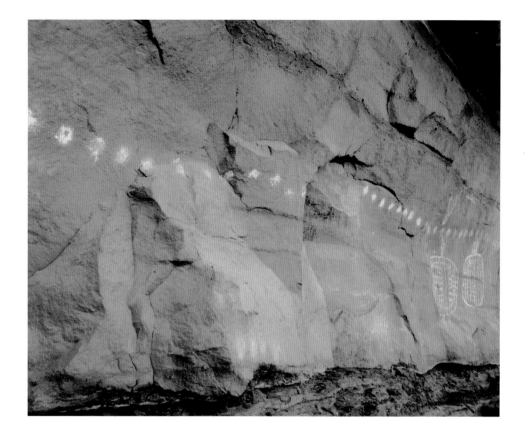

above

Pictographs

An example of midtone separation

The middle-grey scale is often ignored, but can be very important. A luminous middle scale will enhance the upper and lower tones. This prehistoric rock art at Salt Creek, Utah is in a deep alcove, shaded by a large overhang. The tonal range was limited, and I metered the small upper-right shadow for zone III, and placed the white dots on zone VII. The majority of this scene, however, is grey, with little tonal difference. When I began printing this negative, the central tones were lacklustre, giving the entire photo a flat and boring feel. During the second session I began working on these greys, trying to give them more separation. Being careful not to lose the shadow detail, I boosted the contrast in the greys: a slight increase in the high-contrast exposure, with a corresponding decrease in the soft one, gave the greys a rich range, increasing the separation between these tones.

I used a hard-contrast exposure of 5 sec at f/11 on the maximum setting, and a soft exposure of 4 sec at f/11 on the minimum setting. The paper was then run through straight Zone VI developer for one minute, followed by two minutes at 1 + 8 dilution.

usually in the 3 to 5 range. This will, as with the previous method, generally be of short duration. The second, soft exposure will be in the 0 to 2 range, filling in the rest of the tones, and will be a much longer exposure. The duration of the two exposures is of the utmost importance, and slight time changes will make large contrast and tonal alterations.

By employing the hard and soft filtration rather than one middle filter, the control over contrast is greatly heightened, and this is why the split-contrast method is superior to the traditional technique. Subtle tone shifts can make a huge difference in the final print, especially in the shadow and highlight areas.

REVIEWING YOUR RESULTS

As a rule, a negative with normal contrast will have a short hard-contrast and a longer soft-contrast exposure, while a flat-contrast negative will have a longer hard and shorter soft exposure. A negative that is totally flat, completely lacking in contrast, may need only a hard exposure. Conversely, one that has extremely harsh contrast may need only a soft exposure; in my experience, however, this is rare. Figuring out this exposure balance is the key to split-contrast printing. Though it is time-consuming, with experience it becomes relatively easy to calculate. Test strips are key for this calculation, and will save time and paper. This methodology will also work with RC paper, and will pull the maximum from this paper's limited tonal range. The system will be exactly the same, with the two base exposures, and two developer baths.

With all my negatives through the years, there has never been an instance where a final print was managed from the first darkroom session. It has occasionally happened during the second try, but more often it will take at least three attempts before I am happy with the photo. Some particularly stubborn images have cost innumerable pieces of paper and multiple sessions over a period of several years before I finally managed to understand their printing requirements.

right | **Signal Mountain**

During a bitter January trip to Wyoming, driving through Grand Teton National Park, I noticed this row of small pine trees. The combination of a prevalent north wind and the weight of a heavy snow had bowed them over, and they resembled a line of marching skeletons. Snow scenes can be difficult to figure out, as the contrast is often tricky, and this one took several printing sessions before I was satisfied.

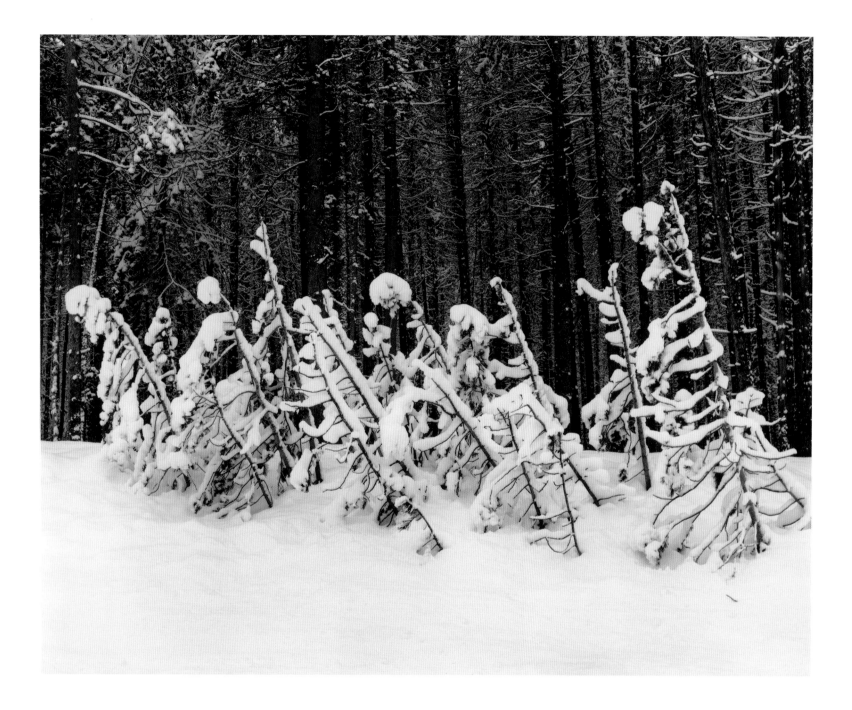

The Art of Dodging & Burning

BURNING AND DODGING CAN OFFER THE FINAL, FINISHING TOUCHES
TO A GOOD PHOTOGRAPH. THE GOLDEN RULE FOR BOTH TECHNIQUES
IS THAT NO MODIFICATION SHOULD BE NOTICEABLE IN THE FINAL PRINT.

DODGING

Dodging is the technique employed to selectively lighten certain areas within a print by withholding light during enlargement, and it must be performed in the course of the two base exposures. I keep a simple set of tools at hand, all consisting of various-sized cardboard circles taped to lengths of wire. The cardboard is cut from light but stiff stock, such as a manilla folder.

In addition to this standard set, I also occasionally need to make custom dodging tools for problem negatives. These run the gamut from a simple circle to a complicated shape, cut to match a difficult tonal area within the negative. These are harder to use, requiring a delicate and active touch. Custom shapes must be cut smaller than the actual size of the area being dodged, to allow for a constant movement during the exposure. This 'wiggle' will soften the edges of the dodged area and disguise the fact that dodging has been used.

The majority of the dodging will be done during the soft-contrast exposure, for two reasons. Firstly, the longer duration of the soft exposure allows more freedom for manipulation, and secondly, the soft contrast makes it easier to hide these alterations. Subtracting time from the hard exposure is more problematic, and usually leaves an obvious density halo. When this

Dodging & burning tools
Pictured left is a set of standard dodging tools (the small circles mounted on wire) and burning tools (the various-sized holes cut in boards). With subtle application and constant movement, these indispensable and easily made darkroom aids will greatly improve print quality. The smaller circle and hole are generally used for flash-dodging and burning, while the larger tools will be employed during large-area dodging and burning.

The Racetrack

An example of dodging

In the high desert surrounding Death Valley National Park, California, there is a large playa (dry lake bed) where small rocks move in mysterious fashion. The Racetrack is a wonder, and I was excited to find and photograph it. After locating the travellers, I wandered among them until a composition caught my eye. It was late afternoon, however, and the scene clearly needed morning light. Leaving my tripod up as a location marker on the huge, featureless playa, I trudged back to the camper and made dinner.

The next morning, shortly before sunrise, this track was reflecting the ambient eastern light. Metering the base of the rock for zone III, I exposed two negatives. Development was tricky, and I decided on normal. The first, hard exposure was 2 sec at f/8, at the minimum setting. The second, soft exposure was 6 sec at f/8, also at the minimum setting. Print development was normal: 30 seconds in straight developer, followed by two minutes in a 1 + 6 dilution.

After considering the photo from this first session, I reprinted, using a small cardboard circle to dodge the lower part of the track during the second exposure. This brought the tone up slightly, and accentuated the trail behind this mysterious rock. The delicate flash-dodging was then duly noted on the print diagram, as was the basic printing information above.

becomes necessary (and sometimes it will be), it must be done for only a fraction of the hard exposure, and must be applied with a quick and delicate touch.

The key to good dodging technique is to keep the tool in constant movement. By wiggling and moving the tool, and by never dodging longer than half the exposure, the resulting work should never be obvious. As a rule, only small areas should be dodged. This is a valuable technique, and slight alterations can make a huge difference.

As previously mentioned, there are two types of dodging. **FLASH-DODGING** is the primary technique, and consists of actively moving a small circle over a larger area for a certain fraction of the base exposure. A gradual lightening will occur in that part of the print, leaving no clue that the area was altered. This is all part of the overall layering process referred to above, except that it is a negative application, removing light instead of building the exposure. This is an important step, and can add an amazing amount of detail to shadows. The time during which this technique is applied will vary from negative to negative, but will rarely exceed half the soft-contrast exposure. More often, it will be far less than this.

LARGE-AREA DODGING is the subtraction of light from a more substantial part of the image, usually by using a larger cardboard shape. This has to be applied in short bursts, otherwise it is difficult to disguise. It will usually be done with a custom tool, cut to match the relevant section of the image. The tool should be smaller than the actual size of the area being dodged, as it needs to be held at least 5in (12cm) above the paper, and must also allow for wiggle within the area. Even during this kind of dodging, a steady movement needs to be used, to blend and overlap the edges between the dodged and undodged areas.

BURNING

Burning is an equally important technique, and is always the last layering before the paper goes into the chemistry. As with dodging, I have a set of standard burning tools, all pieces of cardboard with holes of varying size. Burning adds density to selected areas, and is generally used to bring highlights down. As with the previous method, I often make custom burning tools, depending on the particular negative's requirements.

Burning will almost always be done with a soft-contrast filter or setting, as it quickly becomes obvious when laid down with hard contrast, leaving heavy density lines. The softer setting or filter will allow a gradual burn-down. This also requires a constant movement, and the print density must be slowly built up. The circle of the

'As with dodging, I have a set of standard burning tools, all pieces of cardboard with holes of varying size.'

burning tool can never be held stationary, as this produces a glaringly obvious area of alteration. The cardboard must constantly roam over the area being altered, and density edges must blend smoothly. The cardboard must be held at least 6in (15cm) above the surface of the paper, as the edges will become heavy and obvious if the tool is too close to the paper.

There are also two styles of burning, **FLASH-BURNING** being the best. By using a small hole, and gradually building up density up an area, tonal alterations can succeed with no evidence of the manipulation. Constant movement over the area being burned is the key, and this must be done with soft contrast. In essence, you are 'flashing' light over an area until the density comes down to the desired tone. As with dodging, custom tools are needed occasionally, as the standard ones won't always work.

The second technique is **LARGE-AREA BURNING**, and involves using a larger hole in the cardboard, thus adding a great amount of light quickly. The tool must be moved steadily, to avoid telltale dark lines around the manipulated area. This type of burning must also be applied with soft contrast, and it is hard to hide.

The large techniques of dodging and burning should only be used as a last resort, to rescue tonal areas that are impossible to alter any other way. The flash techniques are far more reliable, and will be your standard.

A subtle and useful modification when burning is to use different contrast settings. If your base soft exposure, for example, was at a mild soft contrast (as with a no. 2 filter), then the burning can be done at a different level. To make a subtle difference, you could burn in the highlight with a no. 0 filter. This adds another aspect to the layering, and gives one more level of control, allowing the burning to be gradual and indistinct. When I was using filters, the majority of my burning was done with the no. 0 or no. 1 filter. These differences are subtle, but can be very useful.

These two techniques of dodging and burning are invaluable, and some degree of both is usually required. In fact, every negative I have ever printed has needed dodging and/or burning to some degree. These offer the finishing touches to your darkroom time, and can be the difference between an average photo and one that glows.

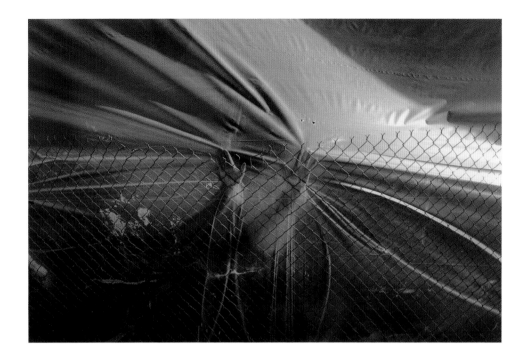

above | **Hands**

An example of burning

This was a grab shot, taken with an Olympus OM-1 with a 28mm lens. My college summers were spent working on construction sites in Houston, Texas, and I would occasionally bring this camera to work. Early one morning, I noticed one of my fellow workers holding up a plastic sheet, waiting for someone to nail the edges up. Running to get the Olympus, I had time for two quick exposures before his hands were gone. This was made with a quick in-camera meter reading, and was probably later given normal development.

The highlight on the plastic is dense, and needs serious burning. The first, hard exposure is short, 1 sec at f/8, with a minimum setting on the contrast dial. The second, soft exposure is 10 sec at f/8, at the maximum setting. Print development is normal, 30 seconds in straight, followed by two minutes in a 1 + 6 dilution. The lower half of the highlight was flash-burned for 8 sec at f/8, at the soft-contrast setting, and this is listed in my printing notes.

These are subtle aspects of the print layering process, and must be done with a delicate touch. In these illustrations, I have purposely overdone both burning and dodging, as examples of how overuse will appear in a print.

right and far right

Deer Creek

VERSION 1:

This is an aerial view of ridges and fog in northern Utah, and the foreground shadow was printing too dark. Even though the detail was still there, it was not strong enough, and was affecting the composition, drawing away from the repeating pattern of ridges. Making a long, narrow dodging tool and attaching it to a straightened paperclip, I dodged the shadow, attempting to lighten it. In this case, I over-dodged, causing this odd ghosting in the circled area. This is the classic telltale for bad dodging, and is mute evidence that the tool was held stationary over the paper for too long.

VERSION 2:

In this print, the dodging tool was moved constantly during the soft-contrast exposure, and the shadow density has been only slightly lightened, without leaving any evidence. The detail has been accentuated without leaving any sign of manipulation, and this step has definitely improved the image.

VERSION 1

VERSION 2

CHAPTER FOUR Printing

Elk Creek Falls

Split-contrast printing is a layering process, where light is gradually added to (or, in the case of dodging, subtracted from) the photo paper, and the last step is always burning. The light in this scene was harsh, and the contrast range – even with a large cut in the negative development time – was long. The brightest highlight was the foam swirling in front of the split foreground rock, and this print needed extensive burning to hold detail here. Choosing one of my standard burning tools (a rectangle of cardboard with a small hole cut in the centre), I held it over the foam, using a soft-contrast setting.

When burning or dodging, the tools must be held at least 6in (15cm) above the paper. If they are closer, an obvious density line will begin to appear around the edges of the area which is being adjusted. Constant motion is also required, to conceal the manipulation.

VERSION 1:
In this print, the piece of cardboard was too close to the paper, was held too stationary, and the burn time was too long. These three factors have given the foam an unattractive greyness, and also built a dark density line around the circled highlight.

VERSION 2:
In this print, the burning tool was held slightly higher, and was rapidly moved over the highlight, using an extreme soft-contrast setting on the enlarger (equivalent to a no. 0 filter). This type of highlight, where there was subject movement during a long exposure, can be difficult to print. Making several test strips, I gradually decided where I wanted the tone to be, and added that much time to the burn. The foam is light, but is set at zone VII, with just perceptible detail. There are slight tonal shifts in this version, and if it is burned down past this point, it begins to display an ugly greyness. The upper highlights in this print have also been burned down, using similar times and technique.

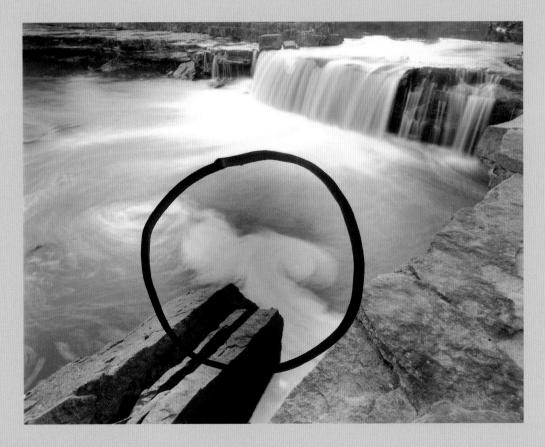

VERSION 1

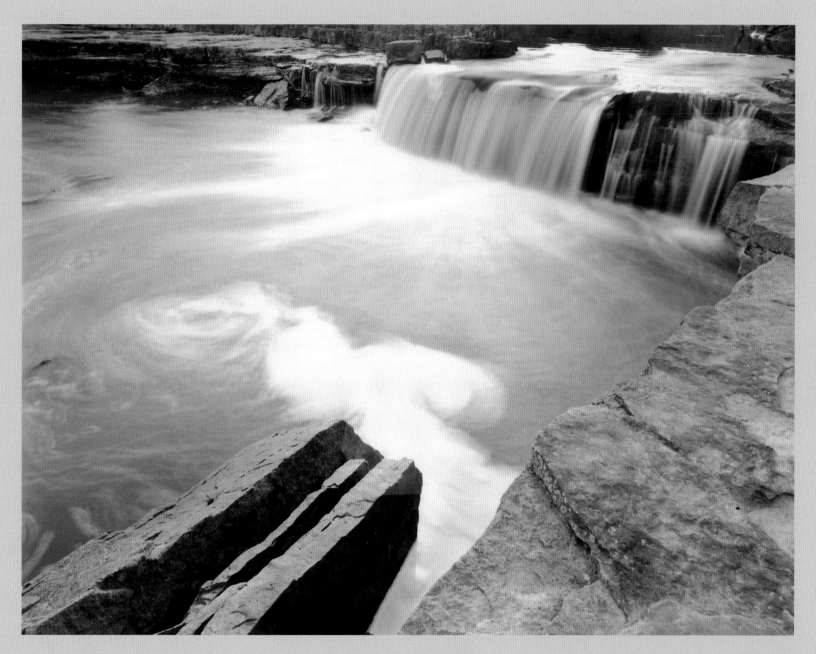

VERSION 2

PRINT EVOLUTIONS 1:

Ice Star

An example of an extreme printing problem

NEGATIVE
4 x 5in

ENLARGER HEIGHT
21in (533mm)

PAPER
Zone VI Brilliant VC, 11 x 14in

TOP SECTION
1st exposure: 1 sec at f/11,
minimum hard contrast
2nd exposure: 5 sec at f/11,
maximum soft contrast

BOTTOM SECTION
1st exposure: 4 sec at f/11,
maximum hard contrast
2nd exposure: 1 sec at f/11,
maximum soft contrast

DEVELOPER
20 sec – Zone VI undiluted
2 min – Zone VI diluted 1+6

During an unusually harsh southern Utah winter, my wife and I hiked down one of our favourite canyons. Courthouse Wash cuts a serpentine course through Arches National Park, and is the place where I began to develop my personal photographic style and vision.

Midway down the canyon, we found this amazing ice formation. The stream had thawed and refrozen, and the resulting collapse had formed an ice bridge across the creek. The contrast range was long and difficult to understand, and was complicated by the ice being in deep shade with the back wall in direct sun. After composing the photo, I exposed two sheets of film, giving them a two-zone cut in development.

While the negative looked OK, the first sessions were hopeless, as I couldn't figure out how to print it. None of these first attempts were even hinting at my feelings when I found this composition, and they were hopelessly boring. After several dismal

failures, the negatives went into the bottom of a dusty drawer, and I forgot about them for years.

While editing photos for a recent book, these negatives reappeared, and I decided to try again. This is an incredibly hard photo to print, but the second attempt yielded better results. I realized that there were essentially two parts to the image, and each needed separate attention. Oddly enough, the sandstone wall has to be somewhat dull, and required a low-contrast exposure series. The lower two-thirds, however, needed some 'pop', and to have fairly contrasty highlights. Blending edges between such radically different exposures is tricky, and it took several more sessions before I pulled a final print. The water around the ice also posed a problem, as it was too bright, and was detracting from the composition.

This is a severe printing problem, one of the worst I have encountered. The gradual comprehension concerning this negative was

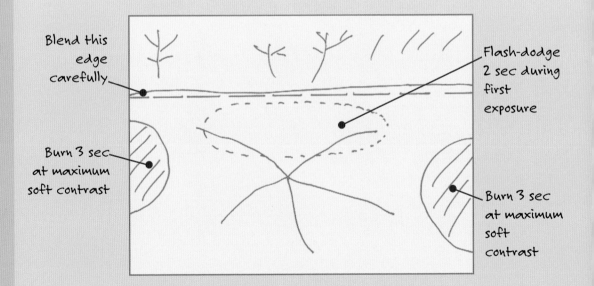

very frustrating, and is thankfully a rare happenstance. This problematic photo required an inordinate amount of thought and darkroom work.

VERSION 1 is a straight print of this negative. The bottom section is too dark, and the ice has no spark. The upper part is too harsh, and draws attention away from the ice star, which should be the compositional centre.

VERSION 2 is a final print, demonstrating the effects of the exposure layering and the several manipulations that are involved in making it. The diagram shows that there are essentially two separate exposures, with the upper wall receiving a strong soft-contrast exposure and the ice getting a much harder contrast. The various burning and dodging is also listed, with techniques, contrast settings and times marked down. The developer dilution and times are listed, as is the enlarger height (which will set the print size). The type of paper used is also recorded in these notes. All of this information needs to be noted, in order to re-create a successful print at a later date.

VERSION 1

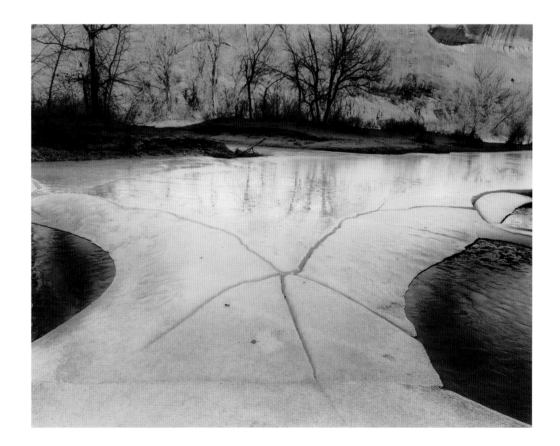

VERSION 2

PRINT EVOLUTIONS 2:

Stalactites

An example of a high-contrast problem

NEGATIVE
4 x 5in (reversed for printing)

ENLARGER HEIGHT
20³⁄4in (527mm)

PAPER
Zone VI Brilliant VC, 11x14in

1ST EXPOSURE
1 sec at f/11, minimum hard contrast

2ND EXPOSURE
6 sec at f/8, maximum soft contrast

DEVELOPER
25 sec – Zone VI undiluted
3 min – Zone VI diluted 1+10

A friend recently discovered a local canyon filled with strange salt formations – just the kind of bizarre subject I love. A canyon wall was coated with salt, part of which had dissolved, leaving a small cave. Taking meter readings and realizing how disparate the shadow and highlight range was, I gave a mental shrug, hoping to correct the problem in printing. These odd formations have been a recent obsession, and this photo is one of my favourites.

Despite a maximum cut in film development, the negative was still unbearably harsh. As I began to play with it in the darkroom, it became obvious that it would need very different hard and soft times to manage the tonal range. Giving up on the first try, I came back to it a week later, and made a dozen test strips, gradually understanding the negative.

VERSION 1 shows the first, hard-contrast exposure laid down on the paper. It is essentially filling in the shadows, and is of brief duration, in order to hold down the contrast. Because this is an extreme contrast problem, the first, hard-contrast exposure is unusually short. This lays down a strong base for the second, much longer, soft exposure.

VERSION 2 shows the soft-contrast exposure, which fills in the middle and highlight tones. This step is especially important when dealing with an extremely contrasty negative, as it will control the shadow/highlight range, allowing a full, smooth contrast range, despite working with a problematic negative.

VERSION 3 demonstrates the combination of exposures in the final print. This photo has a full, rich tonal range, with the cave shadow demonstrating strong detail, a good zone III, while the lighter stalactites are just holding highlight detail, and are on zone VII. The shadow needed a mild flash-dodging, and the amount, time, and contrast used are marked on the diagram. Some flash-burning was necessary to control small highlight areas, and again, the salient facts are put into the diagram. The basic information (height,

Flash-dodge throughout second exposure

Flash-burn 4 sec at maximum soft contrast

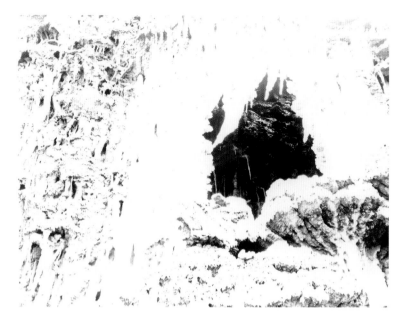

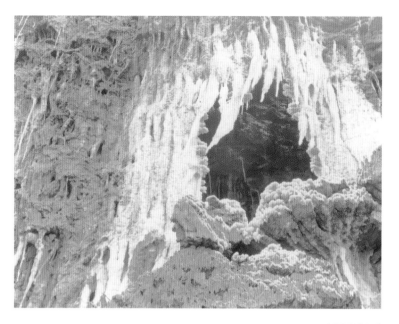

VERSION 1

VERSION 2

paper, developer dilution and times, base exposures) is always listed at the top of the diagram; this will allow you to return to any negative at a later date, reprinting it with as little fuss as possible.

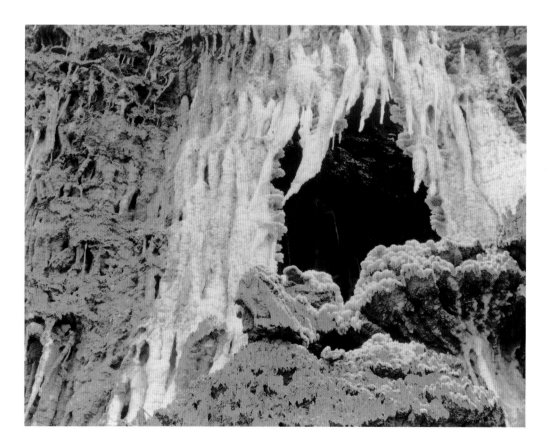

VERSION 3

PRINT EVOLUTIONS 3:

Pacific Dune

An example of an extreme low-contrast problem

NEGATIVE
4 x 5in

ENLARGER HEIGHT
18in (457mm)

PAPER
Zone VI Brilliant VC, 11 x 14in

1ST EXPOSURE
7 sec at f/11, maximum hard contrast

2ND EXPOSURE
1 sec at f/11, minimum soft contrast

DEVELOPER
1 min – Zone VI undiluted
1 min – Zone VI diluted 1+6

Magdalena is an uninhabited barrier island off the west Baja coast of Mexico, and has some of the most photogenic dunes in my experience. The entire island is in constant flux and rich with photographic possibilities.

This is where I met my future wife, as we were both guides for a whale-watching company with a base camp on Magdalena. Between tour groups, she and I would stay on the island, watching the camp and the Zodiac inflatables. These breaks afforded time for exploration and photography, and I made full use of the time.

Perhaps because of the long break between exposure and development, this film holder was mis-marked, and the sheets were underdeveloped. Until I began split-contrast printing, this was an impossible photo, even with a high-grade paper. Using only a high-contrast filter for one exposure (the traditional method), the highlight tonal separations would degrade, making the print contrast harsh and ugly.

Coming back to this negative years later, I gave it an extended hard exposure, and filled this in with a short soft-contrast exposure. This gave it a good range, and held the highlight separations.

The diagram below shows all the basic information, and also demonstrates the areas needing some brief burning.

VERSION 1 shows the initial hard-contrast exposure, and is very close to the final print. The highlights in the ripples, however, are too sharply delineated, giving the photo an undesirable harshness. This negative could almost be printed successfully using a hard-contrast filtration alone, but the delicate highlights require a slight fill-in, and the only way to achieve this is with a brief soft-filtration exposure.

VERSION 2 demonstrates the soft-contrast exposure, which basically provides a light ghosting, designed only to fill in the highlights slightly.

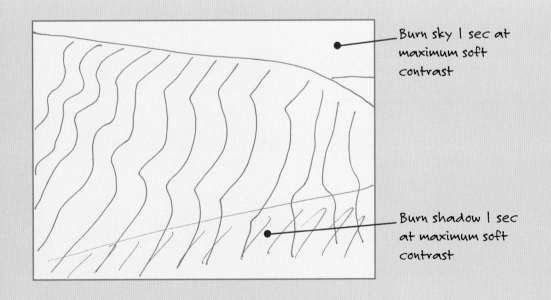

Burn sky 1 sec at maximum soft contrast

Burn shadow 1 sec at maximum soft contrast

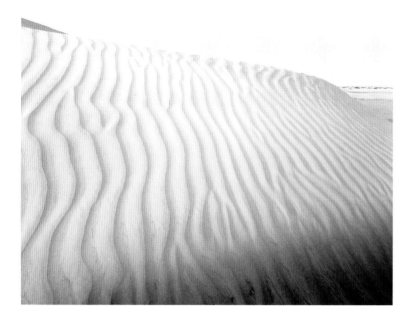

VERSION 1

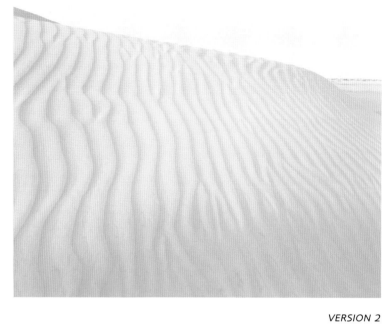

VERSION 2

VERSION 3 is the final image, showing the combination of both exposures, resulting in the subtle highlights this high-key photograph needs.

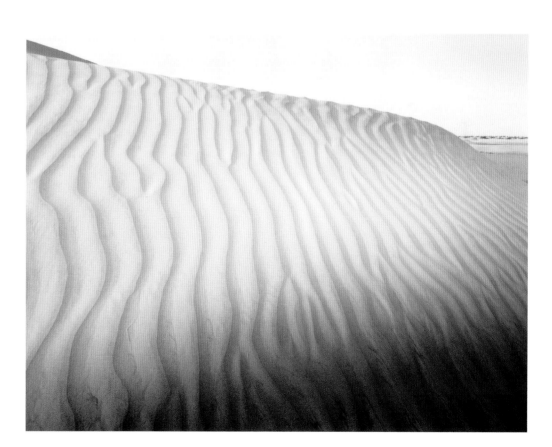

VERSION 3

PRINT EVOLUTIONS 4:

Slickrock Stain

An example of an extreme dodging problem

NEGATIVE
4 x 5in

ENLARGER HEIGHT
22in (558mm)

PAPER
Ilford Multigrade MGF.1,
11 x 14in

1ST EXPOSURE
2 sec at f/11, medium hard contrast

2ND EXPOSURE
5 sec at f/11, minimum soft contrast

DEVELOPER
20 sec – Zone VI undiluted
3 min – Zone VI diluted 1+8

This wall stain was left by aeons of rainfall darkening the surrounding sandstone. The contrast range was large, the tree being in direct sunlight against the shadowed wall. It was difficult to bring the background tones up through film development, as the tree densities would become too thick, and be impossible to print. I was forced to do a two-zone cut, which dropped the stain to zone V (which was too low, but unavoidable), but held the tree highlights down to a reasonable density. As I wanted the stain to stand out, the only alternative was a printing rescue. I recognized this while exposing the negatives, but couldn't figure out a better way to handle the problem.

This was a delicate dodge job, and required a custom tool. By cutting a slightly smaller version of the stain's shape, and by a short,

very active application of dodging, I was able to bring the tones up to the desired level of brightness. The proclivity of Ilford Multigrade to hold highlight detail with little dry-down helped greatly with this problem.

VERSION 1 shows the image before any dodging was done, and demonstrates the effect of cutting the film development time. The tree highlights, considered by themselves, are OK, but as a result of controlling them, the stain is greyed out.

VERSION 2 is the photo after dodging. The stain has become a rich and luminous highlight, which is how I envisioned it when shooting the film. It was difficult to blend the density edges around the stain, and this print required several sessions and a lot of paper before a final photo came out of the fix.

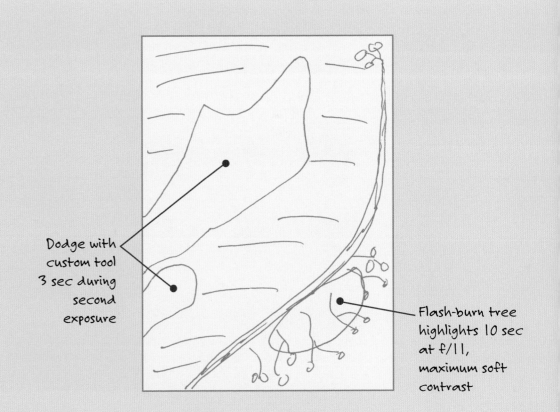

Dodge with custom tool 3 sec during second exposure

Flash-burn tree highlights 10 sec at f/11, maximum soft contrast

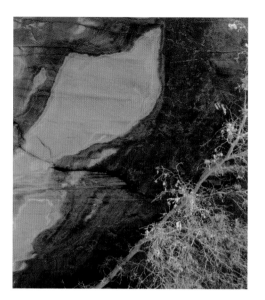

VERSION 1

VERSION 2

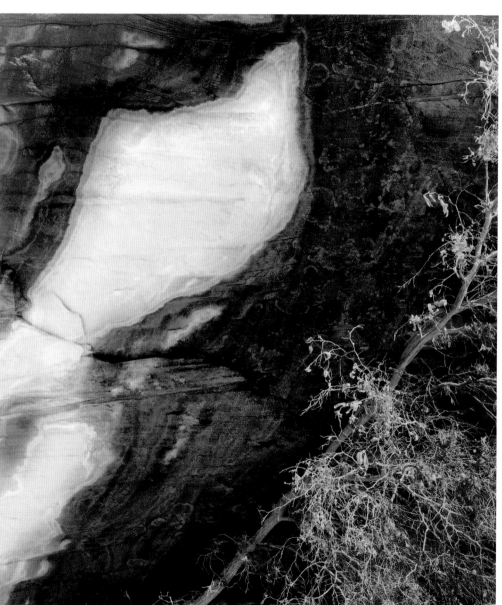

Tidal Pool

An example of an extreme burning problem

NEGATIVE
4 x 5in

ENLARGER HEIGHT
23in (584mm)

PAPER
Zone VI Brilliant VC, 11 x 14in

1ST EXPOSURE
5 sec at f/8, maximum hard contrast

2ND EXPOSURE
1 sec at f/8, minimum soft contrast

DEVELOPER
2 min – Zone VI undiluted

During severe high tide, half of Magdalena Island is under water, with small fingers of ocean reaching into every nook and cranny. During one such tidal rush, I found this classic S-curve composition, accented by a small, dark tidal pool. Due to the ubiquitous and pellucid fog of Magdalena, it was often hard to calculate exposure and development times with any confidence. This negative is very flat, and needs serious burning work to give it adequate contrast.

This is a rare example of using the high-contrast range for burning, but this was the only way to bring the pool down to black. The flash-burning used here had to be delicately done, as the high-contrast filtration would leave horrible edge lines if overused. This is noted in the diagram, and when unusual steps are employed, these notes become very important. After years of printing, it becomes impossible to remember so much information.

The paper was run through straight developer only, in order to boost the contrast further, and this is also carefully noted in the diagram. This was the first photograph I made on Magdalena, and was my introduction to the incredible combination of foggy light and delicate dunes characteristic of the island.

VERSION 1 is the photo before any burning, showing lacklustre contrast.

VERSION 2 is the image after manipulation; the black tide pool has added the missing element, and provides an important balance to the image.

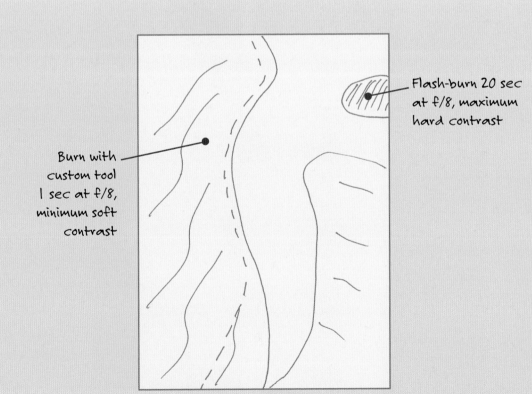

Flash-burn 20 sec at f/8, maximum hard contrast

Burn with custom tool 1 sec at f/8, minimum soft contrast

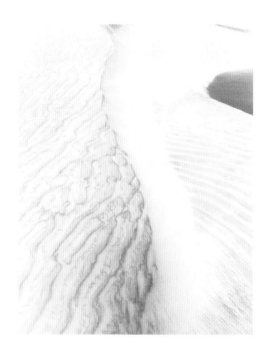

VERSION 1

VERSION 2

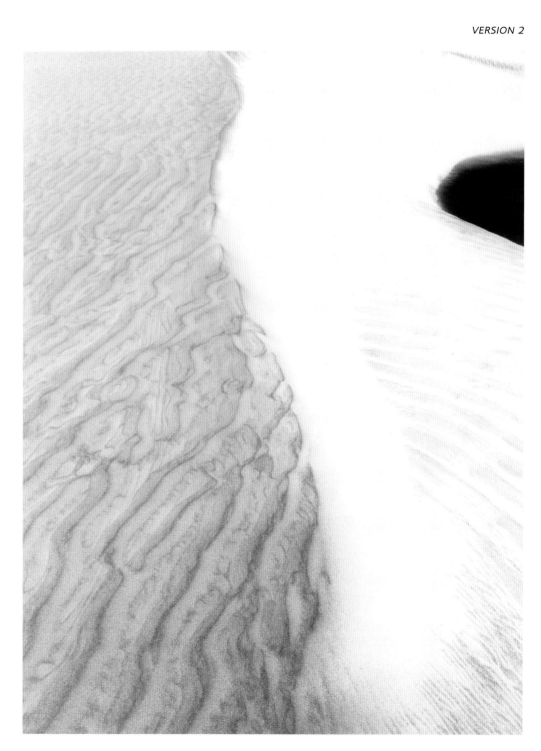

Wet Work

ONCE THE ENLARGER WORK IS FINISHED, YOU STILL HAVE ONLY A LATENT
IMAGE ON YOUR PAPER. DEVELOPMENT AND FIXING ARE NOW NEEDED
TO MAKE THAT IMAGE VISIBLE AND PERMANENT.

DEVELOPING

'The different dilutions offer another contrast control, and will alter the middle and upper tonal scale of the print.'

All chemicals – particularly developers – during paper development should be kept around 21°C (70°F). The first tray contains a straight print-developer solution – that is, the stock solution made up as recommended by the manufacturer. This will almost always be a quick immersion, generally lasting for 30 seconds of steady agitation, or until a ghost image begins to appear. When the contrast needs to be increased, this time can be extended. The contrast difference between a 30-second and a one-minute dip in straight developer is considerable, and this gives you an additional control. After sliding the paper under the solution, tip alternating corners of the tray. This ensures that fresh developer will always be flowing over the paper's surface. This agitation will be used all the way through the process, until the print is in the holding bath. This step will complete the foundation begun with the high-contrast exposure, filling in the shadows and finishing the bottom end of the tonal range.

During the entire series of paper immersions, from the first developer to the final fix, constant agitation is needed. After sliding the paper under the fluid surface, a gentle tipping of the tray will keep fresh solution flowing over the surface of the paper, an important facet of paper development. After carefully pulling the paper out of the tray by one corner, let the excess liquid drain before moving to the next tray.

As the ghost image appears, the paper will be moved to the second tray, which has a dilute developer solution. The dilution will depend on the negative, but will most often be around one part developer to six parts water $(1+6)$. This high dilution is used as a balance to the straight first developer. Harsher negatives will require a higher dilution, up to a $1+10$ mix, and lower-contrast negatives will need less dilution, as low as $1+2$.

The different dilutions offer another contrast control, and while this is more subtle than the straight developer time changes, it will still alter the middle and upper tonal scale of the print. This second immersion will fill in the rest of the tones, completing the layering process. The time for the second bath will vary, but will usually last between two and five minutes. Extending the time beyond five minutes will tend to block up highlights, causing a loss of clarity. Less than two minutes leaves the print partially developed, causing a general muddiness, where the delineation between tones lacks clarity. At the end of a session, the developers will begin to exhaust, and a good indicator of this is when shadows begin to exhibit a washed-out look.

An extremely flat negative will occasionally need to be run through a bath of straight developer, skipping the dilute tray, to bring up the contrast. A very harsh negative, conversely, may need to

skip the straight bath, and be run only through a diluted developer. These are both extreme-case scenarios, particularly the latter one.

STOPPING

After the second developer bath is complete, the paper will be put into a tray of stop bath. The main purpose of this third step is to extend the life of the fixer by neutralizing any developer remaining on the paper. An **INDICATOR STOP** is my choice, since it changes colour as it begins to wear out, which can be a useful guide. There are several different brands available, and any of them will work. This step will last 30 seconds.

FIXING

After stopping, the print is transferred into a fixer bath. This step lasts three minutes, and is followed by a second tray of fixer. This second three-minute bath is the step that begins the archival aspect of processing.

Gelatin silver paper has a high archival rating, which means that it can have a long life with no discernible degradation. It is depressing to finish a photograph, dry and mount it, only to find discoloration occurring six months later. The second fixer bath stabilizes the print, so there should be no staining over time. There is no archival difference between the various brands of silver gelatin paper; the result is determined by processing, toning and wash time.

After the second fix, the print goes into a holding bath, which is simply a tray of water. As your printing session progresses, and as more prints are added, this tray needs to be regularly dumped and replenished with fresh water. There is no need for this step to have a constant flow of fresh water, just a regular replenishment.

below

The Silly Sign

An example of low contrast

This photo was taken during one of my first visits to Arches National Park, Utah, and the whimsical nature of this sign caught my attention, causing me to laugh out loud. The exposure was the same for both photos, with a hard-contrast exposure of 2 sec at f/11, on maximum, and a soft-contrast exposure of 6 sec at f/11, on minimum. The final print (*below right*) was run through a straight developer solution for 30 seconds (at which point a ghost image began to appear on the paper), followed by a 1+6 developer dilution for $2^1/2$ minutes; the other version (*below left*) had the dilute development only, skipping the straight bath. The straight developer dunk has given the right-hand photo a rich shadow base, extending the contrast range, and helping to exaggerate the highlights in the sign. The photo that was run only through a dilute developer has a short and flat contrast range, and lacks the drama displayed in the final image.

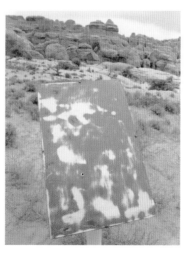

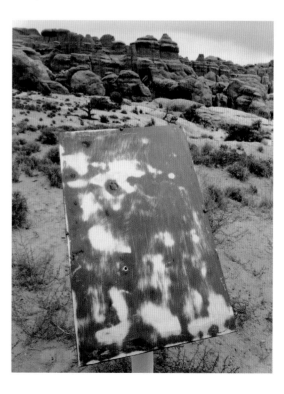

When transferring paper from one tray to the next, hold the print by one corner over the tray, and let most of the chemistry run off before moving to the next tray. The emulsion surface will buckle if treated roughly, and paper should be gently handled, holding it by the corners only.

My average darkroom session lasts around five hours. After this, my eyes tire, and I begin to make mistakes and waste paper. The chemistry will also begin to exhaust, and print quality will suffer. Printing is a slow process, impossible to speed up, and a total of eight to ten decent prints is a good result. Also normal, for me, is to have at least four sheets of paper in the trash, along with dozens of test strips.

SELENIUM TONING

I always tone with selenium before washing my prints, and this does two things. It adds a layer of archival protection, and it also subtly alters the colour of the paper, giving it a gentle warmth. The amount of colour shift will depend on the dilution. The hypo-clear and selenium can be combined: my standard is one part selenium to 30 parts hypo-clear solution, for five minutes. Up to ten prints can be run through this bath at a time, with constant top-to-bottom interleaving combined with steady agitation.

Neat selenium toner can also be used to add density to a seriously underexposed negative (see page 121). Soak for several minutes, with steady agitation, hypo-clear for five minutes, then wash for five minutes. Straight selenium is very strong, and good ventilation is essential.

Various other toners are available, including the brown one used on the lower photo on the opposite page. As a rule, though, colour toners will detract from the desired effect of a rich and luminous black & white print.

WASHING AND DRYING

Whether you selenium-tone your prints or not, hypo-clearing is advisable before moving on to the final washing stage.

For years I tray-washed my prints, by interleaving them in a water bath and constantly changing the water. This needs to last at least 30 minutes, and is a tedious chore. One of my best darkroom purchases was a print washer, something that I should have bought years ago. Though this piece of equipment is somewhat pricey, it will avoid many hours of boredom, and save water. There are several types and brands on the market, and as long as they separate the prints and keep a steady flow of water running over the paper face, any of them will work.

After the prints are washed (I leave them in for two hours, which is overkill, but it salves my paranoia), gently squeegee the excess water off the print surface. This should be done on a chromed platen plate, with the paper first face down, receiving several vigorous swipes, and then a few light face-up swipes. The latter must be performed gently, as the surface of the paper is quite soft until it dries, and scratches easily. There are several brands of squeegees made just for this purpose, with extra-soft rubber blades to save the print surface.

For drying, prints can be hung up with clothes-pins, but each photo needs to have four on it: two holding it to the line, and two on the bottom corners to prevent curling. A print rack is easy to make, and only needs plastic screens in a simple stack unit, made from 1 x 4in (25 x 100mm) battens. Most window shops can make plastic screens to size, at a minimal cost. Allowing the photos to air-dry will enhance the tonal range, while force-drying them with heat will have a negative effect, blocking down the highlights and compressing contrast.

Pictograph

Two examples of different paper/toner combinations

This is an old piece of Comanche rock art at Picture Canyon, Colorado, probably done in the early nineteenth century. After the Spanish introduced the horse to North America, most of the western tribes developed an intricate horse culture, becoming magnificent riders. This is a very stylish line drawing, far more sophisticated than most rock art, and obviously made by someone who loved horses. As my wife also deeply loves her horse, I shot this picture with her in mind.

The top photo was printed on Brilliant VC, and then run through a weak selenium solution for five minutes. The bottom photo was printed on Agfa Multicontrast Fine-Grained Matte, and then run through a strong (1 + 10) brown toner solution for 20 minutes. As a rule, warm toning only looks good to me when used on portraits, but in this case it seems to help the image, adding to the attraction of the stylish rock art.

Final Touches

IF YOU HAVE DILIGENTLY FOLLOWED ALL THE PRECEDING STAGES, YOU SHOULD BY NOW HAVE A PRINT YOU CAN BE PROUD OF – BUT A FEW MORE SIMPLE STEPS WILL ENABLE YOU TO PRESENT IT AT ITS BEST.

SPOTTING

If distilled water was used for the film development, your negatives should be fairly clean. However careful your precautions are, though, some fleck of dust will always manage to mar the print. Small blemishes are easy to retouch or **SPOT**, and good retouching comes with practice. A neutral **SPOT TONE** will work well, and there are several available. I use a 000 paintbrush, which has an extremely fine tip, and a Kodak spotting card, which has lasted me 15 years. By applying a drop of spot tone to the tip of the brush, and by gradually diluting it in a small tray of water, most tonal areas can be matched. A sample of the paper you are trying to retouch can be used to test the density of the spot tone.

Spotting is simply a method of building up density in a small area, and its primary goal is to hide blemishes. Small spots can usually be well disguised. By matching the surrounding tones, a delicate application of spot tone can do wonders. Spotting is an art, and once again, experience is the litmus test. If a mistake is made, the print can be immediately re-washed, dried and re-spotted. Larger blemishes are very difficult to retouch, but stippling with the point of the brush is more likely to be successful than painting with brush strokes. By gradually applying the spot tone to a lighter area (such as where a tiny hair was stuck on a negative), the blemish will gradually blend in with the tones around it.

'Spotting is an art, and once again, experience is the litmus test.'

A **PINHOLE** in the negative will print as a black spot. Pinholes are caused by a tiny piece of emulsion falling off the film base, and are unavoidable. As the black areas in a silver print have a thicker density than highlights, these areas can be gently scraped off with a fine-tipped knife. I use a medical scalpel, gradually reducing the density until the spot is gone. Occasionally this slow reduction will match the surrounding tone, but when it doesn't, it can be spotted.

BLEACHING

Bleaching can be useful, but overuse will ruin a print, as much as any poor application of burning or dodging. Bleaching should always be applied in moderation, to small areas only.

My bleach of choice is Kodak Farmer's Reducer, a two-part chemical that is easy to use. After mixing equal parts of A and B, apply the bleach to a washed and dried print with a fine-tipped brush. The straight mix is strong, and I usually dilute it with an equal part of water. As soon as the area being bleached shows some lightening, it should be quickly immersed in a tray of water. After soaking for one minute, it should be refixed for five minutes, with steady agitation. After fixing, the photo needs to be hypo-cleared again, and then rewashed. This is a tedious process, and I rarely resort to it. When it is necessary, however, a subtle bleach application can enhance delicate areas within the highlights.

Slip-Face Dune

An example of bleaching

Another in the Magdalena dune series, this negative showed great promise, but the prints weren't living up to their potential. After some study, I decided that the small slice of sand that was sliding down the dune face needed to stand out, and the sessions began again. Making a custom dodging tool by attaching a long, thin piece of cardboard to a length of wire, I began trying to bring up the tones through dodging.

After several failures, I gave up on dodging, and realized that the only way to lighten such a small sliver of the image was through the use of bleach. After the print was processed and dried, I mixed equal amounts of Farmer's Reducer parts A and B, and then diluted the total with one part water, and gently brushed the bleach up and down the small sliver of sliding sand. Wanting only a slight lightening, I watched the area carefully, and as soon as it showed a tonal change, slid it into a water bath to stop the bleaching. After re-fixing, hypo-clearing and drying, the print matched my original expectations.

This was a rare case where the only solution was to use bleach, as the manipulation required during printing was impossible. It is a subtle use of bleach, but makes a huge difference in the final print. The area lightened quickly with the reducer, taking only about 30 seconds. This is a high-key print, with the majority of the image consisting of upper tones. If this were printed down, it would be too heavy for the scene, and would ruin the photo.

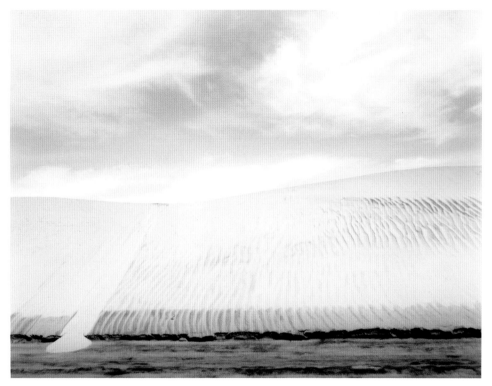

VERSION 1

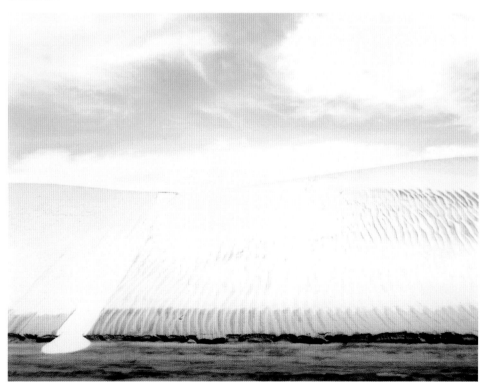

VERSION 2

St Croix River

An example of expert spotting

A friend recently took a fantastic photo at night, with lightning streaking across a cloudy sky over sandstone monoliths and reflecting in a foreground pool. These reflections are important to the composition; however, there was a short, streaky one that looked out of place. It was a true reflection of lightning, but looked like a terrible scratch in the paper's surface, and detracted from the photograph.

This resembled a problem in one of my photos, and reminded me how I was forced to have a natural happenstance retouched out of a scene. The photo is of some trees hanging over the St Croix River in northern Minnesota, and the problem was caused by the combination of a long exposure and the myriad leaves floating in the river. Because the shutter was open for one second, the leaves left several light streaks in the dark water. At first this appeared normal to me, but with repeated viewing, it began to be bothersome, detracting from the composition.

This was beyond my spotting skills, and I sent it to my retoucher in San Francisco. Peg Land is a master spotter, and I knew she would be able to make these annoying streaks disappear. When she returned the corrected print, it was vastly improved, and I decided to include it in *Terra Incognita*, my first black & white book.

Sometimes these small details can make a huge difference in a final print, and retouching the leaf lines definitely saved this image. Recognizing when these tiny alterations need to happen can be tricky, but these decisions will become easier with time and experience.

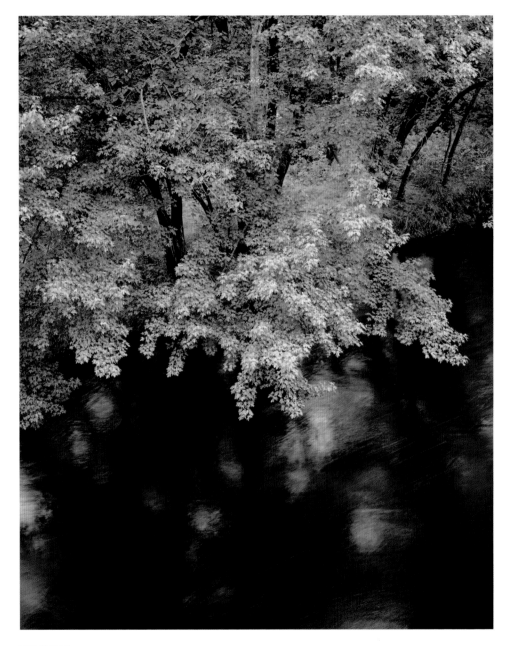

VERSION 1

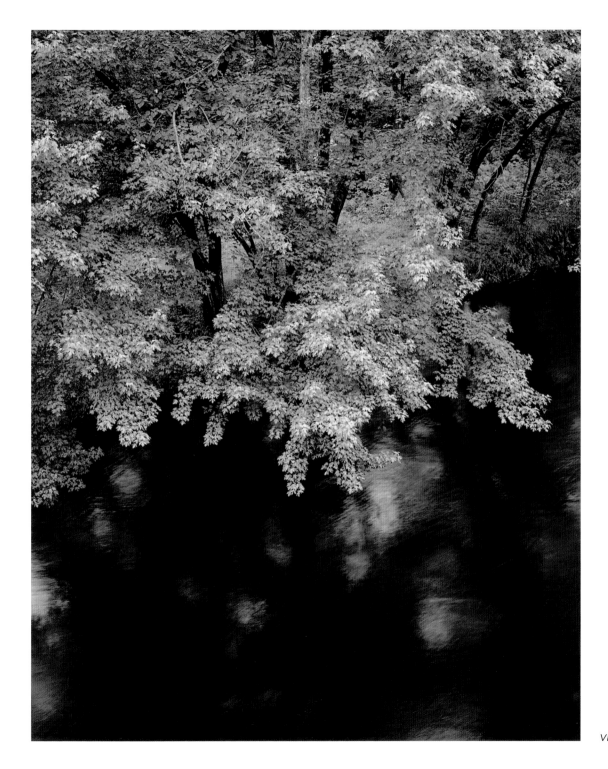

VERSION 2

Framed prints

Two examples of my preferred style of frame and overmatte.

PRESENTATION

Once the print is completed, the last step is presentation. My favourite method is to mount the trimmed print, then add an overmatte (window mount) that covers the edges of the print, which is affixed to the backboard. My signature is placed on the bottom right of the print, with a title or edition number on the left.

As you have archivally processed the photo, it should be mounted and matted the same way. There are many acid-free rag boards available, and several archival tapes and glues as well. I use an adhesive supplied in sheets with a peel-off backing. Lay the photo on the adhesive, with a cover sheet on top, and gently burnish it from the centre out to the edges. Trim away the excess adhesive, then peel off the backing, position the print on the bottom board (substrate), and burnish it with a cover sheet until it adheres. The substrate should be 2-ply 100% cotton rag board.

The next step is to cut the overmatte, and this should be 4-ply 100% cotton rag. These archival boards come in several colours, and my favourite is a warm off-white. Pure white is too harsh, and coloured boards detract from a black & white photo. The overmatte can be connected to the substrate by double-sided tape, of which there are several brands available. Lay several strips on the underboard, and then carefully position the overmatte on it.

The style of framing will depend on the size and subject matter of the image. My current preference is for narrow black metal frames. Any frame should quietly complement the image, and not overpower it.

If a good photo is poorly presented, it will ruin the effort expended in making the image. Good presentation is an important final step in the print-making process.

It can be very difficult to get your work out for people to see, and the available avenues for this are limited. One method I have been using recently is to print small runs of notecards. In the past, a small print run meant having 1000 cards made, and quality printing is very expensive. A recent digital process, however, has made the manufacture of quality cards both accessible and relatively inexpensive.

The Septone process uses an Epson printer and a seven-ink system. Three inks are different shades of warm grey, three are shades of cool grey, and the final ink is black. By shifting the balance between these inks, and laying quite a lot of ink on the paper, a very lush tonal range is available. This process gives a very nice reproduction of a silver print, and pre-folded notecards are available from several digital paper companies.

My scanner and printer has become very adept at reproducing my photographs with the Septone process. These cards, considering their high quality, are fairly inexpensive, and they offer the great advantage of limited runs. I will generally have my printer make ten cards from a new image, deciding later if the photo warrants more.

These cards have been generating interest lately, and I have made several sales to major photo museums and bookstores. They have also opened several doors for me, including an upcoming exhibition at a major gallery. Short of sending original prints to people (which is expensive, and often results in damaged photos coming back, or even worse, none coming back at all), there is no better way to show your work to publishers and galleries.

We have also begun using this system to make book proposals, and I have put two together, both printed with Septone, and bound in good leather covers. I used the same technique to make *Darktown*, a limited-edition book with my plastic-camera photos and my daughter's poetry, which was a great success.

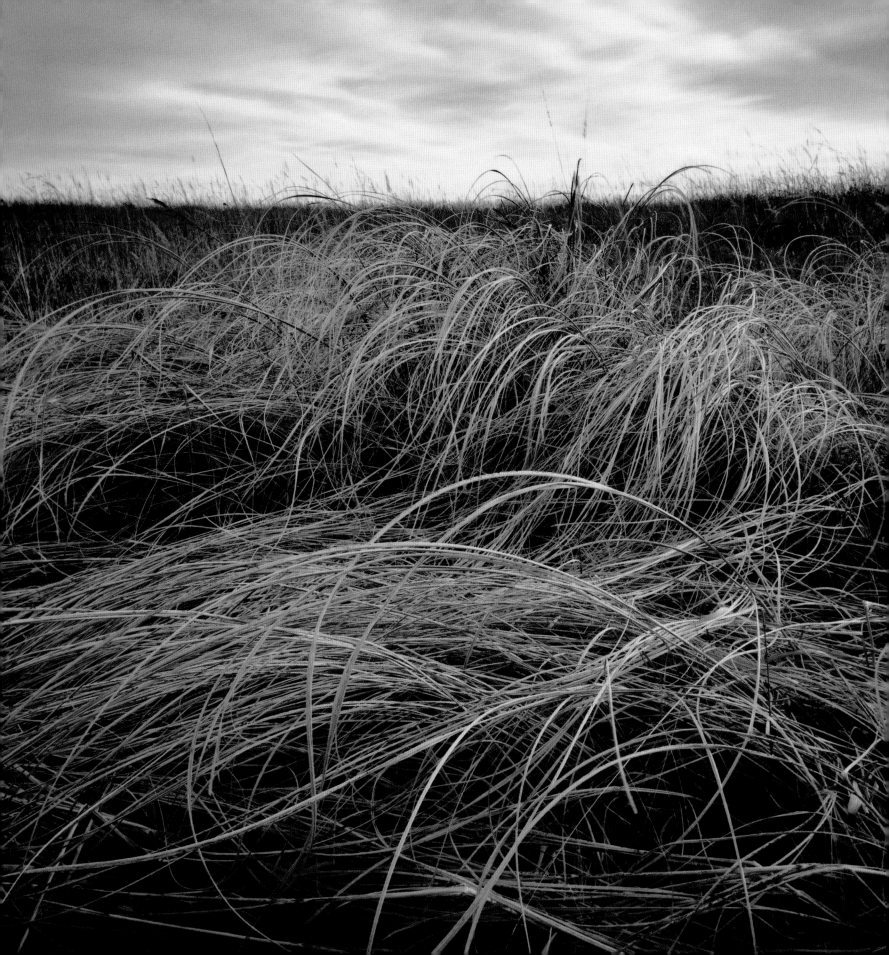

Chapter 5

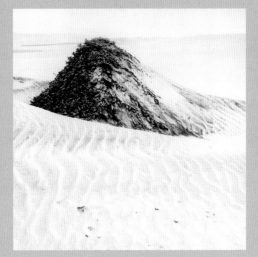

Series

What Makes a Series?

ALMOST ANY GROUPING OF IMAGES CAN FORM A SUCCESSFUL SERIES,
AND ONE OF THE MOST EFFECTIVE WAYS OF DOING THIS IS TO CREATE
A SEQUENCE ABOUT A PARTICULAR PLACE.

By choosing an area that appeals to your sensibilities, then focusing your photographic attention on it, sometimes spending years exploring and shooting there, creating a series can be a rewarding experience, and can result in a strong portfolio.

Sequencing is an important aspect of any series, as the images need to balance with nearby photos, and the portfolio needs to follow a developmental flow. Intuition will play a part in this, as will extended contemplation. I selected and sequenced the images for my first books at our local gym, using the bleacher seats to lay out 60 prints, winnowing them down to the final 40. The selection depended heavily on the sequencing, and several strong photos fell away because they didn't fit in with the other images.

Courthouse Wash

As evidenced by the numerous photos scattered throughout this book and on the following four pages, Courthouse Wash in Utah has long entranced me, and has been my longest-running series. After 20-plus years of shooting there, my occasional forays to this long and winding canyon in Arches National Park are still rewarding, and the series continues to grow. Most of the portfolio is focused on the details in this exquisite canyon.

Flood Debris, Courthouse Wash

Seep Wall, Courthouse Wash

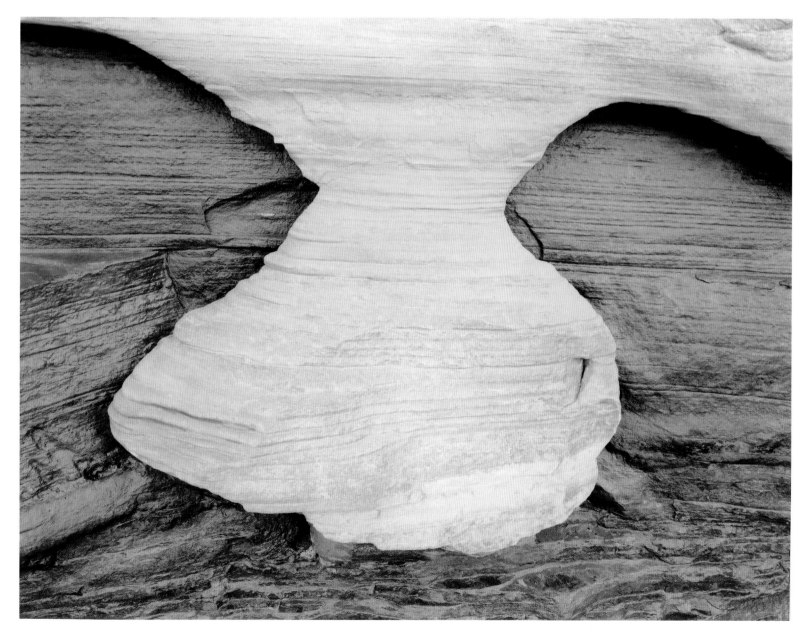

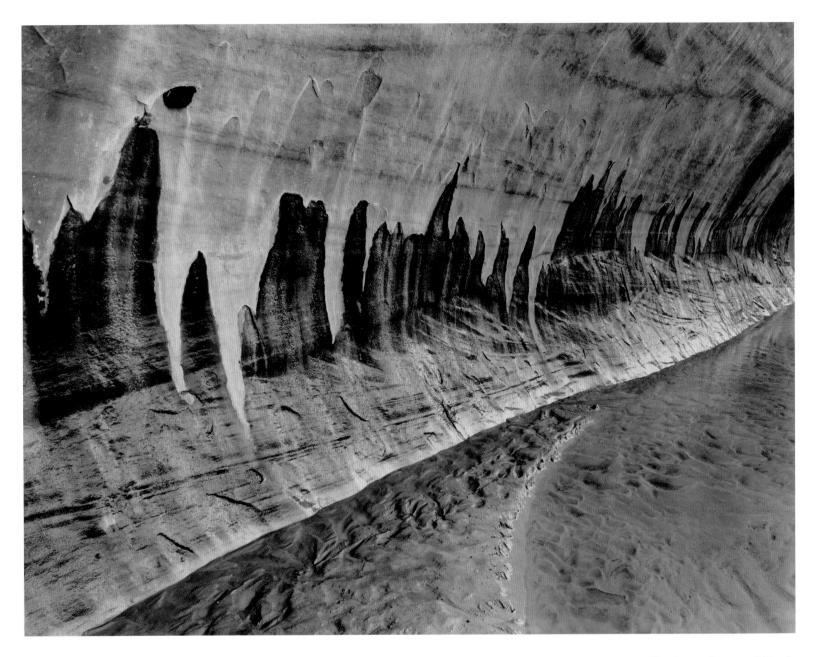

Long Deep Wall, Courthouse Wash

Cottonwoods, Courthouse Wash

Snow and Mud, Courthouse Wash

Great Salt Lake

Another place that has consumed my attention has been Utah's Great Salt Lake. This body of water is a wonder of the world – despite everyone's best attempts to pollute and ruin it – and the esoteric landscape surrounding the lake has provided me with limitless subject matter. This area has captured my imagination, and has been a rewarding subject both along the shoreline and from the air.

Stansbury Island, Great Salt Lake

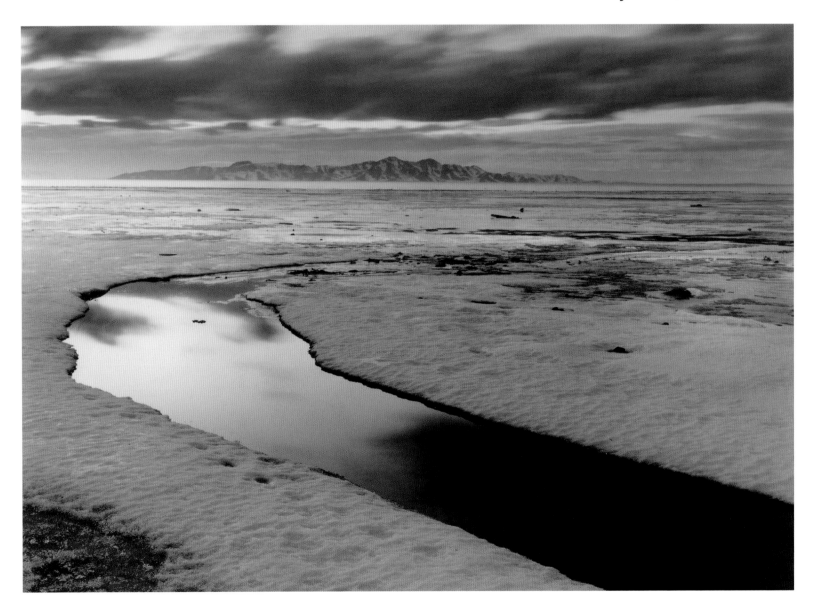

**Russian Thistle,
Great Salt Lake**

Wetlands, Great Salt Lake

Magdalena Island

Magdalena Island is a barrier sand island off the west coast of Baja, Mexico, and has some of the coolest dunes I have ever found. While working for a whale-watching tour company, I would stay on the island between trips, watching the camp and boats, and exploring the dunes.

Rising Tide, Magdalena Island

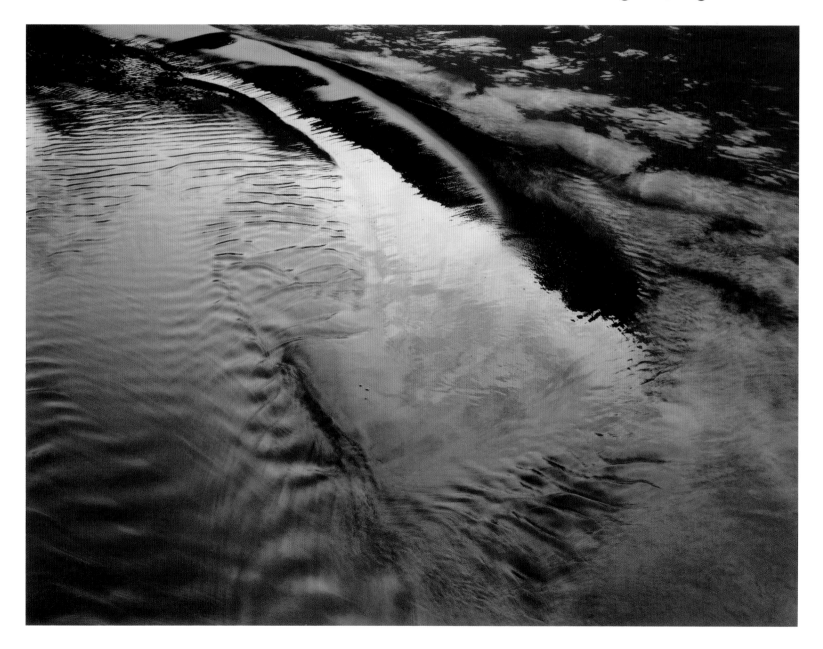

Driftwood, Magdalena Island

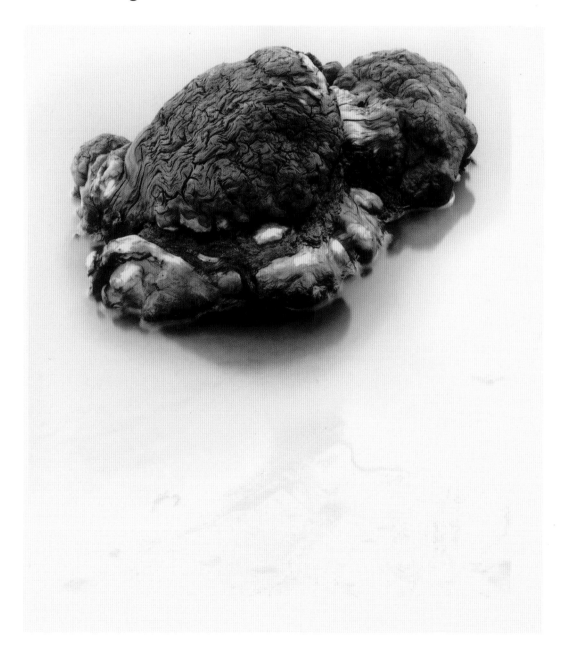

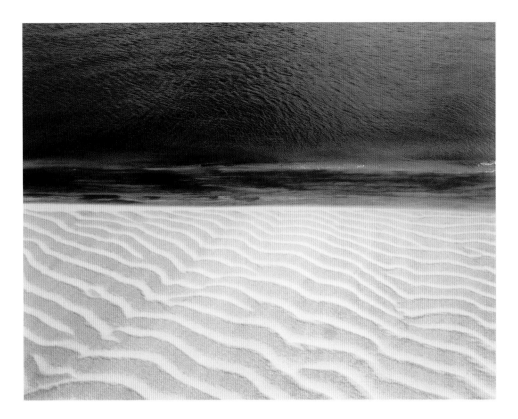

Dune and Bay, Magdalena Island

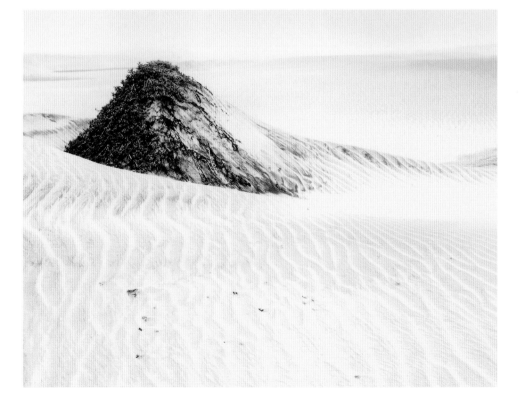

Stabilized Dune, Magdalena Island

Estuary Detail, Magdalena Island

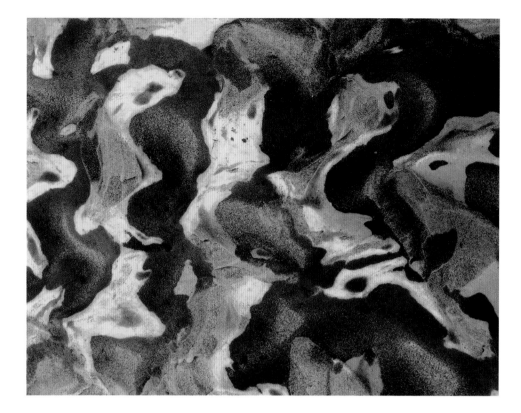

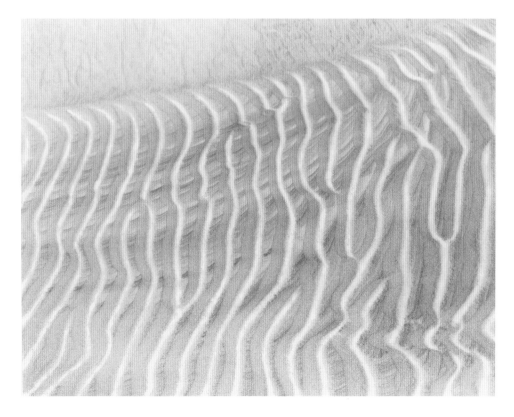

Sliding Dune, Magdalena Island

Grasses

Thematic elements can also provide fodder for a series, and these themes can be centred around any cohesive subject matter. I have recently noticed a developing body of work in which the central element is grass. This group of photos runs a wide gamut, from aerials of tallgrass prairie to a detail of a single blade of grass. This is a relatively new series, and will require some time and thought before it begins to coalesce, but it is showing some promise.

Barn Grass, Canyonlands, Utah

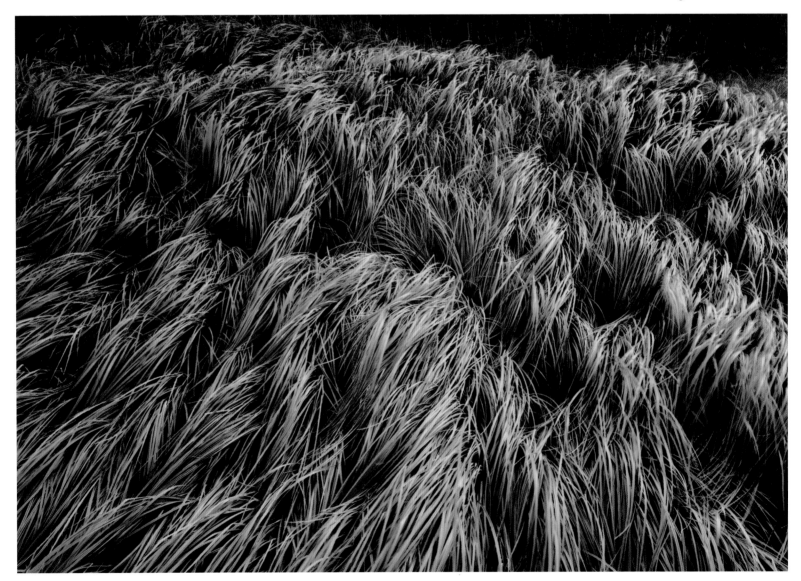

**Konza Prairie,
Kansas**

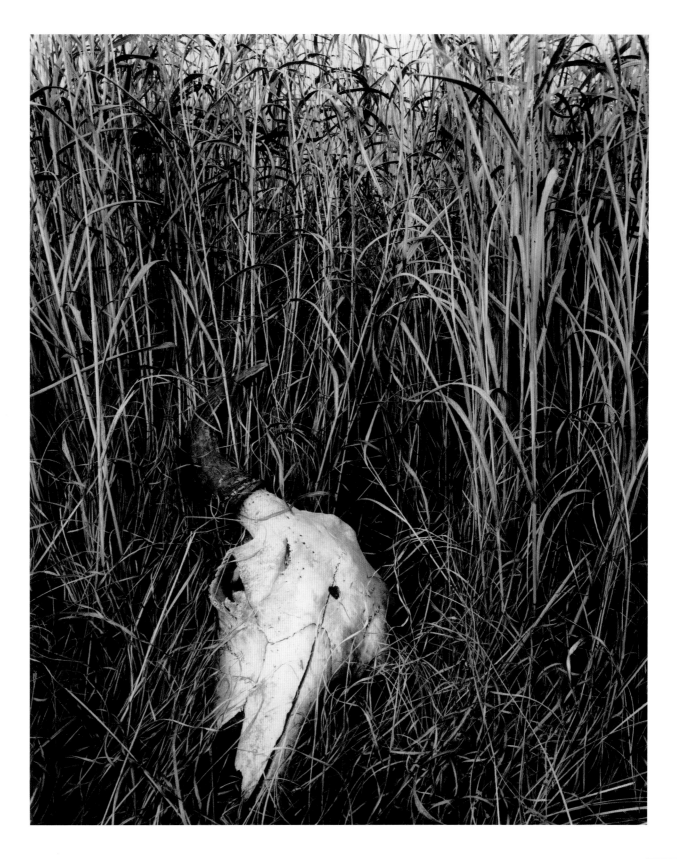

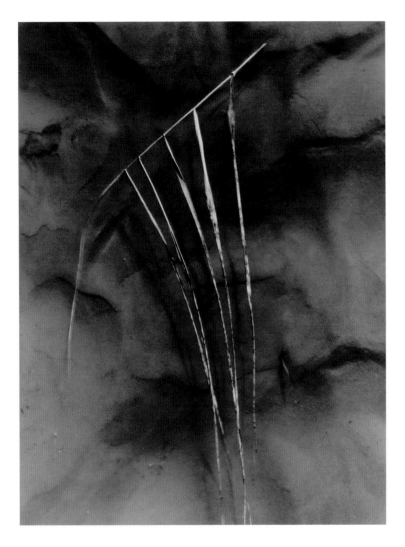

Grass, White Woman Creek, Kansas

Lichen and Grasses, Courthouse Wash, Utah

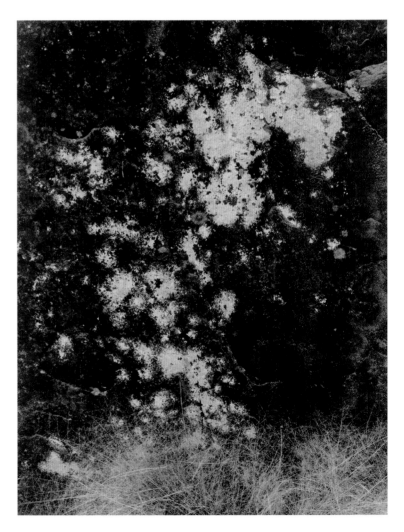

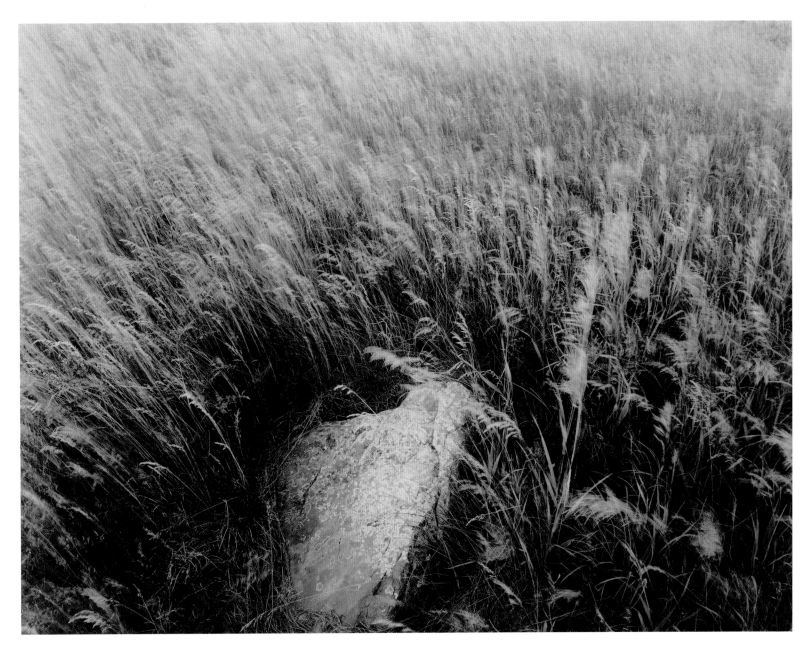

Rock and Tallgrass, Redrock Prairie, Minnesota

Glossary

APERTURE the size of the opening through which light passes through the camera or enlarger lens; it is controlled by an adjustable diaphragm.

BURNING selectively darkening an area of the print by giving additional exposure after the main enlarger exposure.

CAMERA MOVEMENTS the various adjustments on a large-format camera which permit the relative positions of film and lens to be altered, giving control over perspective and depth of field.

COLD LIGHT my preferred form of enlarger light source, a fluorescent light giving softer contrast than other types.

DEPTH OF FIELD the distance between the nearest and furthest elements in the image which appear in sharp focus.

DODGING selectively lightening part of a print by shading it from the light source during enlargement.

EXPOSURE the process of taking a photograph by admitting light to the film; also the amount of light admitted, which is governed by the combination of aperture and shutter speed.

F-STOP the unit in which lens apertures are measured; each whole step in the f-stop sequence represents a doubling or halving of the amount of light admitted.

FIELD CAMERA a large-format camera of the traditional type, with a hinged baseboard, often made of wood.

FILTER a tinted or otherwise treated piece of glass or gelatin which alters the character of light passing through the camera or enlarger lens, usually so as to adjust the contrast of the image.

GRADED PAPER photographic paper supplied in a choice of grades, each providing a different level of contrast.

ISO RATING the standard measure of film sensitivity, specified by the International Standards Organization.

LARGE-FORMAT CAMERA one which uses single sheets rather than rolls of film, most commonly in the 4 x 5in format.

LIGHT METER a device, either built into the camera or made separately, for measuring the light falling on or reflected from the subject, in order to permit accurate exposure.

MEDIUM-FORMAT CAMERA one that uses rolls of film with opaque paper backing, nearly always in the 120 format, giving negative sizes from 6 x 4.5 to 6 x 9cm.

REAR TILT a camera movement which allows the film holder to be tilted backwards, increasing depth of field.

RECIPROCITY the principle by which a one-stop change in aperture can be compensated by a one-stop change in shutter speed and vice versa, so that overall exposure remains unchanged. At exposures longer than 1 second, **RECIPROCITY FAILURE** occurs, and exposure time must be increased.

ROLLFILM film supplied in rolls, permitting numerous exposures on one length of film.

SHEET FILM film supplied in individual sheets for use in large-format cameras.

SHUTTER the mechanism by which light is admitted through the camera lens for a precisely measured length of time.

SPLIT-CONTRAST PRINTING the method of printing which involves separate enlarger exposures at hard and soft contrast settings.

SPOTTING retouching small blemishes in the finished print.

TEST STRIP a strip of photographic paper on which trial exposures are made to determine the optimum exposure for the final print.

TONING applying a chemical solution, such as selenium, to the processed print in order to modify the colour and/or increase longevity.

VARIABLE-CONTRAST PAPER photographic paper which produces different degrees of contrast when exposed through different-coloured filters.

VIEW CAMERA another term for a large-format camera.

ZONE SYSTEM a methodical way of calculating film exposure to ensure that shadows, highlights and midtones appear as desired by the photographer.

Resources

INTERNATIONAL

Calumet Photographic Supply
www.calumetphoto.com
Zone VI products, including Brilliant paper, print developer and fixer, and the Zone VI variable-contrast enlarger; cameras; darkroom supplies. Outlets in USA, UK, Germany, Belgium, Netherlands.

US

Adorama Camera
www.adorama.com
Film and paper.

Archival Methods
www.archivalmethods.com
Archival mount board and supplies, storage boxes, portfolio cases, frames.

B&H Photo
www.bhphotovideo.com
Film, paper, cameras, backpacks.

Freestyle Photographic Supplies
www.freestylephoto.biz
Film, paper, chemistry, cameras.

Light Impressions
lightimpressionsdirect.com
Archival materials.

UK

First Call
www.firstcall-photographic.co.uk
Film, paper, darkroom supplies.

Nova Darkroom Equipment
www.novadarkroom.com
Film, paper, darkroom supplies.

Process Supplies (London) Ltd
www.process-supplies.co.uk
Film, paper, chemistry, print storage.

Retro Photographic
www.retrophotographic.com
Film, paper, chemistry.

Secondhand Darkroom Supplies
www.secondhanddarkroom.co.uk
Used darkroom equipment, books.

Silverprint
www.silverprint.co.uk
Film, paper, darkroom supplies, books.

Speed Graphic
www1.cyranehosting.net/speedgraphic
Film, paper, darkroom supplies.

Acknowledgements

For all her assistance with the massive e-mails this project generated, many thanks to Cindy Lenamond at Systec. For help with the section on Septone printing, and for the fine digital notecards he has made for me, thanks to Chris Conrad at petroscans.com. For her cheerful help over several years, thanks to Melanie at photoeye.com. For the excellent photos of my darkroom, kudos to Bill Godschalx, a master printer in his own right. For repeated assistance through several book projects, many thanks to Richard Newman at Calumet Photographic. Thanks to Eric Trenbeath and Michelle Wurth at framedimagemoab.com for a detailed description of how they mount and matte my photos. For her unstinting support, and for the Foreword, gracias to Ailsa McWhinnie at *Black & White Photography* magazine. For his steady enthusiasm, and for supporting this project from the get-go, thanks to James Beattie, Photography Books Project Editor at PIP. For his extended patience with the massive text I electronically dropped onto his desk, and for catching my stupid mistakes, many thanks to my editor Stephen Haynes.

As usual, nothing in my life would ever come together without family. For their patience, love and support for the five months it took to complete this project, merci to my wife Victoria Gigliotti and daughter Alyssa.

PHOTO CREDITS

Alyssa Mulligan: page 14. Chris Conrad: pages 34 (Wearing the pack), 42–3 (tripod), 47 and 123. Bill Godschalx: pages 124–5. All others by Steve Mulligan.

Index

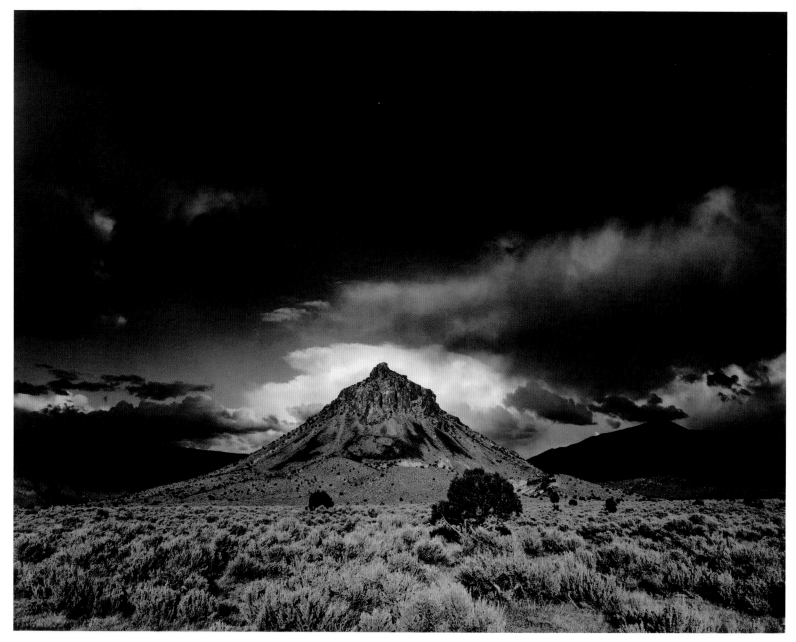

Round Mountain, Utah

To request a full catalogue of Photographers' Institute Press titles, please contact:

GMC PUBLICATIONS, CASTLE PLACE, 166 HIGH STREET, LEWES, EAST SUSSEX BN7 1XN, UNITED KINGDOM

Tel: 01273 488005 Fax: 01273 402866

WWW.PIPRESS.COM